Shooting for Dollars

Simple Photo Techniques for Greater eBay Profits

Sally Wiener Grotta and Daniel Grotta

Peachpit Press

Shooting for Dollars: Simple Photo Techniques for Greater eBay Profits

Sally Wiener Grotta and Daniel Grotta

Peachpit
1249 Eighth Street
Berkeley, CA 94710
510/524-2178
800/283-9444
510/524-2221 (fax)

Find us on the World Wide Web at: http://www.peachpit.com
To report errors, please send a note to errata@peachpit.com
Peachpit Press is a division of Pearson Education

Editor: Jill Marts Lodwig
Production Editor: Lupe Edgar
Interior Design and Composition: Diana Van Winkle
Cover Design: Aren Howell
Indexer: James Minkin
Proofreader: Evan Pricco

ISBN 0-321-34922-9

9 8 7 6 5 4 3 2 1

Printed and bound in the United States of America

To all the eBayers we've sold to and bought from,
who have made it all worthwhile...and lots of fun.

Acknowledgments

Selling on eBay is an ongoing learning experience, which is one of the things that makes it so interesting and fun. Just browsing through the auction listings can be like reading any other great reference resource. But it's the people we have met along the way that have kept us coming back, to buy, sell and explore. The same has been true about writing this book. The people we've interviewed, worked with and learned from have made all the difference.

So many eBayers have helped us over the years that it is impossible to name them all. However, we would like to give special thanks to Bernie Andreoli, Bob Bull, Monica Bush, Diane Clark, Anthony Crawn, John Lang, Chris Miller, Bill O'Malley, John Pivovarnick, Phoebe Sharp, Shanna Smith, Shannon Smith—and, of course, Jim Griffith, the dean of eBay University, who has inspired us all.

Our gratitude to Jan Ozer, our friend and fellow *PC Magazine* contributing editor, who introduced us to Peachpit Press. And to all the folks at Peachpit Press, especially Jill Marts Lodwig, Marjorie Baer, Rebecca Ross, Lupe Edgar, Nancy Davis, Karen Reichstein, Aren Howell, James Minkin, Evan Pricco and everyone else.

Cameras, software, photographs and information were provided by Adobe, Bogen Imaging, Canon, Casio, Eastman Kodak, Epson, Fujifilm, Hewlett Packard, Konica Minolta, MK Digital Direct, Nikon, Olympus, Panasonic, Pentax, Photobucket, Promaster, Samsung and Vendio. In particular, we would like to thank Lillian Ayala, Cheryl Balbach, Michael Bourne, Sally Smith Clemens, Geoff Coalter, Mark Dahm, Ana Doi, Mike Effle, Frank Fellows, Bill Giordano, Leigh Grimm, Jason Ledder, Ryan Luckin, Stephna May, Michelle Martin, Jaime Nacach, Nicole Ramirez, Mary Resnick, Steven Rosenbaum, Mike Rubin, Azenith Smith, Brian Williams, Lyda Velez and Saurabh Wahi.

As with all our books, lectures and articles, we called on our friends and family when we ran out of things to photograph among our own possessions and objects we have for sale. Thanks to the Angell family, Jason Kilpatrick, and Stephanie and Roger Spotts.

And a special thanks to Lee Hacohen, for his considerable energy and skills in organizing our eBay University workshops on digital photography, and to the entire *PC Magazine* events team for their ongoing efforts.

As ever, our deepest thanks goes to our parents and dear friends Edith and Noel Wiener, and their ever-diligent red pencils.

Our apologies for forgetting to mention by name any of the many folks who have helped with this book and over the years on eBay. It doesn't diminish how much we appreciate your guidance and assistance.

Table of Contents

Introduction

Several years ago, we bought Sally's parents a beautiful Mercedes-Benz 300SD turbodiesel sedan on eBay for a ridiculously low price—thousands below fair market value. How did we score such a bargain? Probably because the handful of photographs showing off the car were truly awful. They were overexposed and light-streaked, blurry and indistinct, taken against a white garage door the same color as the car. Nor were there any details or close-ups of the instruments and controls, upholstery and carpets, body paint and blemishes, tires and engine.

Despite the bad pictures, the description sounded very decent, so we took a chance. Only one other person bid against us for the car, and because it was a no-reserve auction, we won it at a relatively low price when our competitor eventually dropped out. The car turned out to be a veritable jewel, beautiful inside and out—but you wouldn't have known it from the pictures we saw on the eBay listing.

Last year, we bought another Mercedes-Benz 300SD turbodiesel for ourselves on eBay, but this time, we paid top dollar, even slightly above its Blue Book retail value. Why did we bid so high, and in competition against so many other bidders? Because the series of photographs the buyer posted on his auction were excellent, displaying and detailing a car that looked almost showroom new. We could see everything—the perfect interior, the gorgeous exterior, the spotless engine, and lots of little details, like the CD changer in the trunk, the backseat pull-down vanity mirrors in the ceiling, the knobs for adjusting the pneumatic lumbar seats, and even the optional heater cord for warming the engine for easy starting when the winter temperature plummeted to zero. (Alas, what the photos couldn't show us were the flummoxed electrical system and bad engine in desperate need of a rebuild, but that's another, sad story that had nothing to do with the quality of the photographs.)

The object lesson from these two purchases is crystal clear: Bad eBay photos directly translate into less money than you would get with good photos. That's great for bidders and buyers looking for a bargain, but terrible for sellers seeking top dollar for their auctions.

eBay is a worldwide phenomenon that has become the place to buy and sell everything and anything, from antique jewelry to lawn tractors, quilts to office complexes. At last count, there were over 135 million registered eBay bidders, 15 million sellers, an annual turnover of more than $33 billion, and at any given time literally millions of items and objects up for auction. The best, most successful auctions are those accompanied by great photographs, showing the bidder exactly what's for sale, with detailed visual information on the condition of the item. But as important as good photos are, they don't always tell the entire story about the item for sale. That's why a good verbal description and a seller's reputation also help in garnering top dollar sales.

The purpose of this book is to help you take consistently great eBay photographs without needing lots of expensive equipment or requiring a degree from an art college. Equally important, we'll help you develop your own personal workflow, or methods, for working faster, easier and smarter. You'll learn how to set up, shoot, process and post your photographs into your eBay auction listings in mere minutes. When you're in business, time saved is as good as money in your pocket.

Whether eBay is a part-time hobby or a full-time vocation, taking photographs of the items you're putting up for sale should be an enjoyable experience, not a dreaded chore. And it's just as easy to take great photos as it is to produce bad shots. So we encourage you to have fun while trying out many of the tips and techniques detailed in this book. While we can't absolutely, positively guarantee that you'll make more money from your auctions, we can assure you that better pictures do attract buyers, and efficient photography will save you time so that you can put even more things up for sale.

1

Choosing Your Digital Camera

With literally hundreds of digital cameras on the market today (more than 700 since 1996), it may seem like a daunting task to zero in on the one that best suits your needs, shooting style and, of course, your budget. Fortunately, choosing the right camera to use for eBay product photos can be relatively simple.

Why Use a Digital Camera for eBay?

eBay and digital photography go hand in hand—both are part and parcel of the Internet age. But if you've been hibernating these past few years and somehow have missed the digital camera revolution, here are some of the important advantages digital offers over film:

✦ **It's immediate.** Take a picture, and you can examine it seconds later on the digital camera's LCD screen. You don't have to wait hours or days for your exposed film to be processed.

✦ **It's fast.** We're not just talking about instant capture and immediate review, but that all-important *workflow*—the technical term that describes how fast or slow the entire process of capturing, uploading, image editing and posting on eBay actually takes. Once you're comfortable using your digital camera and have assembled an efficient shooting area, you can go from photographing an item to posting it for sale on eBay in mere minutes.

✦ **It's free!** No, not the camera, batteries or memory cards (although prices have steadily dropped as more people switch from film to digital), but you'll never pay another penny for film or processing. The memory cards that store your captured images can be reused hundreds, even thousands of times.

✦ **It's forgiving.** If you don't like the picture you just shot, you can simply hit the Delete button and shoot again. If it's too dark or light, or the color seems off, most digital cameras have the ability to help you get a better picture (see Chapter 4, "Exposure and Focus," for more information). And you usually can make quick corrections on your computer (see Chapter 11, "Photo-Editing Techniques that Make Pictures Zing").

✦ **It's easy.** There's no film to load or rewind. Once you understand how your digital camera works, it becomes second nature to navigate the menus (or pull-down functions and settings) that are displayed on the LCD screen. All you usually need to do is point the camera and press the shutter button. The camera's "smarts" do all the work of capturing and processing the image—in seconds, too.

✦ **It's superior.** You can capture details using digital that film never could, especially in dark, or shadow, areas. You also have access to lots of tools for correcting, improving and perfecting your pictures, both in the camera before you shoot and later on the computer using a photo-editing program.

- **It's fun!** After you've finished shooting great photos for your eBay auctions, that same digital camera is perfect for taking snapshots of family and friends or, with many models, recording videos with sound. Then you can print, post or email them to your heart's content.

- **It works.** At the end of the day, a good digital camera becomes an indispensable workhorse, an important component that helps you make more money on your eBay auctions. Handled properly, it can give you years of trouble-free service.

If we haven't yet sold all of you serious and even casual eBay sellers on the advantages that digital offers, then perhaps it's time to consider the downside.

There is no downside!

Digital cameras cost zip to operate; provide instant feedback and rapid workflow; are eminently affordable, easy to use and forgiving of mistakes; produce good-to-great quality pictures; and are versatile enough to use for work and fun. And you don't need to spend big bucks buying one of the latest, greatest, highest resolution, feature-heavy models either. We have a friend who makes lots of money doing eBay full time, illustrating all her auctions with a relatively low resolution, four-year-old Sony Mavica that saves to floppy disks rather than memory cards. (In doggy-digital camera years, a four-year-old camera is ancient.)

Take a quick inventory of the kind of goods you want to sell on eBay. Do you have albums bulging with stamps, drawers brimming with sheet music, shelves full of books or other comparatively flat items? If so, you may be better off using a scanner or a copy stand instead of, or in addition to, a digital camera. (We cover scanners and copy stands later in this chapter.)

The Best Digital Camera for You

Quite frankly, for many eBayers, just about any digital camera will do, as long as it has the following common features:

- A resolution of at least 2 megapixels

- An LCD viewfinder (the small screen on the back of the camera) to preview what you just photographed (**Figure 1.1**)

- Exposure compensation (also called exposure value, or EV) to ensure your photo has the right brightness and contrast

- Removable memory card capability to save your pictures and more easily transfer them to your computer

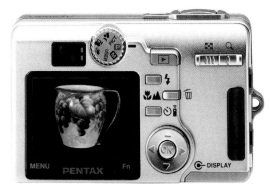

Figure 1.1 *Your digital camera's LCD viewfinder, or screen, such as the one on this Pentax Optio SV, provides immediate timesaving feedback so that you can be sure the photo you just shot will work for your eBay auction.*

The only digital cameras that don't have the features just mentioned are either very cheap or very old (or both) and are certainly too limited, probably not only for eBay, but for your personal photography, too.

You'll need more advanced cameras if your eBay photographs involve any of the following:

+ Small objects

+ Very detailed pieces

+ Close-ups of larger items

+ Low-light photography, which often occurs whenever you shoot indoors

In these instances, consider spending a little more money for a digital camera that features the following components or capabilities:

+ A tripod socket on the bottom for steady, clear photographs that have no motion blur

+ A self-timer to improve the steadiness of your tripod photos

+ White balance presets to help you capture accurate color

+ A focusable lens with macro (or close-up) capability

+ Aperture priority mode to help you control depth of field, or the amount of area from foreground to background that is in focus

+ A histogram to help you get consistently good exposure

(We discuss how to use aperture priority, exposure compensation and histograms in Chapter 4, "Exposure and Focus." White balance is covered in Chapter 5, "Great Lighting the Easy Way.")

Fortunately, these requirements aren't written in stone—you probably can do without some of them. For instance, if the digital camera you have your heart set on doesn't come equipped with a histogram or offer aperture priority, don't despair. You still can take money-generating eBay shots of most products without them. (However, the smaller and more detailed your products are, the more important such controls become.) A significant number of digital cameras come equipped with all these functions, however, so all things being roughly equal, we encourage you to seek out the models that give you everything on our short list of ideal requirements. We explain in later chapters why these features can help you get great shots, how to use them and some workarounds if your camera doesn't have them.

What About a Zoom Lens?

You've probably noticed that we didn't mention a zoom lens in our short list of digital camera necessities. That's because you probably don't need one, although most digital cameras come equipped with an optical zoom lens. (Most also feature a digital or electronic zoom option, which you should always turn off and never use, for maximum image quality.)

In a sort of "Don't raise the bridge, lower the water" logic, the vast majority of amateurs use the zoom to fill the frame, rather than walking a few steps closer or farther away from their subject. What they don't realize is that as the lens optics changes, so does the perspective. With a telephoto perspective, the foreground seems to compress (think of what happens when you look through binoculars), and with a wide-angle perspective, the opposite is true (the subject seems far away from things in the background). Telephoto and wide-angle zoom settings are useful aesthetic tools when you're shooting the kids playing soccer or want to include all your spouse's relatives in a group photo, but they can produce distorted and inaccurate eBay product shots. The only reason to use a zoom lens when photographing for eBay is when you are shooting a very large item in a confined space, or you are too far away to walk closer to get a better shot.

If your digital camera has an optical zoom lens (and most do), we recommend you push the zoom button so that the setting is halfway between Telephoto and Wide Angle. Then, if your subject is too small or spills out of the frame, move the camera closer or farther away until it's just the right size in your viewfinder.

Sure, you can use your film camera, but...

If you're a traditionalist, or if you're just plain frugal, you can continue to use your trusty film camera. Of course, you'll have to pay for film and processing every time you shoot, as well as the cost of having the photofinisher burn a CD of your pictures so that you can upload them to your computer. (If you decide to scan the pictures on your own scanner rather than pay for a CD, you'll spend a fair amount of time setting up and scanning your photos, frame by frame.) A 24-exposure or 36-exposure roll of film, processing, and burning a CD most likely will set you back about $20. Multiply that by the number of auctions you run, and you'll quickly understand why we recommend switching to digital.

Either way, the biggest drawback to using a film camera is the longer time between snapping your picture and getting your auction up on eBay. Keep in mind, too, that without the instant visual feedback a digital camera provides, you won't know for certain whether your shots are perfectly exposed or in focus until you get your film back from the minilab.

We're usually not partial to specific brands, but the best film to use for eBay is Kodacolor. This is because Kodacolor has much more exposure and color latitude and is much more forgiving than other films. But unfortunately for film aficionados, film is becoming the 21st century's equivalent of buggy whips and coal scuttles. So you can depend on film for only as long as Kodak and other manufacturers continue making it. (We expect film to be more difficult to find and buy sometime within the next five years.)

Still stuck on film? If so, the requirements for a film camera are a similar to those for a digital camera:

✦ A focusable lens with macro capability, or a Proxar (closeup) lens that screws in front of your primary lens

✦ Aperture priority to ensure proper depth of field

✦ A tripod socket screw to avoid motion blur

✦ A cable release for rock-steady pictures when the camera is on a tripod

You may have noticed we didn't list a histogram or white balance. That's because these features don't exist in film cameras. Nor do we specify any particular megapixel resolution, since film is chemical-based and captures light via millions of photosensitive silver halide crystals rather than by electronic pixels.

If you sell small items or photograph small details of larger items, the best type of film camera to use is a single lens reflex (SLR). Of course, you can use your auto-everything, point-and-shoot film camera, or even your trusty Kodak Instamatic, but the closer you shoot using one of these cameras, the more likely you'll encounter parallax problems. *Parallax* is the discrepancy between what your optical viewfinder shows you and what the lens actually captures, which leads to cropping off important parts of your subject. (Digital cameras don't have this problem as much because you can use the LCD screen on the back of a digital camera to preview what your photograph will capture.) Canon, Nikon, Konica Minolta, Olympus, Pentax, Sigma and other camera manufacturers produce 35mm and APS (Advanced Photo System) single lens reflex cameras suitable for eBay photography.

Depth of Field: Film vs. Digital

If you're using a 35mm or even an APS film camera, you must carefully watch your depth of field. Technically speaking, *depth of field* is the area from foreground to background that is in sharp focus.

In **Figure 1.2**, the depth of field is deep, and everything is in focus from the foreground to the background. But in **Figure 1.3**, the depth of field is shallow. While the upper-left, or closest, corner of the can is in focus in Figure 1.3, the further back along the can you look, the more blurred things become. Notice, in particular, the letters on the front of the can and the softening of the crease of the background cloth. These details are much sharper in Figure 1.2 (Both photos were taken with a Canon EOS Digital Rebel.) As a rule, you'll want lots of depth of field in most of your eBay shots so that everything is sharp enough for potential buyers to see.

Figure 1.2

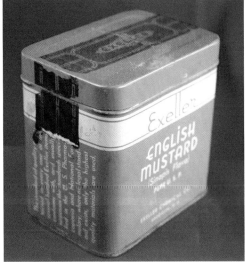

Figure 1.3

Two things control depth of field. The first is the aperture, or the adjustable hole (called a diaphragm) in the middle of the lens that regulates the amount of light that strikes the film (the equivalent of film in a digital camera is the image sensor). The other is the physical size of the lens—the smaller its focal length (the distance from the center of the lens to either the film plane or the image sensor), the greater its depth of field.

Here's why and how the lens size becomes a critical difference: Each frame of 35mm film is 24mm x 36mm, or 1 inch x 1.5 inches. APR film is half that size. According to the technical formula, the "normal" lens for a 35mm camera (that's the lens that "sees" approximately the same degree of magnification as the human eye) is 50mm, or about 2 inches. However, the average size of a consumer-type digital camera's image sensor is less than one-half an inch in diameter, or about the size of your pinky's fingernail. Consequently,

the normal lens for a digital camera is only about 8mm, or about one-third of an inch. That's a lot smaller than a 35mm lens.

The upshot of all this technical rigmarole is that consumer digital camera lenses produce far greater depth of field than film lenses do. A typical digital camera with aperture priority enabled at its smallest opening can capture everything in sharp focus from about a foot away to infinity. In contrast, a film camera with the same aperture setting may be able to manage a depth of field of 6 feet to infinity. Now that doesn't matter much when shooting large objects like cars and boats from a distance, but for close-ups it can be a deal breaker, because a much smaller area of the item for sale will be sharp and in focus.

In Chapter 4, we discuss depth of field in more detail and how to use aperture priority to increase it whether you're using a digital or film camera.

Choosing a digital camera based on the products you sell

Now that we've thoroughly convinced (brainwashed?) you into wanting to shoot all your eBay auctions using a digital camera, the question is, which camera? We'll answer that by briefly describing the various types and models of digital cameras that cry out, "Buy me! Buy me!" By the way, some of the digital cameras we suggest may not be current models, but they're certainly available for sale, especially on—you guessed it!—eBay.

Novelty

Novelty cameras are the least expensive, and the least enabled, of digital cameras—the equivalent of the old Brownie box camera. Selling for between $15 and $50, these devices typically come with a fixed focus, fixed focal-length lens (that means no macro or zoom), no built-in flash, no removable memory (which makes life much less convenient), very few features, and resolutions between 640 pixels x 480 pixels (0.6 megapixels) and 1600 pixels x 1200 pixels (2 megapixels).

Buying a cheap novelty digital camera is penny wise and dollar foolish: Your eBay pictures just won't look good, no matter how well you illuminate and frame them.

Different Cameras for Different Uses

We used a variety of digital cameras for taking pictures of typical eBay products for this book, and all of them produced very good to excellent results, although some were better suited for one type of product over another. Throughout the book, we note along the side of most of the product photos which camera model we used for that shot or series of shots, to give you an idea of the capabilities of the different types of cameras.

Camera phone

Nokia recently sent us a beautifully bound portfolio of pictures of Orlando, Florida, shot by professional photographer Mark Lepow using a Nokia 1.3 mega-pixel camera phone and printed by Kodak's EasyShare online service. The image quality blew us away. The pictures were sharp and well exposed, with attractive colors and details in the shadows that were as good as those we'd seen taken with any 1.3 megapixel digital camera.

Mind you, this was a latest generation, high-resolution, moderately priced Nokia camphone, not one of the cheapie VGA resolution models your cell phone company gives away free with a two-year service contract. While we don't specifically recommend using a camphone for eBay, especially not for anything small, detailed or close-up, a phone as good as the one Mark Lepow used is better than a lot of the low-end digital cameras out there (**Figure 1.4**).

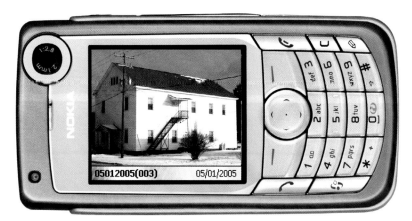

Figure 1.4 *Though we generally don't recommend camera phones for eBay photography, some of the newer high-resolution camphones, like this Nokia 6680, can be used for larger items, such as real estate.*

Point-and-shoot

Also called an entry-level digital camera, point-and-shoot cameras are very easy to learn how to operate. They usually feature an autofocus lens (and sometimes, an optical zoom lens), an electronic flash, a handful of basic functions like exposure compensation and auto white balance, and resolutions between 3 and 5 megapixels. (We explain what exposure compensation and white balance are and how to use them in Chapters 4 and 5.)

Point-and-shooters generally sell for $75 to $250. Of course, you can use a point-and-shoot digital camera for eBay, but we suggest moving up to a camera with a bit more functionality and versatility.

Ultra-compact

We often refer to this class of digital cameras as "Sharper Image" devices, because these palm-sized, all-metal, 3-to-8 megapixel technological marvels are slim, sleek and stylish. Operationally, they range from basic point-and-shooters to very sophisticated devices with many, if not most, of the features found in advanced-consumer digital cameras. Because of their "cool" factor, ultra-compacts carry something of a premium over plain old compacts, and sell for between $275 and $600.

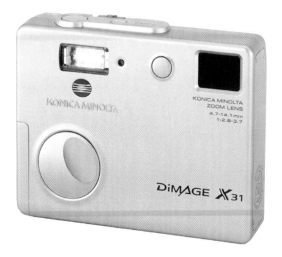

Yes, you can use an ultra-compact for eBay, especially if you're using models like the Pentax Optio 450, Casio Exilim EX-S100, Canon SD-200, or Konica Minolta DiMage X31. Depending on the model, you may or may not have to forego aperture priority or a histogram, but you'll have everything else you need to take sharp, well-exposed pictures. Best of all, you can slip the ultra-compact in your shirt pocket so that you can take pictures wherever you go (**Figure 1.5**). Make sure you avoid any model that doesn't come with a tripod screw socket, since without it, you may not be able to get clear, crisp, razor-sharp shots.

Figure 1.5 *While ultra-compact digital cameras like this Konica Minolta DiMage X31 may not give you all the bells and whistles for fully controlled exposure and close-up eBay photography, they are fun to have and use, and generally produce good pictures.*

Consumer

A bit more advanced than simple point-and-shoot cameras, these 3-to-5 mega-pixel puppies generally feature several program modes (settings optimized for scenes and subjects such as sports, landscapes and night shots) and a variety of exposure and color controls. They are fairly easy to use and may even come with a dock (cradle) to facilitate automatic image transfers to your computer. However, a consumer digital camera probably won't feature the entire Holy Grail of eBay requirements: a histogram, white balance presets, manual capability, macro and aperture priority.

Amateur-consumer-type digital cameras range from compact to the size of a conventional film camera, with prices between $150 and $400. We like the Kodak DX6490 and DX7440, Hewlett-Packard Photosmart R607, Canon A520, Konica Minolta DiMage G400 and Kyocera Finecam M400R as possible eBay cameras.

Advanced consumer

More rugged and robust than consumer or point-and-shoot cameras and equipped with a long list of functions and features, these 5-to-8 megapixel devices, which sell for $400 to $900, have everything you need for production-level volume eBay shooting. Keep in mind, though, that they're a bit more complicated and have a slightly steeper learning curve than simpler devices, and you really don't need the high resolution they're capable of capturing. But once you've gotten the hang of it, you can shoot better, faster and generally higher-quality images.

Just a few models in this category worth considering for eBay photography are any of the Canon PowerShot G series, Casio Exilim EX-P600 or QV-5700, Nikon Coolpix 4500 or 5700, Fujifilm FinePix E500 Zoom or F710, and Olympus C-5050 Zoom or C-5060 Zoom (**Figure 1.6**).

Some of the advanced-consumer cameras have large zoom lenses, superficially look like the more advanced DSLR (Digital Single Lens Reflex) cameras but have no interchangeable lenses, range from $300 to $600, and offer resolutions of 4-to-6 megapixels. A few of these "super zoom" digital cameras that you might consider for your next eBay shoot are the Canon PowerShot S1-IS, Casio Exilim EX-P505, Fujifilm FinePix S5000 Z, Konica Minolta DiMage Z20 and Z10, Olympus C-765 UZ, Panasonic DMC-FZ3 and Pentax Optio MX4.

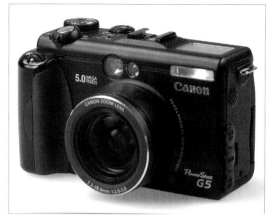

Prosumer DSLR

Loaded-for-bear, "everything but the kitchen sink" prosumer Digital Single Lens Reflex (DSLRs) accommodate interchangeable lenses, an external flash and a host of other accessories. With resolutions between 5 and 8 megapixels, they shoot faster and take better pictures than any of the previously mentioned types of digital cameras. But they're not cheap: A DSLR camera with lens will set you back $700 to $2,200. As a rule, a Prosumer DSLR is overkill for eBay.

Figure 1.6 *Advanced consumer digital cameras, such as this Canon PowerShot G5, have all the controls you need for eBay photography, though they usually have higher resolutions than are necessary.*

But if you absolutely, positively want a prosumer model, check out the Canon Digital Rebels and 20D, Pentax *ist D and *ist DS, Olympus Evolt E-300 and E-1, Nikon D70s and D50, and Konica Minolta Maxxum 7D (**Figure 1.7**). A good rule-of-thumb for choosing a model you'll be happy with is to buy from the manufacturer that makes the film SLR camera you've been comfortable using. If you do, some of the lenses and other accessories from your film camera may work with the same manufacturer's digital model, which may help offset the sticker shock.

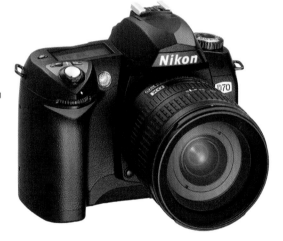

Professional DSLR

For those with pro experience or aspirations, professional DSLRs are faster, more rugged and take even better pictures than prosumer DSLRs. While they feature resolutions ranging from 5 to a whopping 18 megapixels, a pro camera body alone will set you back $4,000 to $7,000, and the lens is extra. Pro cameras are absolutely, totally unnecessary for any eBay auction.

Figure 1.7 *Digital DSLR cameras that have interchangeable lenses, such as this Nikon D70, may be overkill for eBay, but they take great pictures...if you know how to use them.*

Is a scanner what you really need?

If the items you sell tend to be flat or nearly flat, such as books, autographs, artwork, illustrations, magazines or tickets, you might consider buying a flatbed scanner instead of a digital camera (**Figure 1.8**).

When shopping for a scanner (either new or used), here's what you should look for:

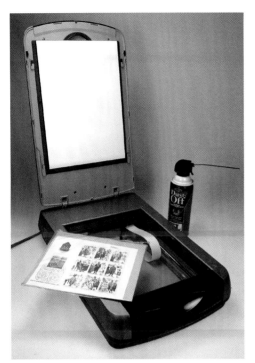

Figure 1.8 *When we want to photograph flat items, such as stamps, sheet music or coins, we usually use this Epson Perfection 3200 Photo scanner instead of a camera.*

◆ The scanner platen (scanning area) must be large enough to accommodate the products you want to scan. Most scanners can handle 8.5-x-11-inch originals, some can handle legal-size 8.5-x-14-inch originals, and a few (more expensive) models can accommodate up to 11 x 17 inches.

◆ The scanner should have an optical (not interpolated!) resolution of at least 600 x 600 pixels per inch (ppi, though it is commonly but erroneously listed as dpi, or dots per inch), and a color bit depth of at least 24 bits (most modern scanners are 48-bit devices).

◆ The scanner should have a USB interface (or for the Mac, a FireWire interface). Avoid scanners that feature parallel or SCSI interfaces, because parallel is too slow, and SCSI requires a special board and is touchy to set up.

◆ The scanner must come with a software driver. Of course, if you buy a new, sealed unit, it should ship with a CD full of software. But if you buy it used, make sure the seller includes the driver (as well as power cord and USB cable) and that the driver will work with your more modern computer. Some scanners were discontinued so long ago that the manufacturer never bothered getting around to releasing an up-to-date Windows or OS driver that will work with your PC or Mac.

◆ As with digital cameras, buy brand-name flatbed scanners. This includes Acer, Benq, Canon, Epson, Hewlett-Packard, Microtek, Mustek, Plustek, Umax and Visioneer.

Some scanners come equipped with ADFs (Automatic Document Feeders) and others have built-in transparency adapters (for film negatives and slides). You don't need an ADF for eBay photos; a transparency adapter is useful only if you sell transparent items like slides and x-rays.

By the way, we've seen some great buys for scanners on eBay. Type "Flatbed Scanners USB" in the Search field to see what's available at the moment.

Buying Your Digital Camera

TIP

Be wary of unusually low-priced cameras from unknown merchants, or you may end up a very disappointed buyer. See "If It Sounds Too Good to Be True" in the Appendix for more information.

Where you purchase your digital camera and exactly how much you pay depends on how astute a buyer you are. If you already have scoped out the exact make and model that you want (say, a Konica Minolta DiMage Z3 or a Kodak EasyShare DX6490), then the next step is to compare availability and prices. For this, you might consider checking out shopping search engines like pricewatch.com, pricescan.com, or shopzilla.com. Then look for a reputable merchant with a favorable feedback rating.

More digital cameras are sold on eBay than any other source, and for good reason: a wide variety is usually available, and if you are a shrewd eBayer, you probably can win one of them at a bargain price. However, we recently glanced at eBay's Digital Cameras listings and found 23,264 items for sale. Unfortunately, while eBay's Search box lets you list and display the brand, type, resolution, zoom lens and condition of the camera you're interested in bidding on, it doesn't sort by features. So, unless you have a clear idea beforehand which makes and models you're looking for, you won't be able to tell if the cameras listed have a histogram, aperture priority and so on.

Our expert advice for those of you who don't already have a specific make and model in mind is to forget about buying on the Internet and go shopping the old-fashioned way. Visiting your local camera shop, electronics boutique, stationery supplies superstore, or any other place that sells digital cameras provides a little hands-on, try-it-out, look-and-feel time before you buy. After all, what good is a digital camera with all the tools and controls you need, if it doesn't fit your hand or you just don't feel comfortable using it?

Usually, you can handle and compare a number of cameras in a store and, if you are lucky, have all your questions answered by a knowledgeable salesperson. This way, you can tell how the camera you're interested in feels, handles and shoots. Is it heavy or light, awkward or comfortable? Are the buttons well marked, easy to push and strategically positioned? Can you see the menus clearly and do they make sense? And of course, does it have the features you'll need for eBay photography, such as aperture priority, histogram and macro?

If you don't like or feel comfortable using the camera when you handle it in the store, move on to another model and try it out. Eventually, you'll find the one that feels right, has everything you want and sells at an affordable price.

The bottom line is that buying your camera at a physical store will almost always cost more money than buying it on the Internet or eBay. But offsetting the few bucks you might have saved is the instant gratification of taking the camera home and using it immediately, and having someplace nearby where you can take it to complain about it or return it if you change your mind or need service.

Finally, there's no compelling reason why you must have a brand-spanking-new, state-of-the-art digital camera for shooting your eBay auctions. Though it may not shoot as fast, or the megapixel count might be lower, last year's discontinued model is probably just as good for eBay photography as the current one, only it will be a lot less expensive to buy.

Refurbished units, such as those sold on eCost.com, are as good as new (some say better, since they must go through higher quality-control inspections), and are significantly cheaper than shrink-wrapped units. And because most digital cameras have virtually no moving parts (only the motor that focuses and zooms the lens), there's not much that can go wrong with buying a used camera (unless it was dropped and the lens is out of alignment). Usually, it works perfectly, or not at all. However, avoid buying a unit that's so old that it uses a serial rather than a USB interface, doesn't accommodate a removable memory card, and lacks those all-important eBay features, such as a tripod screw, macro, aperture priority and histogram.

For eBay, we recommend sticking with a major brand digital camera. For more information, see "Buy Brand-Name Digital Cameras" in the Appendix.

Caveat Emptor

You can't always trust the advice or the recommendation that your friendly, smiling salesperson gives you. That's because the salesperson touted as the store's digital-camera expert could have been selling major appliances the week before, and all he knows about the product is what he reads in the sales manual. More insidious are bonuses and sales commissions—you have no way of knowing if the camera he's telling you is the greatest thing since sliced bread is truly great, or if he's making an extra thirty bucks selling it to you instead of the model that really is perfect for you.

The best way to protect yourself from ignorant or predatory salespeople is to come to the store armed with a little knowledge (which you can get by reading camera descriptions and specifications from digital camera manufacturers' Web sites).

2

Outfitting Your eBay Studio

Now that you have a digital camera and are ready to photograph the stuff you want to sell on eBay, the next step is to create your eBay studio. A suitable studio for taking eBay product shots doesn't have to be elaborate or expensive. In fact, it shouldn't take you more than about an hour to put one together. You'll find that assembling your studio beforehand pays off in the long run: By having all the necessities on hand, not only will you save yourself time and aggravation, you'll also have what you need to distinguish your eBay auction photos from "run of the mill" product shots.

Defining Your Space

The first element in your eBay studio is space: You should dedicate an area in your home, apartment or office that you can use to photograph the items you plan to sell. Ideally, it should be a permanent setup, but if you're really pressed for square footage, you can always roll up your studio paraphernalia and store it in a nearby cabinet or closet. If your setup is well organized, even a corner of a cramped apartment can be quickly transformed into a shooting studio (**Figure 2.1**).

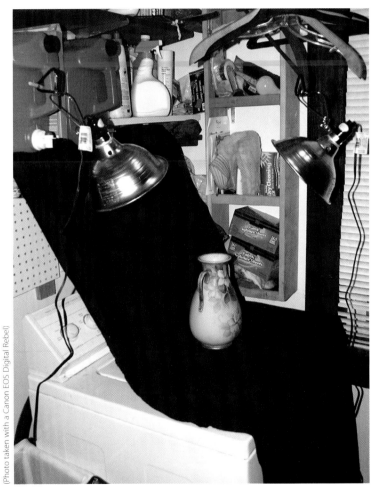

(Photo taken with a Canon EOS Digital Rebel)

Figure 2.1 *Limited space and budget? This laundry-room studio setup cost us less than $20, if you don't count the washing machine.*

What shape, configuration or position your studio space will take depends on your ingenuity and imagination. While we have permanent, professional backdrops and shooting tables in our studio, we often set up an ad hoc, improvised studio by clearing the dining room table, clamping a piece of paper to a bookcase, setting up a folding card table (make certain that the legs are fully extended!), or laying a large cardboard box upside down on the floor and draping a cloth over it.

One eBayer we know of uses her laundry sink as a small studio. She simply lays a piece of half-inch plywood over the sink, pins a paper background to the shelf above it and drapes it over the plywood, and then clamps reflector lights onto the sink edge and cold water pipe behind the washing machine. Not pretty...but hey, it works!

The trick to making your eBay space work for you, regardless how small, is to organize it for easy assembly and shooting, as well as for storage, if it isn't a permanent setup. A tripod and rolls of background paper and cloths can fit neatly in almost any corner standing up. We cut the top off a tall cardboard box for storing lights, stands, tripod and backdrops. (However, try to keep your lights at least partially assembled to save effort and time when you want to use them.)

You'll also need to reserve space such as cabinets, shelves or closets for storing your products (preferably organized according to what needs to be photographed, what is up on eBay and what needs to be shipped). For instance, if you sell mostly porcelain and pottery, set aside an area that is slightly larger than your largest plates, platters and figurines. If you usually sell wristwatches but in a blue moon put up a chair or desk for sale, set your studio up for the watches only, and improvise when it's time to shoot the larger stuff.

TIP

We try to schedule a specific time each week (or month) to photograph our eBay items, concentrating on products that are similar in size and color each session. That way, once we have the background, lights, tripod and paraphernalia in place, all we have to do is click away, pausing only to position another item and adjust the lighting (see Chapter 5, "Great Lighting the Easy Way."

What Type of Studio Gear?

Throughout this book, we show you a variety of shooting setups that can be created using ordinary tables, lamps, boxes, clamps and other inexpensive stuff that you may have around your house or apartment. However, it's often easier, more efficient and even more cost-effective to use professional photographic equipment (new or used) rather than trying to re-invent the wheel. Two professional studio fixtures we can't do without are our light tents and shooting tables.

Light tents

Perhaps the most useful apparatus for eBayers who sell small-to-medium-size items is a light tent (**Figure 2.2**). Also called a light box, light cube or a softbox, a *light tent* is a square, round, arched or cylindrical translucent white cloth or plastic surround that houses the object to be photographed, with the camera positioned just outside.

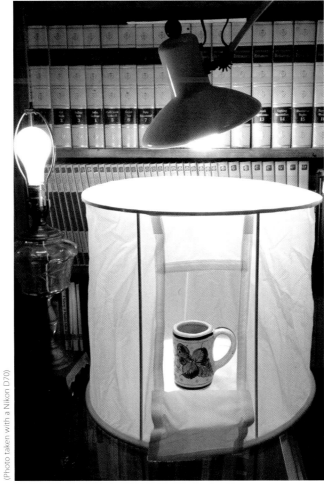

(Photo taken with a Nikon D70)

Figure 2.2 *A light tent surrounds your product with soft, diffuse light. Notice we're using ordinary household lamps in this setup.*

Light tents come in a variety of sizes, from very small to quite large. Most units are featherweight, fold up flat and fit into small carrying cases for easy transport and storage. Metal or plastic rods usually hold a light tent in a semi-rigid state when it's fully expanded. However, some of the more expensive light tents don't collapse and use fixed reinforcement instead.

As its name implies, a light tent is illuminated by shining lights directly into the front, sides and top of the tent. For shadowless photography, the bottom of the tent can also be illuminated from underneath. Lighting the tent in this way creates soft, even illumination that virtually eliminates glare or harsh shadows and even helps minimize or eliminate reflections. The background is usually white, but many light tents come with black liners you can use to switch to an all-black background in seconds. Of course, you can make the background any color you want by attaching a paper sheet or colored cloth inside.

Instead of using a light tent, you can achieve a similar effect by draping thin, translucent white cloths around your product. But basic light tents are so cheap and easy to use that it doesn't make sense to try and build your own (lower-end models retail for about $25). Larger light tents sell for anywhere between $60 and $150, although some units that are branded "studio in a box" can cost thousands of dollars (and may include a digital camera, lights, tripod and other accessories).

Shooting tables

A *shooting table* is a metal or plastic frame that holds an *S*-shaped piece of translucent, white Plexiglas. It fits onto a tabletop or functions as the table, depending on its size. A shooting table makes it easy and convenient to illuminate and photograph small-to-medium-size objects. Its *S* shape rises in the back, creating a seamless, neutral background that isolates the product (which is what you want). Because it's translucent, you can shine a light from underneath the table for shadowless photography. (Of course, you can change the color of the background by placing a sheet of paper or cloth over the Plexiglas, although it will lose the advantage of translucency that way.) You may even be able to clip lights, reflectors or mirrors onto it, depending on the unit.

Shooting tables come in all sizes and shapes, with or without bells and whistles. They sell for anywhere between $65 to several thousand dollars. (One really fancy table we saw at a photo tradeshow sells for $12,000!) We bought a used, medium-size table through a classified ad in Shutterbug magazine for $250, and a new, but somewhat smaller one at a photo trade show for $69 (**Figure 2.3**).

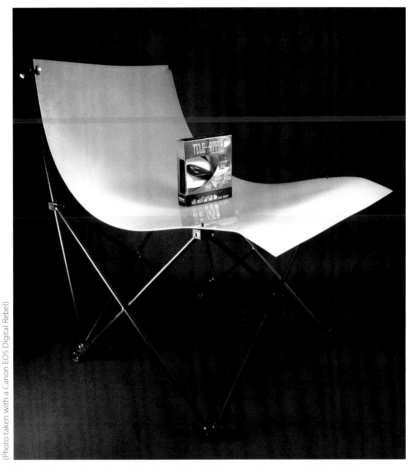

(Photo taken with a Canon EOS Digital Rebel)

Figure 2.3 *The frame of this shooting table, which we purchased on sale for only $69 from APV Photo (www.APB-Photo.com), folds up like an umbrella and stores easily. However, the Plexiglas can't be rolled up.*

Make Your Own Shooting Table

While we were lucky to find a good shooting table for only $69, most of the ones available today sell for more than that. If you don't want to spend a lot of time hunting down a shooting table at that price, you can make your own in less than an hour for about $85. Here's how:

1. At your local hardware store, buy six PVC pipes that are 10 feet long and 1 to 1.5 inches in diameter, and fourteen three-way connectors that are 1 to 1.5 inches in diameter. (Naturally, the connectors and pipes should fit into each other.)

2. Cut the pipes so that you have nine pieces that are 3 feet long, twelve pieces that are 2 feet long and two pieces that are 1 foot long.

3. Assemble the pieces using three-way connectors until you have two squares: one that is 2 feet by 3 feet, and another that is 3 feet by 3 feet.

4. Use the remaining pipes to connect the two squares so that you end up with a rectangular frame that looks like the skeleton of a step stool. This is the frame for your shooting table.

5. Look in the Plastics section of your local Yellow Pages to determine where you can buy a translucent Plexiglas panel that is 4 feet wide by 6 feet long and 1/8-inch or 3/16-inch thick. Make certain the panel has a smooth surface and is flexible enough to bend before you buy it.

6. Use C-clamps to attach the panel to the frame of your shooting table, bending it so that it forms an *S* shape.

Selecting Your Lighting System

One of the most important requirements for producing high-quality product photos is proper lighting. In this section, we discuss how to choose a lighting system for your eBay photography that meets your needs and your budget. In Chapter 5, we show you how to work with all kinds of lighting systems, including ones that involve nothing more than household lamps, such as Figure 2.2.

A bargain system that works

For an entry-level lighting setup that will cost you next to nothing, amble down to your local hardware store and buy a pair of standard 75-to-150-watt floodlight bulbs and a pair of clamp-on sockets. The sockets will set you back about $8; with shiny aluminum reflectors, you'll probably pay about $10 to $20, depending on the size of the reflector bowls and whether they're on sale.

If you want to skip the floodlights, you can use two ordinary 100-watt, 150-watt or 200-watt household light bulbs, screwed into a pair of reflector-type clamp-on sockets.

With this kind of simple setup, you don't even need photo light stands, because you can clamp the lights onto any nearby anchor point, such as a chair, table, sofa, bookshelf, pipe, window sill, desk or music stand (**Figure 2.4**). But be sure to have an extension cord or two handy, since it's likely your lights won't quite reach the nearest wall outlet (they almost never do).

(Photo taken with a Canon EOS Digital Rebel)

Figure 2.4 *You can use an inexpensive clamp-on reflector with an ordinary bulb to put light wherever you need it.*

Photo lighting kits

The next level in cost and sophistication is a photo lighting kit. A bare bones basic lighting kit comprises two reflectors and sockets, two photo bulbs and two light stands. A new kit with these components costs between $50 and $110, depending on how strong or how tall the stands are and whether they come in a cardboard box or portable case. A three-light setup (which we strongly recommend) will set you back $75 to $150. (We discuss the pros and cons of two-light, three-light and four-light setups in Chapter 5.)

Better units with heavier stands and easily adjustable sockets (the core light fixture that attaches to the stand and the reflector) can cost hundreds. You can save some money by buying them used—we snagged a basic set of three lights with stands for $20 at a garage sale. Every time we've looked, we've found a variety of two-light and three-light kits for sale on eBay (search in the Camera & Photo and Continuous Lighting categories under the Lighting & Studio Equipment header).

Choosing your light source

The first major decision you must make before bidding on or buying studio lights is what sort of bulbs you want to use. Your choices include:

✦ Photoflood

✦ Halogen

✦ Photo fluorescent

Photofloods are tungsten bulbs, the same sort of technology in an ordinary household light bulb. However, instead of a light bulb's average 100-watt brightness, each photoflood pumps out between 200 and 600 watts, depending on the strength of the bulbs you buy. That makes them very bright—but also power hungry and hot. And hot can be a problem, not only because it's uncomfortable and a potential fire hazard, but because some goods can be damaged or destroyed by excess heat. While photofloods are relatively inexpensive (ranging from $4 to $10) and easily replaceable, the bulbs don't last very long (between 3 and 20 hours, depending on the wattage), they draw a lot of power and—we can't say it enough—they're hot!

Watt for watt, halogens are somewhat brighter, so you can illuminate larger objects more easily without having to add more light fixtures. And each bulb lasts between 75 and 400 hours, much longer than power-hungry photofloods. However, most halogens run even hotter than photofloods, and replacement bulbs can cost you an arm and a leg (from $20 to $50). And while you can use ordinary, inexpensive socket-and-reflector light fixtures for photoflood bulbs, you'll probably have to buy more expensive, dedicated halogen light sockets and fixtures.

Photo fluorescent bulbs are fluorescents that are rated for photography. They illuminate evenly and burn much cooler than ordinary light bulbs. In fact, they're so cool you can put your hand on the bulb without burning your fingers. They also put out light that's roughly equivalent to daylight, as long as you buy one that is "daylight balanced" or is rated somewhere between 5000K (kelvin) and 5500K. Because their illumination simulates daylight, you won't have to change your digital camera's white balance settings or adjust the color using image-editing software

(see Chapter 5, "Great Lighting the Easy Way," and Chapter 11, "Photo-Editing Techniques That Make Pictures Zing," for more information about color balance and correcting image color).

While photo fluorescent bulbs cost between $14 and $35 each, depending on the wattage and configuration, they last and last and last—like the Energizer Bunny—at least 7,000 to 10,000 hours, or for years of regular use. And they're much better on your electric bill, too. But the downside is that fluorescents emit far fewer lumens, or light, than photofloods or halogens, so you may need to use two or three lights or position them much closer to your subject to produce light that is equivalent to a single photoflood or halogen lamp.

What About Studio Strobe Lights?

We didn't list studio strobe lights as a possible lighting option for your eBay studio because, in a nutshell, they are difficult to control and are best left to pros. And since you probably aren't shooting live models or any other moving targets, you don't need the freeze-frame capability of strobe lights.

Using strobes for your eBay auctions can cause several problems. The biggest issue is that it's hard to see precisely where the light will fall, because the strobe fires for only a thousandth of a second (and sometimes even faster). While many studio strobes have a low-powered modeling light that previews what the flash illuminates when it's fired, it's difficult to accurately predict the full effect of the light. This can be a major pain because flash heads generally have more limited areas of coverage than regular reflector lights. Of course, the photographer can attach "barn doors" (movable baffles for narrowing the light), a photo umbrella, a diffuser, a reflector bowl or some other external add-on for aiming, directing or scattering light. But these accessories generally cost extra and require some expertise to use properly.

Another problem with strobes is that they can be expensive: A basic set of three studio strobes costs considerably more than entry-level photofloods, halogens or fluorescents. However, strobes do suck up less electricity than continuous lights. And the flash tubes last for years, but replacing them may cost half again as much as the strobe units themselves. Keep in mind, too, that if you decide to move up from a basic to a professional studio strobe-light setup, you may have to spend hundreds or even thousands of dollars.

In our studio, we have a variety of photofloods, halogens, fluorescents and pro strobe lights. For most of our eBay auctions, we use a five-light fluorescent lighting kit for the small stuff. And we sometimes downsize it to a two-light or three-light setup, depending on the product (see Chapter 5). For larger products and

items for which we need more light, we generally use the halogens, only because we don't like frequently changing (and paying for) blown photoflood bulbs. When shooting with halogens, we regularly turn them on just before taking our shots, and off as soon as we are finished. Otherwise, the heat builds up and it gets downright uncomfortable, not to mention that the electric company makes bigger profits from our pockets.

Softening the light

Regardless of the type of light, uncovered bulbs can cast harsh, directional or contrasty light. This can translate into unappealing pictures in which the light is striated or mottled with hot spots and very dark shadows, or in which there are reflections that distract or obscure details. That's why most professional photographers diffuse the light by employing a variety of devices and materials.

Most commercial diffusers or diffusion screens are made of translucent white cloth, frosted glass or plastic (**Figure 2.5**). They are positioned between the light and the subject and usually are attached in some way to the light reflector. The diffuser softens and spreads light evenly, so no spot or section is brighter or darker than any other spot. You can buy ready-made diffusers for almost any size reflector bulb. They generally sell for $5 to $30 each, depending on whether they attach via elastic or built-in clips.

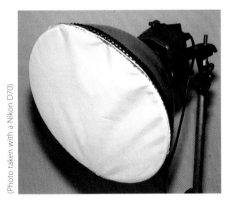

(Photo taken with a Nikon D70)

Figure 2.5 *The elastic bonnet diffuser, which is fitted around this photo fluorescent fixture like a shower cap, cost us only $4, but it does a great job of softening and diffusing the light.*

TIP

If you use your camera's built-in flash as your primary light source, consider taping a piece of single-ply Kleenex tissue over it to give off a softer light. But be careful to not cover any of the tiny holes on your camera, which may function as sensors for focusing and metering.

If you use photofloods and halogens, make sure the manufacturer guarantees its diffusers are heat-resistant and won't melt or catch fire. If you use fluorescent bulbs (which are much cooler), you can make your own diffusers by cutting up an old white sheet or other thin white material and attaching it to the reflector bowl using clothespins or tape.

Another type of commercially made diffuser that pros use is called a *softbox* (**Figure 2.6**). It's a semi-rigid, metal-rod-reinforced cloth tent that has black sides and a translucent white diffuser in front and attaches to your light (it usually comes with its own mounting hardware). A softbox can be square or round, and as small as 12 inches square or as large as 6 feet in diameter. Some softboxes are designed for specific brands and models of lights, while others are more or less universal.

Figure 2.6 *A Lastolite Ezybox softbox.*

(Photo courtesy of Bogen Imaging)

The downside to using softboxes is that they can be expensive. While we've seen them sell on eBay for only a few dollars, the really big ones can run into the hundreds. The big ones can be very bulky (and usually require heavy pro stands). However, softboxes produce excellent, even illumination—certainly better than clip-on or homemade diffusers.

Another option for diffusing light is to use a photo umbrella. Photo umbrellas are lined with white, silver or gold-colored fabric. (We recommend avoiding the gold for eBay, because a gold tint can alter the true color of your product). They are mounted on a light stand by inserting the center pole through a special umbrella bracket. The light fixture is pointed at the umbrella, which diffuses and reflects the redirected light onto the product being photographed (**Figure 2.7**). Photo umbrellas are relatively inexpensive, costing from $12 to $50, depending on the size and color, but keep in mind you'll also need a light stand and bracket. They also can be somewhat bulky when fully deployed, although they store away easily like regular umbrellas. Photo umbrellas are also great for concentrating high-quality light where you need it.

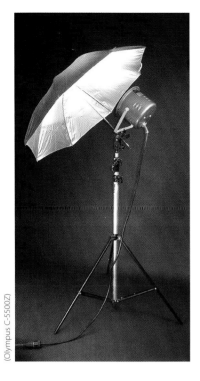

Figure 2.7 *An umbrella on one of our Halogen lights.*

(Olympus C-5500Z)

A final item you may want to have on hand to soften the light is a handful of reflectors. Professional reflectors are round or oval-shaped pieces of gold, silver or white cloth that you angle to reflect extra light onto the product. Again, for eBay, we recommend only white or silver reflectors. Pro reflectors cost between $20 and $100, depending on the size, color and whether a stand is included. They're great for adding a little extra sparkle or highlight to what you're shooting, without having to turn on additional lights.

Make Your Own Reflectors

You don't have to spend your hard-earned money on ready-made reflectors. We make our own with whatever materials are at hand: aluminum foil, white or colored poster board, shelf-lining paper, silver gift-wrapping paper—even pieces of an old bed sheet. Except for the poster board, we cut, shape and wrap the material around a piece of cardboard and then hold it in place by gluing, tacking, taping or pinning it. If it's small enough, we prop the reflector up with a plate easel, a Plexiglas display platform or a couple of books. For larger reflectors, one of us holds it in place while the other takes the shots, or we simply use a clamp or tape to attach it to a light stand, a bookshelf or wherever we need it.

Light stands

Most pro-type lighting fixtures are held in place by light stands. Looking a little like fold-up music stands, light stands range from a couple feet high to over 12 feet (notice the stand holding the umbrella and halogen light in Figure 2.7). Lightweight stands can hold lighting units that weigh two-to-three pounds, while thicker stands are needed to accommodate bigger, heavier light fixtures.

For heavier lights, or when you use a counterbalanced boom (an adjustable extension that can put the light directly overhead or almost anywhere else you want), you may have to weigh the stand down at the base to keep the light from toppling over. While there are commercial sandbags available (costing $10 to $20), we make our own by putting kitty litter in a plastic trash bag, which we then stuff into an old pillow case and drape over the light stand's legs.

Light stands sell for between $5 and $100, depending on the height and diameter and whether the stand includes a counterbalanced arm. Like the old saying, "You can never be too rich or too thin," a photographer can never have enough light stands. We have about 15 of them around our studio, and most of them we bought on eBay for under $25.

Other Necessities

Once you start assembling your eBay studio, you'll quickly discover you need a host of small items to better show off and photograph the items you sell. These may include such things as clips, speaker or microphone stands, clamps, string, duct tape, clothes pins, display stands, blackout curtains, power strips, extension cords, plate easels and a box knife. We even have a full-length mannequin (bought on eBay for $210, and nicknamed "Vanessa Quinn" by one of our assistants) that we use when shooting women's clothing. We'll discuss in later chapters how you can use these and other accessories effectively. However, the three components no eBay studio should be without are an assortment of background cloths or paper, a tripod and a computer system.

Backgrounds

We recommend you slowly accumulate a good assortment of backgrounds so that you'll have the right texture, color and size available that complements or contrasts the product or item you're selling (so that the item stands out). We use rolls of seamless paper for shooting large items, and individual sheets of paper, poster board or cloths for smaller products. A roll of 9-x-36-foot seamless paper costs about $40, and rolls half that width go for about $20. We buy individual

sheets at a local crafts store for anywhere from 50 cents to $2, depending on size and thickness. Seamless paper does wear out, so we try to keep a good supply on hand so that we're never shooting on scuffed or torn paper.

While we often improvise with whatever materials are lying around—sheets, bedspreads, tablecloths and so on—most of our color cloths come from fabric stores. Somewhere in a back corner of every fabric store, you can find a treasure trove of odd-sized or discontinued bolts of fabrics, or remnants, that sell quite cheaply. We rarely pay over a dollar a yard for really great cloths that make excellent backgrounds for our eBay auctions. (To learn more about choosing between fabric and paper backgrounds and how to use them, see Chapter 3, "Creating Great eBay Photos.")

Recently, Daniel surprised Sally with a gift for the studio—a chain-driven background system comprising two extension polls and three crossbars, for easily deploying and retracting three long rolls of seamless paper (**Figure 2.8**). We use it for photographing things like furniture, clothing on our mannequin and large urns. In fact, the photographs of our folding shooting table (Figure 2.3) and of the umbrella on the light stand (Figure 2.7) were set up in less than five minutes using this backdrop system. See Chapter 8, "Getting Great Photos of the Big Stuff," for more information.

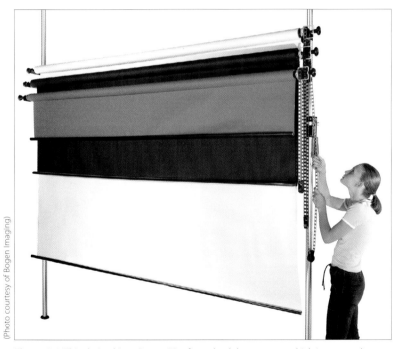

(Photo courtesy of Bogen Imaging)

Figure 2.8 *This chain-driven Bogen-Manfrotto backdrop system, which is mounted on spring-loaded pressure poles, is very similar to ours.*

What's great about this type of background system is that it takes up very little room. While many similar units are usually mounted on light stands (with their extended legs that take up so much floor space), our new system is mounted on Bogen-Manfrotto Autopoles, which employ spring-loaded pressure to brace them between our floor and ceiling. The entire system is only a few inches deep. It's so compact that we keep it in front of our music CD bookcase, which is easily accessible when the backgrounds are rolled up. The only drawback is cost: Depending on the brand, number of poles and whether the chains are manually or electrically moved, a new background system like this can set you back $250 to $2,000, not including seamless paper. Of course, it will probably be much less expensive if you can buy it used on eBay. By the way, a more basic background kit comprising two stands and a single crossbar sells for about $100 to $130.

A tripod

Very few people have rock-steady hands capable of taking truly sharp, perfectly focused pictures indoors without a flash. To avoid even minute camera movement, which produces soft and blurry pictures, you need a good tripod (**Figure 2.9**). A tripod is a stable three-legged platform that eliminates camera shake. Depending on the type tripod you buy, it may have a crank for easily raising and lowering the camera into position and an adjustable tripod head for angling the camera up, down or sideways so that the product you're shooting can be perfectly framed.

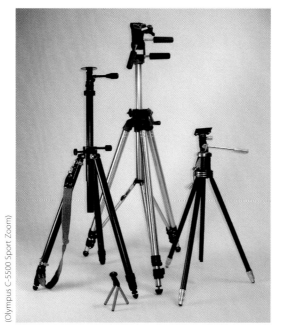

(Olympus C-5500 Sport Zoom)

Figure 2.9 *Tripods come in all sizes and weights, including the tiny blue minipod in the foreground, which we use to brace our camera on a table or other raised stable platform.*

Tripods generally come in two types: those for still cameras (their heads swivel up, down and sideways) and those for camcorders (their heads move only up and down). For the most flexibility, opt for a still camera tripod.

You must also decide whether you want a light, medium or heavy-duty tripod. Lightweight tripods can be flimsy and wobbly but are inexpensive, while heavy-duty tripods are large, heavy, and usually expensive. A medium tripod is very stable, often extends to 5 feet or 6 feet, collapses for easy storage and can be purchased on eBay for anywhere from $5 to $150. The more expensive units usually extend more, have better heads and may even come with extras, such as a built-in spirit level for getting your pictures perfectly straight or a quick-release system for easy attachment and removal of your camera.

Make sure the tripod you're buying has a 1/4-inch thread (that's the diameter of the tripod screw sockets on almost all digital cameras), rather than a 3/8-inch thread (the European size found on some pro cameras).

Computer requirements

Last, but certainly not least, you'll need a desktop or laptop computer with an Internet connection so that you can connect to eBay. Almost any computer manufactured in the last four or five years will be suitable, as long as it has a color monitor, USB ports and enough hard drive space to store all your product shots. However, modern Macs and PCs with the latest operating systems (Windows XP or Mac OS X) are easier than older systems for quickly uploading and managing a bunch of photos from your digital camera.

The only peripheral we strongly recommend buying specifically for your eBay auctions is a USB card reader, which sells for $5 to $50. Downloading your pictures from your camera to your computer is a lot easier if you slip the memory card from your camera into a card reader (**Figure 2.10**), rather than attaching your camera to the computer via a USB port. A card reader enables your computer to see, read and use the memory card in the exact same way it accesses its own hard drive, CDs or floppies, so it makes it that much easier to move your photo files from the memory card directly to your hard drive.

For tips on how to get your photos from your camera or memory card into your computer, see Chapter 10, "Efficiently Handling Your Pictures After the Shoot."

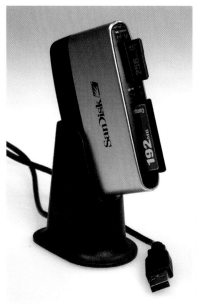

(Konica Minolta DiMage A2)

Figure 2.10 *Some memory card readers have multiple slots for different kinds of cards. Other less-expensive ones have a single slot for only one kind of memory card. Be sure to get a USB 2.0-enabled unit rather than the much slower USB 1.1 model.*

3

Creating Great
eBay Photos

TIP

Study the catalogs you get in the mail for ideas about product photography. This will be especially helpful if you sell the kinds of items that are often featured in catalogs, such as tools, cameras, jewelry and pottery.

eBay photographs have one overriding purpose: to generate more and higher bids—a simple concept that requires simple, direct and honest pictures. They should be devoid of the emotional ploys, fantasy appeals, sexual innuendoes and other subliminal or obvious manipulations typically featured in product photography in magazines like *Cosmopolitan* or *Newsweek*.

The type of traditional product photography that is closest to what works well on eBay are the pictures you see in mail-order catalogs. We're not talking about lifestyle catalogs like Lands' End, but the more common ones that have unadorned, unambiguous photos of things for sale, such as Edmunds Scientifics, J.C. Penney's or even your grocery store's weekly flyers.

Defining a Great eBay Product Shot

What makes a great eBay product shot boils down to a few, simple guidelines that aren't that difficult to follow, once you know what they are. An eBay photograph should be:

✦ Appealing, but still being an honest, accurate representation of the item for sale

✦ Tightly framed with no extraneous items or unnecessary empty space

✦ Isolated and unambiguous as to what is for sale

✦ Illuminated well and perfectly exposed, with appropriate highlights and shadows (see Chapter 5, "Great Lighting the Easy Way.")

✦ Precisely in focus (see Chapter 4, "Exposure and Focus.")

Let's look at some typical, ineffective eBay photographs and how you can easily avoid the same problems to get a great picture. (All the "bad" pictures in our book were inspired by actual auction photos we've seen on eBay.)

Frame it

One of the simplest problems to correct is what we call the long-distance photographer, or the person who stands so far away from his subject when taking a picture that you can't help but feel he must have a fear of intimacy. The result is a photograph containing mostly empty space, which certainly won't capture the attention of a potential buyer (**Figure 3.1**). After all, if the owner doesn't want to get any closer to the item, why would anyone else?

Take a few steps closer to fill the frame completely, and you'll end up with a photograph that is immediately accessible, filled with informative detail, and—bottom line—much more interesting and appealing (**Figure 3.2**).

Figure 3.1

(These photos taken with a Konica Minolta DiMage Z3)

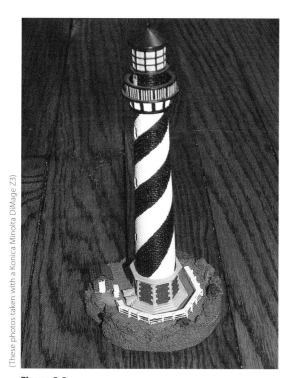

Figure 3.2

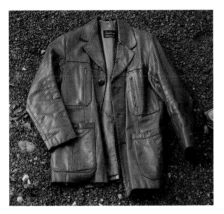

Figure 3.3

Figure 3.4

Look, think and shoot

What's the essential difference between an amateur photographer and a professional? An amateur takes a picture, snapping the shutter button at whatever happens to be in front of him. A pro takes charge and makes a picture. That includes being critical of what he sees in the viewfinder, making sure it's good. If it isn't, he'll move both himself and the object until everything looks right.

In **Figure 3.3**, it's hard to determine what's for sale, though we can assume it's the jacket. That's because the composition has no area or point that draws your attention, and the background is filled with distracting, uninteresting, downright ugly elements. What's more, the lighting is flat, and the model is bored and ready to run as soon as the shutter button snaps.

At least **Figure 3.4** is tightly framed to center only on the jacket. However, it's simply thrown there, on the ground, as though a teenager had just gotten home and was in a hurry to get to his Xbox. The subliminal message is that the jacket has little value, certainly not enough to bother to keep it nicely, and not worth the minute or two that it would take to arrange it neatly for the photo. If the seller doesn't care about the jacket, why would a potential buyer? What's more, the jacket and stones are the same color, and the lighting is flat, which makes the photo not only messy, but boring and uninteresting.

Now, **Figure 3.5** shows a photo of a jacket that we might be interested in bidding on. All we did in creating this shot was to have Sally walk a few steps from the driveway and stand in front of a dark evergreen tree. Daniel moved in closely, so that the jacket filled the frame and Sally's head was out of the picture (she's not for sale!). And to avoid the flat lighting of the other two pictures, he popped open the camera's built-in strobe light and set the camera on fill flash. That's what created the highlights in this photograph, which gives the leather jacket contour, texture and an appealing sparkle. (See Chapter 5 for more information about lighting.)

Figure 3.5

Protect Your Feedback Rating With Good Photography

Jim "Griff" Griffith, the dean of eBay University, likes to say that eBay is a community composed of good people. What we find fascinating is that he is essentially correct. Throughout the year, every year, many millions of transactions between absolute strangers who never see each other are finalized to both the buyer's and seller's satisfaction—money and products changing hands across many miles— most without a hitch.

While we agree with Griff that most people are probably decent, one of the keys to this system of personal honesty and commercial trust is eBay's feedback system. If you've been eBaying for a while, you're already quite familiar with it and most likely can tell us with pride what your own feedback rating is. The higher your feedback rating, the greater the number of buyers or sellers who were satisfied with a transaction they completed with you. Anyone with a low feedback number or, worse, lots of negative feedback, quickly goes out of business on eBay. That's because most people are hesitant to trust buyers or sellers with low ratings or small numbers of transactions.

Good photography is key to consistently winning positive feedback from buyers. In addition to capturing a buyer's imagination and attention, a good series of photographs on your auction site accomplishes the following:

✦ Assures potential buyers that what they see is what they'll get

✦ Provides proof of authenticity

✦ Displays the extent of any imperfections

On the other hand, poor photographs that don't disclose the full truth of a product, don't correctly represent the item, or simply leave questions unanswered can open the floodgates to buyer remorse or other post-sale problems, including negative feedback from the buyer.

TIP

Take the time to make sure the item you are putting up for sale is clean, pressed, polished or dusted. Otherwise, potential buyers may believe that the dirt, wrinkles or tarnish are permanent imperfections and won't be willing to pay as much. Besides, something that has been kept in good condition by the owner is certainly more appealing and worthy of higher bids.

Background Check

In the final leather jacket photo (Figure 3.5), Sally stood in front of the evergreen so that we would have a good, dark, contrasting background that contained no distracting elements. But what do you do if you don't have a convenient stand of trees available; it happens to be raining, snowing or dark when you want to take your pictures; or the item for sale isn't easily photographed in the great outdoors?

Not too many homes, offices, stores or studios have a large enough empty space that can be used to provide an effective background for photography. That's why we've seen innumerable photos on eBay that were taken in their "native habitat," with all kinds of stuff surrounding them, as **Figure 3.6** demonstrates. In contrast, **Figure 3.7** makes clear what a difference a good, clean background can make.

(Both photos—Nikon D70)

Figure 3.6 *What's for sale? This photo, which is typical of many photos you see on eBay, shows a jumble of items displayed in their "native habitat" on a curio cabinet shelf. Not only is it confusing to the potential buyer in that too many things are present, nothing is shown to its best advantage.*

Figure 3.7 *Here's the same antique inkwell, removed from the curio shelf and placed on a contrasting cloth. We also made sure we framed the picture fully on the inkwell.*

The majority of the pictures we take for our eBay auctions have cloth or paper backgrounds, to visually isolate our product. It's not unlike a college student quickly throwing a bedspread over an unmade bed just before her parents come for their first visit to the dorm. Since you're dealing only with surface appearances, it can be quite easy.

A set of inexpensive clamps, a collection of different-colored papers (or cloths) and a folding card table can turn nearly any corner of a room into a photography studio (**Figure 3.8**).

When we have larger pieces to photograph, we'll remove the table, use larger backgrounds and clamp them higher on the bookcase. If you don't have a bookcase, you can put a taller piece of furniture behind a table, or use boxes on a table. Then drape your cloth or paper over everything (**Figure 3.9**).

Figure 3.8

Figure 3.9

(This series— Konica Minolta DiMage A2)

Figure 3.10 *The background is similar in color and brightness to the object, so the sailor seems to fade into it.*

Choose the right paper or cloth

Before setting up your photograph, consider what you want to use for your background. You want to make sure your object stands out, catching and holding the buyer's eye. Therefore, the paper or cloth should have the following properties:

✦ A solid color, with no pattern that might distract

✦ Not clash with any of the colors in the object

✦ Contrast to the object, meaning a dark background for a light object or vice versa (**Figures 3.10 and 3.11**)

Choosing between paper and cloth is often a matter of personal preference and what you happen to have on hand. But there is a difference between the two: Paper is rigid and smooth, while cloth drapes. Depending on your item, the flexibility of cloth may make it easier for you to arrange the object. What's more, the folds can add a sense of dimensionality and texture to the picture. On the other hand, the smoothness of paper can create the feeling that the background doesn't even exist (**Figure 3.12**).

The one important advantage that cloth has over paper is the ability to put shapes under it. For instance, when photographing a necklace or hat, we will often place an inverted mixing bowl under our background cloth. A smaller bowl works nicely for bracelets. Similarly, when photographing a set of items, we may put a small box underneath to create a slightly raised platform. That way, the objects in the back of the picture aren't obscured by those in the front.

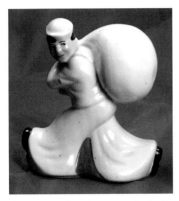

Figure 3.11 *Here the contrasting background makes the sailor "pop" out of the picture. (Notice, too, the shadow on the sailor's face—we' show you how to fix that in Chapter 5.)*

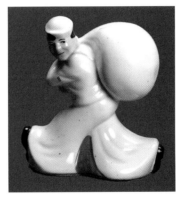

Figure 3.12 *Here we have the same sailor coin bank, this time with a smooth background such as you would get by using a paper background. For this piece, we prefer the feeling of depth that the cloth background adds (Figure 3.11), but for other objects we prefer the way a piece of paper can avoid being noticed at all.*

Shoot inside the softbox

If you are photographing small items, one of the easiest ways to eliminate background distractions, as well as provide even, pleasing illumination, is to use a softbox, similar to the ones we describe in Chapter 2. A softbox completely surrounds the item with translucent cloth that softens any light source, while isolating it completely (**Figures 3.13 and 3.14**). It can also help control reflections.

Figure 3.13 *Because we're using a softbox, we can adjust our camera angle without having to worry about background items creeping into the edges of our picture. We often use a sheet of thin paper inside a softbox to keep the box's seams out of our pictures.*

(Photo taken with an Olympus C-8080)

Figure 3.14 *Even though this Leica M4 camera was photographed on our dining room table with a (messy) kitchen in the background, we have a seamless and perfectly isolated product shot because we used a softbox.*

The Right Angle

Don't hide imperfections from bidders—take close-up photos of them. You'll end up with satisfied buyers who won't experience any unhappy surprises when unpacking their newly acquired treasure. And you'll establish a reputation as a trustworthy seller with a high positive feedback rating, which will help you sell more items for better prices. And yes, less-than-perfect products do sell well on eBay.

The *camera angle*, or the relationship of the lens to the object being photographed, adjusts the perspective of the photograph, which in turn, determines what the picture captures. Changing your camera angle involves moving the camera so that the lens is pointed at the object from a different position. These positions can be any or several of the following:

+ Higher

+ Lower

+ Above

+ Under

+ To the side

+ From the back

+ Closer

+ Farther away

Let's take a look at how different angles can affect a photograph that has more than one item in it (**Figures 3.15 through 3.17**).

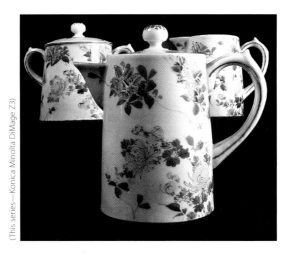

(This series—Konica Minolta DiMage Z3)

Figure 3.15 *Here our camera (on a tripod) is at the same height as the teapot, so although the cream and sugar containers are on a slightly raised platform (a suburban phone book under the black cloth), they are blocked from view.*

While the photographic composition of Figure 3.17 is the most appealing of the series, Figure 3.16 is actually preferable for eBay. Even though the camera angle in Figure 3.16 produces an unanchored effect for the sugar and creamer, it avoids obscuring them, and potential buyers want to see as much of the product as they can.

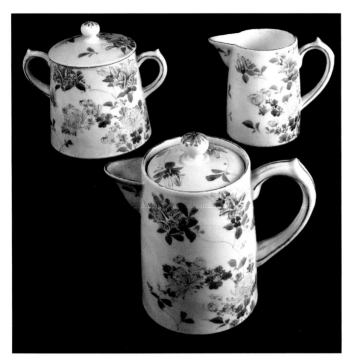

Figure 3.16 *We raised the tripod, which meant we had to angle the camera downward to aim the lens at the three pieces. While this provides a different view that now includes the lids, the perspective makes the cream and sugar containers look as if they are floating.*

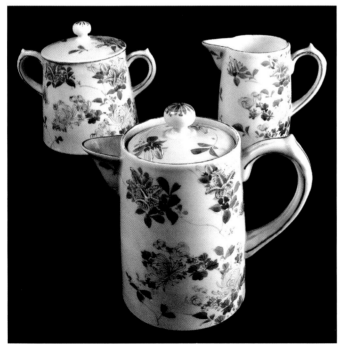

Figure 3.17 *In this photograph, we used a midway tripod height, which let us use a less-severe camera angle.*

Angling for sales

As a rule of thumb, you'll want to post more than one photograph on an auction page, with each shot using a different camera angle. It's the best way to provide full visual information about what your product really looks like.

Look at your item from different camera angles and determine what new information or visual enticement each perspective might give a buyer (**Figures 3.18 through 3.23**).

Figure 3.18 *A straight-on camera angle is good for showing the silhouette or shape of an object.*

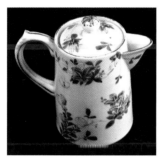

Figure 3.19 *Using a higher camera position and downward camera angle yields a distorted perspective but is useful for showing the relationship of the components (here, the lid and spout) to the rest of the object.*

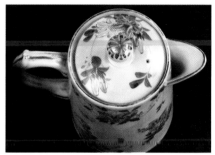

Figure 3.20 *Here the camera angle is from almost on top of the pot looking downward, providing a detailed view of the lid.*

Figure 3.21 *This rather unusual camera angle shows the inside of the spout and the small holes in the porcelain that function as a strainer.*

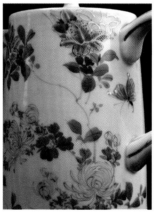

Figure 3.22 *This close-up focuses on the quality of the handpainting, as well as details of the side opposite from that shown in Figures 3.18 and 3.19.*

Figure 3.23 *Showing the maker's mark is one of the more important camera angles to provide for a hallmarked piece of porcelain. (You should frame this photo even more closely to give viewers a clearer view of the hallmark; we did it this way so you can see where it is located on the piece.)*

Make sure you pay attention to how changing your camera angle affects the visibility of important details. For instance, you can't really see the shape of the lid knob as clearly in Figure 3.19 as you can in Figure 3.18.

No Reflection on You

If you've ever attended Jim Griffin's excellent eBay University seminar, you've seen the famous silver pot—the one that shows a lot more of the (naked) photographer than any of us would ever want to see. (Of course, you have to look very closely.)

Reflections in photographs of silver, mirrors, glass and other shiny items are a very real problem, especially when they are as distracting as they are in **Figure 3.24**.

Figure 3.24 *The reflection of Sally taking a picture of this antique tin and glass mirror is so distracting that you might not even notice the mirror itself, except to note how dirty the glass is.*

We used a variety of digital cameras for taking pictures of typical eBay products for this book, and all of them produced very good to excellent results, although some were better suited for one type of product over another. Throughout the book, we note along the side of most of the product photos which camera model we used for that shot or series of shots, to give you an idea of the capabilities of the different types of cameras.

There isn't any one single solution to the reflection problem, and sometimes you have to get rather inventive. But, in most cases, we've been fairly successful in reducing or eliminating reflections. Here are some suggestions of things to try:

✦ Shoot from another camera angle.

✦ Photograph within a softbox.

✦ Shine a soft diffused light into the mirror.

✦ Use a polarizing filter, if your camera has lens threads or a filter adapter.

✦ If the item is small, use a shiny reflector or some foil (see Figure 3.25 on the next page).

✦ If large with not much depth, use a low *f*-stop number (*f*2.8 or *f*3.4) to reduce the depth of field (see Chapter 4).

- If you can't eliminate the reflection completely, make sure it doesn't impact negatively on the photograph by being distracting, misleading, ugly or, worse yet, embarrassing.

- In some cases, you can use a photo-editing program such as Photoshop Elements to erase the reflections, but that can take time and skill (see Chapter 11, "Image-Editing Techniques That Make Photos Zing").

Angles of reflection

The physical relationship of the camera lens to the object being photographed determines just what the picture will capture, as we've already discussed. Taking that principle one step further, reflections are based on a similar angular relationship. So the trick is to either position the camera so that the shiny item reflects something innocuous (such as a blank wall), or to place something (like a piece of foil) exactly at the angle of reflection to avoid pictures like Figure 3.24.

In **Figure 3.25**, we covered a piece of cardboard with aluminum foil and set it up on a plate easel. Then we played a little with the angle of the camera lens to the mirror and from the mirror to the foil, until the two angles matched. The result is a photograph in which the mirror's reflection was filled with foil from the camera's point of view (**Figure 3.26**). We have been known to use two or more such homemade foil reflectors to help eliminate reflections from silver pots and bowls. Unfortunately, we have never been able to cut a piece of aluminum foil that is perfectly smooth.

Figure 3.25

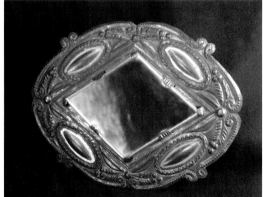

Figure 3.26

Exposure and Focus

Ever take a photograph that was too dark or too light, blurry or looked muddy? Of course, you have—everyone has. The good news is that once you understand a handful of basics about photography, you'll be able to consistently shoot attractive, in-focus and well-exposed pictures every time. And that reliability is one of the keys to eBay profits, because the quicker you can get a good photo, the sooner you can get the product up for auction and move onto the next item.

Essentially, getting consistently good shots boils down to the original definition of photography: "writing with light." When light hits film or a digital camera's image sensor, a photograph is created. The trick is to control the amount, quality and focus of light so that you get a great picture.

TIP

Learning photography shouldn't be a passive endeavor. Please have your digital camera and its user manual in hand as you read this chapter, and try the various features we discuss. The more you actually use the controls and explore your camera beyond its basic point-and-shoot settings, the more comfortable you will become with it. If you aren't sure what a particular button, dial or menu option does, try it. You can always reset your camera to its original default (factory) settings, usually via a menu option. If that fails (or you can't find the control), just remove the batteries for at least 10 seconds, which will set everything back to the factory defaults.

Controlling Exposure Is Easier Than You Think

Exposure is the measure of how much light is used to create a photograph. Too much light, and your picture will be pale and indistinct, as though a piece of gauze was placed between the object and your camera (**Figure 4.1**). Not enough light, and it will be dark, with details lost in the shadows (**Figure 4.2**). But when the light is just right, so is the photograph's exposure (**Figure 4.3**).

(This series—Olympus C-8080 Zoom)

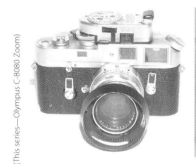

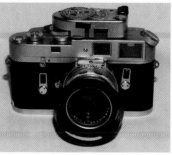

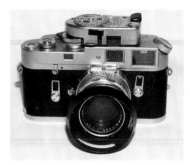

Figure 4.1. *When too much light is used to create a photograph, you end up with an overexposed picture.*

Figure 4.2. *Too little light results in an underexposed photograph.*

Figure 4.3. *A well-exposed photograph like this one is crisp, with all details clearly defined.*

Even with modern auto-everything, point-and-shoot cameras, you can't always count on getting perfect exposures. It all boils down to the fact that the camera's electronic "intelligence" isn't always functioning as well as we might assume it should, and the exposure setting it "thinks" is just right for the product you're photographing may be quite wrong. And that can waste your time when you have to reshoot a picture.

Fortunately, it's a lot easier than most people realize to achieve proper exposure.

Spot-on Photography

One of the more frustrating experiences with photography is trying to take a picture of an object on a bright background when, no matter how much light you pour onto the scene, the picture turns out too dark. The answer isn't the amount of light, but how your camera is reading it.

All modern cameras (film or digital) use an electronic meter to measure the light of a scene, which in turn determines what exposure settings will be used to take a photograph of that scene. The meter is activated when you point your camera and press the shutter button halfway (or all the way to take the picture).

Most digital cameras have at least two and often three different meter settings:

- ✦ Matrix metering

- ✦ Spot metering

- ✦ Center-weighted metering

(Please note that your camera may use different names than these for its meter settings, but the functionality is the same, regardless.)

Matrix metering, which is usually the factory default setting, reads the light in the center and periphery of a scene and averages them together. So if the periphery is really bright (such as when you add extra lights to illuminate an already bright background), matrix metering assumes the entire scene is quite bright. Matrix metering can be useful for party scenes or other times when all the light values in a large area are equally important. But it's not the best for product photography, in which the item in the center of the shot is the only real purpose for taking the picture.

We recommend setting your camera's meter to spot metering for most product photography. That's because spot metering determines the camera's exposure according to what's in the center of your picture and nothing else.

Some sophisticated cameras often have adjustable spot metering, in which you can select what small area in your picture you want the meter to read. This is quite useful if the critical point on your product isn't positioned dead-center in the lens. If your camera doesn't have adjustable spot metering, just point your lens at that critical point, press and hold the shutter button halfway to lock in that meter reading, reframe and then shoot.

For larger objects, such as a car, a building or anything big that fills your viewfinder, you'll probably want to use center-weighted metering, if your camera has it. Set to center-weighted, your camera's meter reads the light levels of the periphery and the center, but when averaging the various values, it gives more weight to the center.

Figure 4.4

The easiest way to get a well-exposed photo

The one exposure control that almost all digital cameras (and many film cameras) have is called *exposure compensation* (or EV, for *exposure value*). Exposure compensation lets you either crank up or reduce the light reaching your image sensor (or film) with a flick of a switch, press of a button or turn of a dial. The exposure-compensation control on your camera is probably marked with a plus-minus icon like the one in **Figure 4.4**, or it may simply use the abbreviation *EV*.

Here's how exposure compensation works:

✦ EV settings usually range from -2 to +2, or from -3 to +3 (**Figure 4.5**).

✦ If your picture is too dark, you can increase the amount of light by using a positive EV value for the next shot. The higher the setting on the plus side of the scale, the brighter the picture will be.

✦ If your picture is too bright, use a negative EV setting to decrease the light. The lower on the minus side of the scale you select, the darker the picture will be.

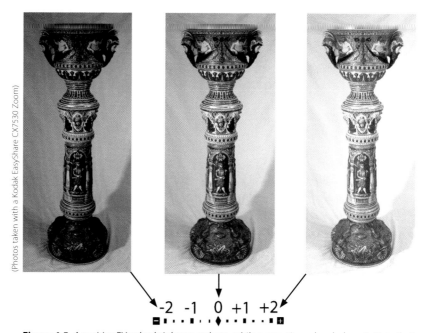

(Photos taken with a Kodak EasyShare CX7530 Zoom)

-2 -1 0 +1 +2

Figure 4.5. *A positive EV value brightens a photo, while a negative value darkens it. Note that most exposure compensation settings are fractional, so the effect can be much more subtle than this illustration.*

Bracketing: exposure insurance

One problem your digital camera instruction manual probably doesn't mention is that the LCD screen (the small monitor on the back of your digital camera) isn't a precision instrument. In fact, depending on your angle of view and the quality of the screen, it can out-and-out lie about exposure. The picture you just shot may look pretty good on the LCD screen, but it could actually turn out to be too light or too dark when you view it on your computer. That's why we suggest using exposure bracketing as a type of "exposure insurance."

Bracketing is a technique that photographers have been using for many years, long before digital cameras were invented. It basically involves taking a series of pictures for every image and using various exposure-compensation values (EV) in the following manner:

1. Take the first photograph by simply clicking the shutter button. That will shoot the picture according to the exposure setting your camera "thinks" is correct for the scene.

2. Take one or two photos with different negative EV values.

3. Then shoot one or two photos with different positive EV values.

How many pictures you should shoot in either direction depends on how sure (or unsure) you are that you've got the picture you need. Internationally recognized photographer Jay Maisel once confided in us, "I sometimes drive myself crazy by bracketing… . In some cases, a stop over [one exposure increment] works; in others, a stop under works."

Fortunately, many digital cameras have a feature called *auto bracketing*. When you press the shutter button with auto bracketing turned on, the camera automatically fires off a series of three or five shots, each at a slightly different exposure setting. (The number of shots it fires depends on the make and model of the camera. With some cameras, auto bracketing works by pressing and holding the shutter button, while others require a separate press of the button for each shot to get automatically bracketed shots.) Your camera may have auto bracketing for properties other than exposure, such as for color, sharpness or contrast, which also can be useful.

Remember to turn off auto bracketing when you no longer need it, such as when you take your camera to a family gathering. Otherwise, you could end up with an uneven variety of exposures and three-to-five times the number of pictures you expect, which eats up storage space on your memory card.

Nothing is really difficult about mastering digital cameras. The rule of thumb is simply to take it one control at a time. Learn what one knob or command or button does, and then move onto the next. After all, the best way to learn to take great photographs is to keep taking them.

Histograms: The pros' secret weapon

A professional photographer can't afford to get exposure wrong, and neither can an eBay seller for the same reason: Inadequate photos can translate into wasted time and lost income. Many digital cameras come equipped with a unique tool that tells you *exactly* what areas of your picture are light, dark or in between. It's called a *histogram* (**Figure 4.6**).

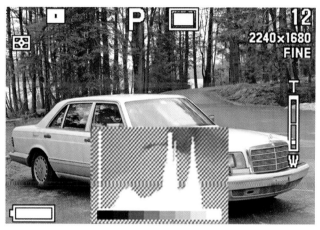

Figure 4.6. *The graph superimposed on this photo is a histogram, as it would appear in the LCD screen of a Casio QV-4000.*

For those of us who are mathematically challenged, histograms can seem intimidating at first. But they are really very logical and easy to interpret, once you understand what the graphs represent. A histogram is a statistical analysis displaying what percentage of your photograph is in the shadows, the midtones and the highlights.

Notice in Figure 4.6 the grayscale bar at the bottom of the graph. Moving from left to right, the bar progresses from black to lighter and lighter levels of gray until it turns white. The black on the far left represents deep shadow, while the white on the far right represents bright highlights. What the histogram of this photo of a Mercedes tells us is that most of the data defining the picture is in the center (the midtones), and that there are no bright highlights (pure white), although there is a single spike in the far-left area related to deep shadows (pure black).

You'll see slight differences in the way each digital camera displays histograms; those that don't have the grayscale display on the bottom like the one in Figure 4.6 still follow the same principle. A dark, underexposed picture tends to have most of the data displayed toward the left of the graph (**Figure 4.7**). And a bright, overexposed picture will have a lopsided graph that's pushed toward the right (**Figure 4.8**).

Figure 4.7. *Even if we couldn't see this photograph, the histogram tells us that it has no whites or even bright information in it because the data is located mostly on the left. That is usually indicative of a photo that is underexposed.*

Figure 4.8. *This histogram is pushed to the brighter end of the scale, with no dark areas. It is typical of a photograph that is overexposed.*

The perfect histogram

The ideal histogram is a classic "bell-curve" graph, with most of the picture data located in the midtones with the curve sloping downward from the center, and only a bit of data in the highlights and shadows (**Figure 4.9**).

Figure 4.9. *This histogram comes close to looking like the "bell curve" of an ideal histogram, which few digital photos ever achieve.*

Figure 4.10

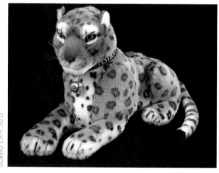

Figure 4.11

(Casio EX-P505)

It should come as no surprise that in photography, as in life, the ideal is seldom achieved—or desirable. What picture (or product) is a perfect balance of midtones, highlights and shadows? For instance, in **Figure 4.10**, notice how most of the data in the histogram is located on the lighter end of the graph, and not much data is located in the shadows on the left. That's because this well-exposed photograph is of a light-colored figurine on a light-colored background. And there's very little in the picture itself that should be dark or shadowy. (However, notice that the graph indicates that there is some data throughout the grayscale, from the deepest shadows to the brightest whites.)

By comparison, look at the histogram of **Figure 4.11**. The well-exposed photo of a toy leopard is on a black background. The background is represented by the spike in the shadows area of the graph.

When you judge a photograph's histogram to determine how good the exposure is, look first at the scene and consider the following:

✦ Are there bright colors and dark shadows? If so, do they balance each other?

✦ Is the scene overwhelmingly bright, as in Figure 4.10?

✦ Does the scene tend to be even in tone, as Figure 4.11 is (if you disregard the black background)?

Learning to correctly interpret histograms takes practice, especially since you'll have to study the histograms of a variety of different kinds of pictures before you get the hang of it. But it won't be long before you'll be able to understand why any photograph has a specific histogram pattern. And once you understand that, all you have to do is glance at a histogram to know whether you've got a perfectly exposed picture. If you don't, you'll be able to fix it right away (we explain how in the next section).

Using histograms and exposure compensation together

While histograms used to be available only on professional digital cameras, more and more consumer digital cameras now have them. Some cameras have what is called a *live* histogram, which displays on the LCD screen while you're composing the photograph. When you add or remove light, zoom in or out, alter your camera angle or otherwise change the composition and exposure settings, a live histogram instantly updates with each new setting or adjustment. Other digital cameras display histograms only on playback. With these, you take a photograph and then look at the histogram while reviewing the picture you just shot.

Both playback and live histograms are superimposed over the image on your LCD screen (Figure 4.6).

What makes histograms really useful is the ability to use them in conjunction with exposure compensation (as well as other exposure tools). Here's how it works:

1. Turn on the histogram of your scene or the shot you just took.

2. If the histogram looks like it has too much data in the shadows (the left side of the graph) and not enough in the highlights (the right side), turn on exposure compensation (which is also called EV) and set it to a positive value. Continue increasing the EV until the histogram appears appropriately balanced for the photograph, and then shoot (if it's a live histogram) or reshoot (if it's a playback histogram).

3. If the histogram displays too much data in the highlights and not enough in the shadows, use a negative EV setting. Continue decreasing the EV, until the histogram is appropriate for the photograph. Then shoot or reshoot.

This process sounds much more complicated than it is. But once you get used to activating these controls together, you'll wonder how you ever took photographs without them. The combination of histograms and exposure compensation lets you shoot with confidence, knowing that your exposure will be good, which, in turn, will save you energy and time.

If your picture is underexposed, consider adding more light rather than changing the exposure settings. (See Chapter 5, "Great Lighting the Easy Way," for more information on getting the right lighting.)

Photo-editing software doesn't take the place of good photography. If you get the exposure, color, focus and so forth right before you snap the picture, those qualities become essential elements of the photo, which translates to higher quality. Making edits and corrections after the picture is created actually destroys image data, diminishing quality. More importantly, it's always easier and less time-consuming to do things correctly in the first place (when you take your photos), rather than trying to fix them later (using a computer).

Understanding *f*-Stops and Shutter Speeds

Aperture nomenclature can be confusing sometimes, because larger *f*-stop numbers (such as *f*8 or *f*11) indicate smaller apertures (less light), while smaller *f*-stop numbers (such as *f*2.8 or *f*3.4) indicate a larger aperture (or more light). It may help you to think of them as fractions or inverse numbers.

Understanding and using *f*-stops and shutter speeds correctly can enhance your product photography. Don't worry, despite the mystique that pros create around shutter speeds and *f*-stops, this stuff is really rather easy.

If your camera has any of the following controls, you'll want to read this section, because these controls determine the relationship between *f*-stops and shutter speeds:

✦ Aperture priority

✦ Shutter priority

✦ Manual exposure

What are *f*-stops and shutter speeds?

Light coming through your camera lens is controlled by two factors:

✦ The size of the aperture (or diaphragm) in your lens through which the light enters

✦ The shutter speed, or the length of time that the lens is open to the light

In other words, aperture controls the amount of light, and the shutter controls the duration of the light. However, using your camera's aperture and shutter speed to select your exposure settings gives you control over much more than light. It affects your entire composition, including what in your photograph (if anything) is in crisp focus.

As a rule, we recommend shooting all products using aperture priority. That way, you can control depth of field, while keeping an eye on the corresponding shutter speed.

The aperture is a circular opening inside the center of your lens. If it is large (wide open), it lets in more light. If it is small (closed, or stopped down), then it lets in less light. The size of the aperture is measured in *f*-stops, such as *f*3.5, *f*5.6 and *f*8.

Shutter speeds are measured in fractions of seconds (such as 1/60, 1/125, 1/250 and so forth) or whole seconds (1 sec, 2 sec, etc.).

A balancing act

Shutter speed and *f*-stops work together to control the amount of light. If you think about what each does, their relationship becomes quite obvious:

✦ A slow shutter speed allows more light to reach the image sensor than a fast shutter speed, for the simple reason that the camera is open to the light for a longer time.

✦ A large aperture (small *f*-stop number) allows in more light than a small aperture (large *f*-stop number).

If you increase the shutter speed—thereby reducing the length of the exposure—you should also increase the aperture size, and vice versa.

The aperture priority and shutter priority controls in your camera determine the shutter speed and *f*-stop. If your camera is set to aperture priority, you control what *f*-stop is used, and the camera then automatically chooses what it believes would be the best corresponding shutter speed for optimum exposure. If your camera is set to shutter priority, you select the shutter speed, and the camera automatically sets the corresponding *f*-stop.

If your camera is set to manual exposure, shutter speed and aperture won't be automatically coupled. While many professionals prefer the manual setting for the ultimate control it provides, it does require more knowledge, skill and consideration to get a good picture. For that reason, we do not recommend using manual exposure settings for eBay, unless you have experience with the concepts behind it.

Choosing the right *f*-stop and shutter speed

Shutter speeds and *f*-stops control much more than light, and that's what makes them so very important for eBay photography. In fact, *f*-stops can be critical to good product photography, because the size of the aperture controls the depth of field. Briefly, *depth of field* is that area of a picture, from foreground to background, that is in focus. (See the sidebar "Depth of Field: Film vs. Digital" in Chapter 1 for a more detailed explanation.) The smaller the aperture, which is indicated by a larger *f*-stop number, the greater the depth of field (see **Figures 4.12 and 4.13** on the next page).

The closer your lens is to your subject, the narrower the depth of field becomes. So, when you photograph small items or shoot close-up details of larger objects, you'll want to be sure to set a smaller aperture for deeper depth of field. On the other hand, use a larger aperture when photographing large items, to blur backgrounds that are unattractive or distracting. (see **Table 4.1** on the next page.)

Table 4.1: *f*-Stop and Shutter Speed Scenarios

Desired Effect	Aperture Setting	Related Shutter Adjustment	Recommendation
Large depth of field to increase the area of focus (particularly for close-up photography)	Large *f*-stop number (small aperture)	Slower shutter speed	A tripod is required to avoid motion blur
Blur the background with narrow depth of field	Small *f*-stop number (large aperture)	Faster shutter speed	Tripod not necessary, but still a good idea

Shutter speed is important for product photography for the simple reason that the slower the shutter speed, the more difficult it is to handhold your camera without experiencing motion blur. Even breathing can cause tiny movements and blur your picture, if the shutter speed is slow. Any time you shoot at 1/60th of a second or slower, we strongly recommend using a tripod. And to better ensure that your photographs have that extra sharpness and clarity, use your camera's self-timer whenever it's on a tripod.

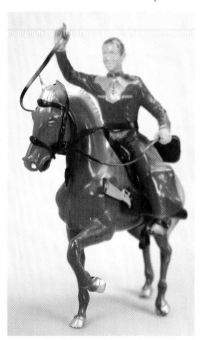

Figure 4.12. *This photo was taken at f5. Notice how narrow the depth of field is with only the front of the horse in focus. The rest of the toy is soft, with the rear legs of the horse quite out of focus.*

Figure 4.13. *Shooting the same toy with an aperture at f18, we produced a larger (deeper) depth of field. Notice how sharp the cowboy's face is, including the imperfection on his nose.*

(Both photos taken with a Canon EOS Digital Rebel)

Staying Focused

As eBay buyers, we're often surprised (and disappointed) how many product photos on eBay auctions are out of focus. Some are so soft and blurry that we can't really tell what the item is, and, naturally, we decline to bid on them.

All the digital cameras we recommend for eBay (including the more advanced DSLRs) have autofocus capability. But if you don't use autofocus correctly, you can still end up with soft, indistinct, fuzzy pictures (**Figure 4.14**). And if your photographs aren't crisp and sharp (**Figure 4.15**), bids for that product will tend to be low or nonexistent. After all, buyers won't bid on something they can't see or whose details they can't distinguish.

Making autofocus work for you

Regardless how much electronic intelligence is embedded into today's digital cameras, they are still essentially dumb machines with no imagination. They simply follow the rules that have been programmed into them. To help you get a better handle on how to use autofocus effectively, it helps to know what those "rules" are:

✦ What a camera focuses on depends on where you point it.

✦ Cameras focus on areas of contrast. That means if the camera is pointed at an area that is one uniform color with no contrasting details, or an area that is so dark that it can't distinguish any details, it won't be able to focus well, or perhaps not at all.

✦ Every camera has its limits of how closely it can focus. Some can get as near as an inch or even less, while others have to be at least 10 inches or more away from the subject.

To help your camera's autofocus zero in on the right setting, try the following:

✦ Use the correct focus option for the photograph. Very similar to your camera's metering options (described earlier in this chapter), focus can be set to spot or matrix on many cameras. The names may vary with each camera model, but the concepts are the same. As a general rule, we recommend spot focus for product photography, because it gives you more precise control. Some sophisticated cameras have adjustable spot focus in which you can choose the point of focus. With others, you aim your lens at the critical point and press the shutter button to lock in the focus. Then, while holding the shutter button halfway, you move the camera to frame your picture.

Figure 4.14. *If you've been browsing on eBay, you know we're not exaggerating here. We've seen eBay pictures much worse than this fuzzy one.*

Figure 4.15. *When a photograph is crisp, sharp and well-focused, buyers are drawn to offer more and higher bids.*

(Both photos taken with a Nikon D70)

If you plan to do lots of
close-up photographs
(such as for jewelry),
be sure to buy a digital
camera with good macro
capabilities that will let you
put your lens within a few
inches of your product. You
might also consider buying
close-up lenses (they look
like clear filters) if your
camera can accommodate
them.

✦ If the center of your lens is pointing at a uniform area of color, focus on another area that provides enough contrasting detail for the lens to respond. But make sure that this area is approximately the same distance from the lens as the area you want to capture. Then, lock down the focus (press the shutter button halfway), frame and shoot.

✦ If the area is too dark for your camera to get a focus lock, add lights, or as a last resort, boost the ISO equivalency (see Chapter 5 for more on ISO).

✦ Learn what your camera's capabilities are, and don't try to take macro (close-up) photographs closer than your camera can focus. They just won't be sharp. Using your zoom lens might help to some extent, although we have found some cameras' telephoto settings have difficulty with focusing on near subjects. If you need to get closer to your subject than your camera lens seems to allow, take the picture at the closest point at which you are in sharp focus, and then crop the picture using photo-editing software (see Chapter 11). Of course, use the highest resolution and highest quality settings your camera allows.

✦ Use a good depth of field setting to extend your area of focus, as discussed earlier in this chapter.

Avoiding Shutter Lag

Shutter lag, which is the delay that happens between pressing the shutter button and the moment the photograph is actually taken, isn't exactly relevant to eBay, or any product photography for that matter. After all, the items you have for sale aren't about to walk off your shooting table if there is a few seconds' delay. But most of us use our digital cameras for more than product photography, and one of the most frequent complaints we hear about digital cameras is shutter lag, which can negatively impact on the pleasure and quality of your personal photography experience.

Shutter lag happens because so much is going on inside the camera the instant you press the shutter button—analyzing the scene; prepping the flash; and selecting the right exposure, color, focus and so on. Even at the speed of tens of millions of instructions per second, such analyses can take time. More expensive cameras are loaded with extra memory, which helps minimize shutter lag. And if the manufacturer throws in enough memory, shutter delay is imperceptible.

For those cameras that don't have lots of memory, you can reduce shutter lag considerably by using the following simple trick:

1. As you are composing your picture, point your lens at the most important item in the scene (the critical area that must be in focus and well-exposed).

2. Press your shutter button down halfway. That wakes up the camera, and tells it to lock in exposure and focus ahead of time.

3. While continuing to hold the shutter button halfway, frame your picture and then shoot by gently pressing the shutter button all the way.

This simple process takes much longer to describe than it does to do. But it's a technique used by every professional photographer we know. Practice it for a short while, and it will become an instinctive, automatic aspect of your everyday photography.

Great Lighting the Easy Way

Light is the essence of photography—without it, pictures would be pitch black. Properly lighting your eBay product shots makes them more viewable and appealing. Specifically, it produces the right kinds of highlights, shadows and colors that add dimension, sparkle and interest, while still producing a truthful representation of your product.

But the trick isn't just creating good lighting for your eBay photos—it's about creating *consistently* good lighting that lets you shoot quickly, efficiently and accurately, with picture-perfect results each and every time.

The Quality of Light

Any light source can affect your photographs in a variety of ways. Generally speaking, the effects of light on a photograph can be described in the following ways:

✦ Brightness

✦ Darkness

✦ Highlights

✦ Shadows

✦ Contrast

✦ Color

Brightness and darkness

Like Goldilocks, we've all had pictures that were too dark, too light or just right (**Figures 5.1 through 5.3**).

In Chapter 4, "Exposure and Focus," we discussed how to use your camera's various exposure settings to control the amount of light that reaches your image sensor (or film). But you can also control the light coming directly from the source.

(This series—Nikon Coolpix 990)

Figure 5.1 *Too much light creates an indistinct, overexposed photograph.*

Figure 5.2 *Too little light creates a dark, underexposed photograph.*

Figure 5.3 *With just the right amount of light, the colors and details of your product reproduce clearly and accurately.*

Three conditions define how your lighting affects the exposure:

+ **The distance between the light and the subject.** One of the easiest ways to increase a photo's brightness is to move the light source (such as your lamp) closer to the object. Similarly, pulling the light farther away makes your photo darker.

+ **The intensity of the light.** If your picture is too dark, add stronger lights. For a photo that is too light, use weaker ones.

+ **The number of lights.** When you need more light, add another fixture. When you have too much light, remove one of the lights.

Highlights

In Figure 5.3, the amount of light is just right. But notice the distracting reflection in the lower right quadrant (near the 5 o'clock position, over the suitcase on the floor). The problem with that highlight is that it obscures some of the detail of the Rockwell painting. However, it's rather innocuous compared to the unattractive or obscuring highlights we've seen in some eBay photos (**Figure 5.4**).

On the other hand, some highlights are not only desirable, they can add sparkle to a photograph and even help to delineate and define an object. This is particularly important with transparent or indistinct items like glassware (**Figure 5.5**).

Being aware of how highlights and shadows affect your photo is one of the most important keys to getting control over your photography. You can fine-tune your photographic eye by studying where the highlights and shadows fall, not only in pictures you see but in the world around you, as well as in successful ads in catalogs and magazines.

Figure 5.4 *The exposure and amount of light is correct in this photograph, but the angle of the lights creates undesirable, bright highlights, which make it look overexposed.*

(Casio Exilim EX-P505)

Figure 5.5 *Without highlights, this photograph of crystal candlesticks would have no definition.*

Highlights are controlled by the angle of the lights in relationship to the object being photographed. To see where the highlights are on your item, look through the camera viewfinder rather than with your unaided eye. That's the only way you can see the object as your camera sees it. Then slightly adjust either the lights or the object, angling them in relationship to each other, until the highlights are where you want them, rather than where they don't belong. (For a more in-depth discussion on how to eliminate and create highlights and reflections, see Chapter 7, "Shooting Items that Fit on a Tabletop.")

Shadows

To get a better understanding of how shadows affect your photographs, see "Shadow and Light Exercise" in the Appendix.

Like highlights, shadows are controlled by the relationship of light to the object you're photographing. The one situation you want to avoid at all times is having the light coming from behind your object. This type of lighting creates a backlit situation, in which shadows fall forward toward the camera lens, covering your object in darkness (**Figure 5.6**). It's always best to have light coming from the front or side (**Figure 5.7**).

However, look closely at Figure 5.7. It's very contrasty, with shadows causing the creases in the material to appear exaggerated. By adding another light from the left front, we were able to soften the shadows (**Figure 5.8**).

We could have fine-tuned the lighting of the purse shot even further, adjusting the amount and position of the lights until we had a completely shadowless photo. In traditional product photography, shadowless pictures are often preferable, but for most eBay shots, you just need to make sure any shadows you do have in your pictures are soft and unobtrusive. Of course, as with highlights, some shadows are desirable. The key is to be aware of their position and their effect on your photographs.

When you see a shadow that is too strong or that you don't want in your photo, either alter the angle of the lights or add lights. We'll discuss setting up multiple lights and shadowless photography later in this chapter.

Figure 5.6 *If the light or sun is behind your product, shadows fall toward the camera lens, darkening the front of the item.*

Figure 5.7 *Notice how the shadow in this picture is cast toward the back and left, because the light source is from the front, and a bit above and to the right of the purse.*

Figure 5.8 *The shadows are softer in this photograph, so that the only thing you really notice is the purse.*

ISO Equivalency

ISO equivalency (ISO, for short) determines how sensitive your camera's image sensor is to light. Most digital cameras' ISO default value is Auto, which usually works well. The best quality ISO is the lowest number—50 or 100, depending on your camera. If you're still getting dark shots after adding light, you might try boosting ISO to a higher number, say 200 or 400. Raising the ISO will brighten the picture, but it also creates noise—unwanted spots or splotches throughout the image. That's why we generally recommend against boosting ISO, except when it's necessary to get a decent exposure.

Contrast

Contrast is the relationship between light and darkness. When a photo is too contrasty, the shadows and bright areas are exaggerated, destroying all the details except for those located in the midtones (**Figures 5.9 and 5.10**). When a photo doesn't have enough contrast, the lack of shadows and bright areas makes the picture look dull (**Figures 5.11 and 5.12**). A picture with good contrast balances light and dark to create a faithful and attractive reproduction of the object (**Figures 5.13 and 5.14**).

(This series—Kodak EasyShare DX6490 Zoom)

Figure 5.9 *In this contrasty photo, notice how you can't really see any details in the dark or bright areas.*

Figure 5.10 *This histogram reveals the high contrast in the photo: The only spikes of data are located at the far ends of the graph, which represent the large amount of pure black and white in the photo. The midtones are flat.*

Figure 5.11 *A low-contrast photo looks dull and boring.*

Figure 5.12 *Notice how this corresponding histogram has no data at all on either end of the graph, indicating that the photo has no full shadows or highlights. All the image data is located in the midtones.*

Figure 5.13 *A good balance of dark, light and midtones creates an appealing, faithful photograph.*

Figure 5.14 *The corresponding histogram is an appropriate bell-curve graph for this real estate photo, with the single spike in the highlights representing where the sun is glinting off surfaces. Notice how data is evident throughout the "dynamic range"—that is, image data ranges from the shadows through the midtones and up to the highlights.*

Figures 5.9 and 5.11 are rather exaggerated examples of poor contrast, to help demonstrate the concepts. As with shadows and highlights, the more you become aware of the level of contrast in your photos, and how it affects their accuracy and appeal, the better a photographer you'll become.

Color

It's a fact of physics: all light has color. The human eye sees white as white all the time, even when it's really blue-white, yellow-white or green-white. That's because humans possess a truly remarkable device—the brain—that automatically processes visual information and adjusts what we actually see to what we expect to see.

Cameras, however, are literal devices, capturing exactly what is in front of their lenses. So if you're taking photographs using tungsten (yellow-white), halogen (blue-white) or fluorescent (green-white) bulbs, the pictures can have a distracting, quality-robbing yellow, blue or green color cast (**Figures 5.15 through 5.18**).

Figure 5.15

Figure 5.16

Figure 5.17

Figure 5.18

Different kinds of light can introduce a wide variety of color shifts. But digital cameras' white-balance controls can remove such color inaccuracies to ensure your photos' colors are correct.

If the reds in your eBay photos appear orange or there's a cyanic blue cast throughout your picture, these wrong or distracting colors may discourage potential bidders from wanting to buy your product. Even worse, a successful bidder might cry "foul" if the sweater she thought was pink turns out to be orange when she receives it. To avoid potential color problems that could lead to lower bids or negative feedback, you'll want to get the color right every time you shoot.

One of the things that digital cameras (and camcorders) do much better than film cameras is provide a precise, easy-to-use tool for recording accurate color. *White balance* adjusts the colors in a picture so that whites photographed under off-white lighting conditions look truly white. By extension, when the whites look truly white, removing any color "shift" introduced by the lighting goes a long way in making all the other colors accurate.

Almost all digital cameras power up with the auto white balance control activated by default. This means the camera's intelligence continuously analyzes the light you're shooting under and automatically adjusts the whites (and other colors) accordingly. Auto white balance works reasonably well under normal shooting conditions.

You can't ever be sure that the colors buyers see on your auctions are the colors you meant to display. Because of various technical factors, monitors are notoriously unreliable with accurate color. However, using the correct white balance will help ensure that your photos begin with the right colors. Now that monitors and operating systems are getting better at accurately reproducing colors, you have a better chance of communicating your products' colors to your buyers than ever.

Understanding Color Temperatures

In addition to white balance presets, some prosumer digital cameras and DSLRs may list light sources according to their color temperature (expressed in degrees kelvin). This is useful if you have a device called a color temperature meter, which measures the exact lighting conditions of your setup. Then, you can set the camera's color temperature to match.

If you don't have a color temperature meter, you can guesstimate and see how the results look.

Here are some basic guidelines for color temperatures:

✦ 2800K–3400K covers tungsten and halogens.
✦ 4000K is the temperature of common fluorescent bulbs.
✦ 5000K–6000K is the "ideal" daylight temperature (also the temperature of most electronic flashes).
✦ 8000K–10,000K is what you tend to get when the sky is cloudy or overcast.

If your camera offers it, try using automatic color temperature bracketing, which takes a series of photos at various incremental settings.

Once you know the color temperature of your lighting system, you'll be able to dial the value in every time. However, be aware that as bulbs age, their color temperature drifts.

 Typical White Balance Icon

 Auto White Balance

 Tungsten WB (household bulbs)

 Fluorescent WB

 Daylight WB

 Cloudy WB

 Shade WB

Figure 5.19 *Digital-camera manufacturers tend to use different icons for their white-balance presets; however, they're usually variations of similar pictographs such as these from a Nikon D70.*

Some digital cameras let you save your white balance and other settings under a "user profile" or "user default." If you tend to use the same lights for all your eBay photos, you can save a manual white balance setting and then use that same setting again by simply calling it up with a click of a button.

Almost all digital cameras also have what are called *presets*—white balance profiles for different kinds of light, such as sunlight, fluorescent, and tungsten. Better cameras may have additional presets, such as for cloudy/overcast, flash (although the sunlight and flash presets are virtually identical), and fluorescent 2, which often refers to full spectrum fluorescent bulbs (**Figure 5.19**).

Manual white balance

Auto white balance and presets generally work well, but they can easily become confused by a strong source other than sunlight or mixed light sources (such as a room that is lit primarily by typical household light bulbs but has some sun streaking in the windows and a little fluorescent lighting from the hallway).

The most precise white-balance setting under all conditions is manual white balance, although not all digital cameras offer it. This mode lets you set the white balance according to your actual light setup or situation. It is especially useful for eBay setups in which studio lights, household lamps or makeshift lighting setups are used for illumination.

Using manual white balance is easy, and if you do it often enough, it should become second nature. Here's how:

1. Select manual mode from the white balance menu. On some cameras, you cycle through to manual mode by repeatedly pressing the white balance button.

2. Hold a piece of white paper or cardboard (photocopy or inkjet paper is fine) under the lights you plan to use for your shoot, close enough to the lens so that it fills the entire frame.

3. Press the shutter.

That's all there is to it. Your camera instantly recalibrates, adjusting the whites and the colors so that they look accurate under the lights you are currently using.

If you use the camera exclusively for your eBay auctions and your lighting remains the same, you can take manual white balance readings only once in a while to ensure the color of your lights haven't changed as your bulbs age. Otherwise, leave the setting as it is.

On the other hand, if you use your digital camera for personal photography and eBay auctions—or if you use different kinds of lights for your eBay pictures—be sure to reset your digital camera's white balance to auto when you're finished. If you don't, the colors will be wrong when you shoot outdoors or use a flash or any lights different from the ones you used to take the manual reading.

It's always best to get the right white balance when you take your eBay photos, rather than correcting it later using photo-editing software because it takes a lot less time to shoot correctly than to edit the photo. And as we've said before, wasted time translates into getting fewer auctions up on eBay and reduced potential profits. However, we cover tweaking color using software in Chapter 11, "Photo-Editing Techniques that Make Pictures Zing."

Daylight

The easiest, cheapest, and most readily available lighting is the sun. You don't have to buy or set up any artificial lights or stands, and you can shoot outdoors or in any well-lit room where sunlight streams in. Your digital camera's "smarts" automatically measure the quantity of light and set what it thinks is the proper exposure. It also simultaneously evaluates the color of the light and adjusts the settings to ensure correct white balance.

But sunlight is not consistent light: It changes from minute to minute, according to the time of day, the seasons, the weather and the latitude where you live. For example, sunlight is different at dawn than it is at noon or twilight. In other words, it becomes necessary to be aware of just what kind of light you have and how it is affecting the quality of your photograph.

One drawback to shooting outdoors in natural sunlight, of course, is the weather. You won't want to be taking pictures in rainstorms or the freezing cold, if you can help it. But if the weather is cooperating, sunlight can be great, as long as you know how to use it properly.

When shooting outdoors, keep in mind the following guidelines:

◆ Take your photos in mid-morning or mid-afternoon light.

◆ Try to shoot with the sun at your back.

◆ Use center-weighted metering.

◆ Use reflectors to direct and control sunlight.

◆ Your camera's flash may be useful even in bright sunlight (see the next section, "Using Your Camera's Flash").

The best times of the day

The best outdoor product shots are taken between mid-morning or mid-afternoon (the actual times depend on the season and your latitude). The light at these times is mildly oblique (at an angle), although it's not as angled as it would be at sunrise or sunset. Mildly oblique light helps produce relatively short and shallow shadows, which adds depth and dimensionality to your photos. Conversely, strong oblique light (such as you would get very early or very late in the day) creates long, dark shadows that can detract or distort your product shots. Most professional photographers prefer to avoid noonday light, which can produce harsh and contrasty light with little or no shadows.

As a rule, shooting with the sun out is better than shooting on a cloudy day, when the light tends to be flat and unappealing. However, bright sunlight can make your photos quite contrasty, which is why some photographers prefer a slightly overcast sky, because it diffuses sunlight nicely. Avoid rainy, drizzly or snowy days, not only because it would soak the objects you're photographing, as well as your camera, but it would also tend to dull and flatten the light.

The sun at your back

It's almost always best to have the sun at your back (**Figures 5.20 and 5.21**), rather than shooting into the sun (**Figure 5.22**) because it reduces or eliminates lens flare (unwanted streaks of light). In addition, having the sun behind you forces the shadows to fall away from the object you're photographing, rather than toward it. If, for any reason, that's not possible—for instance, if you are photographing all four sides of a house—then try to choose a time of day when the sun will be anywhere other than directly behind the more important sides of the building as you shoot (**Figure 5.23**).

Figure 5.20 This photo was shot at 10:00 a.m., with the sun behind the photographer, so the vase is nicely illuminated.

(This series—Kodak EasyShare DX6490 Zoom)

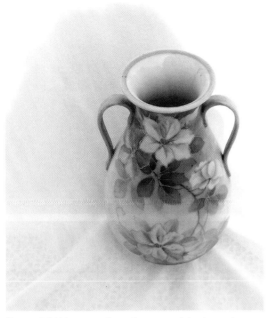

Figure 5.21 *You must always be aware of shadows when photographing. Here, the sun was behind Sally when she took this picture, but her shadow mars the picture.*

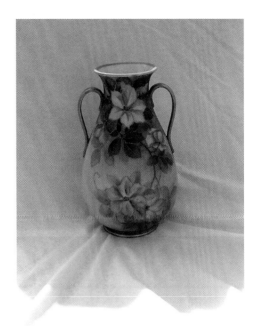

Figure 5.22 *One situation you want to avoid is having the sun behind the subject you're photographing. Otherwise, you'll end up with a shadowy, less attractive picture.*

Figure 5.23 *Having the light coming from the side does darken the other side, but it's still preferable to having the sun behind the vase.*

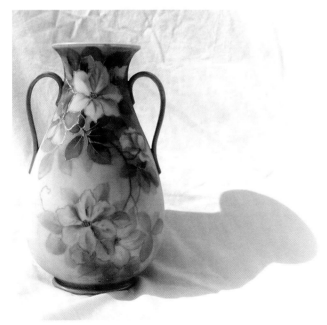

Center-weighted metering for shooting outdoors

Your digital camera may have two or three different metering modes, as we discussed in the last chapter. When you're shooting indoors using some sort of lighting system, as you will for most eBay photography, we recommend choosing spot metering so that your camera sets the exposure only for the item you're photographing. But when you're shooting outdoors using the sun as your primary light source, it's better to read the light reflected from the item you're shooting *and* from the surrounding ambient light. So we recommend using center-weighted metering, which averages the light levels of the periphery and the center, but gives more weight to the center. (For a review of the different metering modes, see the "Spot-on Photography" sidebar in Chapter 4.)

Controlling sunlight with reflectors

The sun is not exactly something we think of controlling. It shines when and where the laws of the universe and weather patterns say it should, regardless of what kind of photographs we need to take. However, using reflectors, we can redirect sunlight where we need it (**Figure 5.24**).

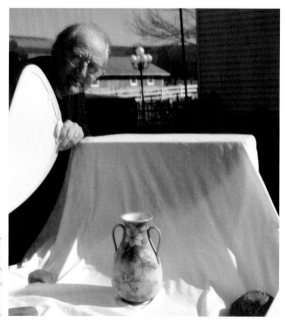

(Samsung Digimax A5)

Figure 5.24 *Daniel is holding a reflector to direct some sunlight onto the shadowy area created by this sidelight situation. Notice the rocks—wind is another problem you have to address when photographing outside.*

When we want to throw more light onto a product we're shooting (whether indoors or out), we use white and silver square and circular reflectors that range in size from about 15 inches to 4 feet in diameter. We angle them behind or to the side of the item so that they catch the light and reflect it onto the item. Silver reflectors are more pronounced and throw more light; white reflectors are softer and more subtle. Avoid using gold reflectors for eBay, because of the misleading color cast they create.

If you don't have a willing spouse or assistant to hold the reflector while you shoot, you can use clamps to attach it to nearby tables, walls or chairs. We have a couple of stands that are specifically designed to hold reflectors, which we purchased at a photography store.

Using Natural Daylight Indoors

Because you usually can get the best shots if you direct and control the light so that it nicely illuminates the product you're photographing, taking great eBay pictures indoors using natural light often takes some imagination and ingenuity. To help us master natural light, we use reflectors and a variety of commercial and homemade blockers and diffusers.

For controlling the amount of sunlight streaking in our studio windows, we open or partially close our custom-made blackout curtains from Denny Manufacturing Company (www.dennymfg.com). To diffuse the light so that it spreads evenly and appealingly, we hang white cloth (a torn bed sheet or gauzy curtains) between the window and the object we're shooting.

Using Your Camera's Flash

Conventional wisdom preaches you should never, ever use your camera's flash to illuminate the items you're putting up on eBay. We suspect the reason for this common advice is because most shooters simply turn on their flash, point the camera and hope for the best. And generally, taking such a casual, cavalier approach translates into product shots that exhibit annoying glare, significant overexposure or distracting deep shadows.

Though we seldom use a camera's flash as our only light source, we often employ it to augment and enhance both natural and artificial light, usually with excellent results. It all depends on what you're photographing and how you set your flash.

Using flash outdoors

Shooting in daylight—especially backlit pictures in which the camera is pointed toward the sun—often creates strong, harsh shadows that obscure or eliminate details. You can soften or even eliminate those shadows by using a forced flash if the item you're shooting outdoors isn't as big as a truck or more than 15 feet away. Using a forced flash can also put life and sparkle into your product shots (**Figures 5.25 and 5.26**). To locate the forced flash setting on your camera, look for an icon that looks something like a lightning bolt (**Figure 5.27**). Don't confuse it with a similar icon that has an *A* next to a lightening bolt, which is the icon for auto-flash mode.

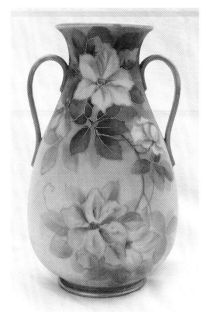

Figure 5.25 *This photo is dull because it was shot at midday when the sky was quite overcast.*

Figure 5.26 *By simply turning on the forced flash, we've created a sparkling lively photo taken at the same time and under the same conditions as Figure 5.25.*

Figure 5.27 *Your camera's icon for forced flash is probably a pictograph of a lighting bolt.*

Types of on-camera flashes

Depending on your camera, it will have one of two types of built-in flashes:

✦ A pop-up flash that either automatically deploys when you need extra light, or one that you lift open or press a button to activate (**Figure 5.28**).

✦ A fixed position flash that doesn't move or close, and is always ready to shoot (**Figure 5.29**).

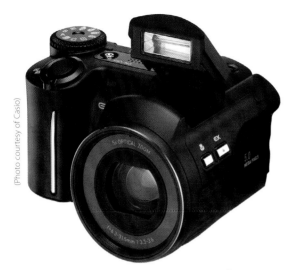

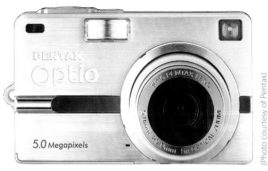

Figure 5.28 *Other cameras' flashes automatically pop up when you need extra light, or you manually open them when you need them, such as the one on this Casio Exilim EX-P505.*

Figure 5.29 *Some digital cameras have small, fixed-position flashes like the one on this Pentax Optio SV.*

With both types of units, you have to consider two things:

First, you can't swivel the head for bounce flash, so your illumination is straight and directional. This doesn't matter much when you're using the flash to supplement natural lighting and shooting at a distance of more than a foot. But as you draw closer, the distance between your lens and the flash, which is called the *parallax*, influences how much area the flash covers. The greater the parallax, the greater the chance that the flash may not entirely cover the item you're photographing up close. If you have an auxiliary flash with a swivel head, you can simply angle the flash tube so it bounces off a wall or ceiling. That helps avoid the parallax problem, while providing more diffuse and even illumination.

Second, as you move closer to your subject, the flash will usually put out the same light, eventually overexposing your photograph to the point where your item looks like a polar bear in a snowstorm at high noon. However, some cameras automatically adjust, or lower, the flash output to compensate for distance, even down to a couple of inches.

Check your user manual or do some tests using your flash for close-up photos to determine your camera's flash capabilities and limitations.

Auxiliary flash

Recognizing the limitations of a built-in flash, many advanced digital camera models are designed to use auxiliary flash units, or strobes (**Figure 5.30**). These connect to the camera either using a clip on top of the camera, called a *hot shoe*, or a pc connector (a small round port for plugging in a standard flash cord).

External strobes are generally much more powerful than built-in flashes, and they can be tweaked to produce just the right amount of light where you need it. Some have swivel heads, so that you can bounce the flash for indirect, rather than direct light, which helps minimize or eliminate unwanted harsh shadows.

Auxiliary strobes typically cost between $40 and $500, depending on whether it's a generic "dumb" flash or a sophisticated branded "intelligent" unit. The intelligent ones communicate directly with the camera's brains, so they can control the flash according to the exposure settings and the camera's sensor readings of the scene.

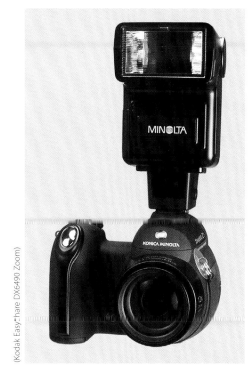

(Kodak Easy-Share DX6490 Zoom)

Figure 5.30 *An external, auxiliary flash attached to the hot shoe on top of a Konica Minolta DiMage Z3.*

Does your camera have flash compensation?

Many advanced consumer digital cameras have a menu option that lets you adjust the flash's intensity. It's usually called *flash compensation*, although it might be called *flash intensity* or some similar name on your camera. Flash compensation works almost exactly like exposure compensation (see Chapter 4). You use a positive setting to boost the amount of light, or a negative one to reduce the flash's light output. If your flash is putting out too much or not enough light, try adjusting the flash intensity until the histogram or the picture on playback looks good. One important caveat: If you use flash compensation, make certain you zero it out when you're finished, or else all future shots may be too bright or dark.

Slave Lights

Studio strobe lights are expensive and require some photographic skill to operate properly, so we don't recommend using them for your eBay auctions. But if you happen to like the strong, contrasty light and saturated colors that a flash produces, consider buying a couple of slave lights. A slave light is an electronic flash with a photoelectric eye, designed to automatically fire the instant it detects another flash going off. We sometimes use as many as four slave units for illuminating a light tent. More often, we use them to help illuminate a large item or room.

Generic slaves generally cost between $10 and $50 each and are available in two varieties: portable battery-powered units and screw-in light-bulb-style devices. You can attach them to light stands, or in the case of the screw-in slaves, install them in any handy floor or desk lamp. Some models even come with their own tabletop stands.

Here's how you use slave lights: Either directly aim them at the item you're photographing, or set up a silver or white photo umbrella and bounce the light. It takes a bit of trial and error (moving them closer or farther away) until you achieve the right balance and exposure. But once you've set them up correctly, you won't have to change the settings from shoot to shoot. If you're interested in acquiring a couple of slaves, go to eBay's Camera & Photo section and type in *slave flash* or *slave flash unit*.

Lighting Setups

Photographers often describe lighting setups by the number of fixtures used: one light, two lights, three lights and so forth. This applies regardless of the type of artificial lights you use, and the logic of deploying them works pretty much the same. (For a discussion of different types of lights, see Chapter 2, "Outfitting Your eBay Studio.")

Correctly placing and angling lights takes a bit of practice, but the thinking behind it is really quite simple. Each lamp projects a cone of illumination, which results in a circle of light on your product. The positioning of the lamp defines the following aspects of the light that falls on your product:

✦ Angle

✦ Intensity

✦ Quality

Rather than go into theory, let's look at what this means in practice. In **Figure 5.31** on the next page, we have a single light illuminating an antique bronze urn. It's really not enough light for such a large item (**Figure 5.32**). Later in this chapter, we'll discuss when a one-light setup will work, but for now, let's move on.

Adding a second light (**Figure 5.33**) on the other side helps improve the picture somewhat (**Figure 5.34**).

However, the left side lamp in Figure 5.33 is too far from the urn to illuminate it well. We lowered it, positioning it at approximately the same height and angle as the one on the right (**Figure 5.35**). In the resulting photo, the lighting on each of the two sides of the urn is better balanced with respect to the other side (**Figure 5.36**).

(Setup shots taken with a Nikon D70)

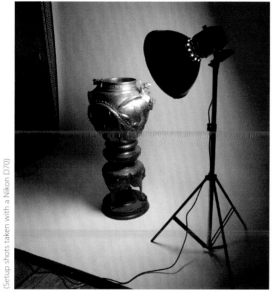

Figure 5.31 *A one-light setup.*

(Product shots— Fujifilm FinePix S5100)

Figure 5.32 *The circle of light projected by a one-light setup on this bronze urn illuminates a small portion of the urn, leaving the rest in shadow.*

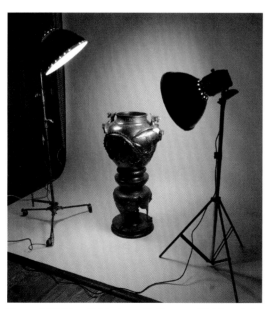

Figure 5.33 *A two-light setup, with the second light angled from a higher position.*

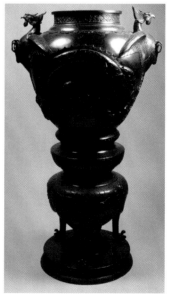

Figure 5.34 *Notice how the circle of light on the left of the urn is not as bright as that on the right. That's because the lamp on the right is closer than the one on the left.*

Okay, we now have the upper sides of the urn well lit, but the rest is still in shadow. So, let's add another light from the front. But this time we're going to place it much lower so that it angles upward (**Figures 5.37 and 5.38**).

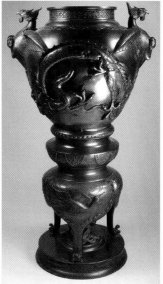

Figure 5.36 *With the second lamp closer, the circle of light on the left is brighter and better balanced to the other side.*

Figure 5.35 *A two-light setup with the second light closer to the urn than in Figure 5.33.*

Figure 5.38 *A properly deployed three-light setup provides a good level of illumination over the entire urn.*

Figure 5.37 *A three-light setup with all three lights angled differently, so the resulting circles of light on the urn cover it fully and attractively.*

One-light setup

Depending on what sort of products you sell and the type of light you use, a single light source might be sufficient. The key is to make sure the one light is soft and that the area it illuminates is much larger than the item you're photographing. A one-light setup we often use employs our small softbox (**Figure 5.39**).

Another type of one-light setup is to employ a large diffuser over a light positioned slightly to the side and above the item you're photographing. The diffuser should be as large or larger than the width of the item you're shooting, so that it illuminates everything without clipping the corners.

If you aren't using a diffuser, softbox or an equivalent, such as a homemade light tent made of white sheets, you'll get better results shooting against a black background, which helps absorb the shadows. But if you are using a white background, you should angle your single light so that the shadow is short and tapers off at the rear of the item.

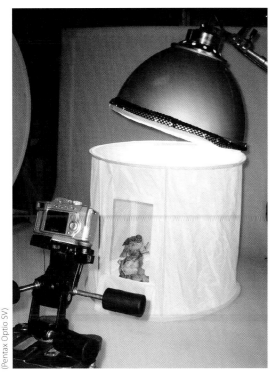

(Pentax Optio SV)

Figure 5.39 *In this one-light setup using our small softbox, the area that is illuminated is larger than the box's diameter and softly diffused by the box, surrounding the figurine with light.*

Two-light setup

Two lights are sufficient for many eBay photos. In photographic terms, a two-light setup comprises a main light and a sidelight.

Place your main light in front of, but slightly to the side of the item you are photographing. The other light should be off to the side. If you picture a clock positioned under the object you're shooting, with the 12 o'clock position located directly behind the item you're shooting, the main light should be at about the 5 o'clock position, and the sidelight should be between the half past 8 o'clock and 9 o'clock position (or the reverse, if the most important and interesting part of the item is on the left, rather than the right side). The height of the lights, as well as how close or far they should be positioned from the item, depends on how bright the lights are and how wide their beams spread. Just make sure the circles of light they project onto your product clearly and attractively illuminate the product.

The downside to using a two-light setup is the hard or harsh shadows it can produce. Distracting shadows that obscure details can be softened using a reflector

> **TIP**
>
> To soften shadows, put a little light in dark corners, minimize or eliminate unwanted reflections, and generally brighten whatever item you are shooting, position a white or silver reflector (or white sheet) directly opposite your primary light source. Reflectors are especially useful with one-light and two-light setups.

or by changing your camera or light angle so that not all the shadow is visible in the picture. Try experimenting a little by moving the lights closer or farther apart, lowering or elevating them, or placing them nearer or farther from the item being photographed (or a combination of all three).

Three-light setup

Three lights are better than two lights, anytime. Three lights can beautifully illuminate the item you're shooting, minimize or eliminate distracting shadows and give your eBay product shots more dimensionality without boosting the contrast too high.

To set up your three lights, we suggest that you apply some logic. Simply pay attention to where the circles of light are projected onto your product, where the shadows are falling and what areas of your item are bright or dark.

For instance, if you have a distracting shadow somewhere on or around your product, re-angle a light to soften it. If an area of your product isn't bright enough, lower, raise or otherwise reposition a light to cover it.

More than three lights

While a three-light setup usually works best for photographing most small-size to medium-size items sold on eBay, there are times when you may want to add one or two more lights. In fact, it may be necessary if you are shooting large objects, such as a sofa, highboy chest or a long bureau. Pulling your lights farther away so that you can illuminate the entire item may not work if your three-light setup doesn't pump out enough lumens (brightness), which is often the case with fluorescent bulbs. This is when adding a fourth or even fifth light fills the gap nicely.

In addition to illuminating all areas of your product, the extra lights may help you increase your *f*-stop setting, for expanded depth of field, as well as allowing you to shoot at a higher shutter speed. It also ensures that details will be lit properly and shadows will be eliminated or minimized.

There is, however, a caveat about adding more lights: You may actually end up with too much illumination. Too much light can make the item you're photographing appear flat and uninteresting, create multiple shadows or even introduce reflections of your lights. You'll want to be on the lookout for any pictures that lack contrast, have mirror-like reflections on shiny parts or display shadows falling in more than one direction. If that's the case (and you'll know it immediately when you view the image on your computer), either remove a light or lights, or move them farther away from the item.

TIP

To achieve maximum depth of field using aperture priority, set your digital camera at its highest *f*-stop. Then move your lights closer to the item you're photographing to increase the brightness, making certain that they're not so close that they fail to illuminate the entire item. Because the shutter speed automatically changes to compensate for the increased light, you won't have to worry about overexposure.

Shadowless shooting

Shadowless photography is a great way to isolate, enhance and emphasize whatever you're selling. Using this technique, the item seems to be floating above a white, colored or black background. There are no shadows, so the viewer sees only the object in your listing, with no context or anything extraneous to distract. Shadowless photography works especially well with jewelry, porcelain, glass, figurines, cameras, cell phones, dolls, shoes and other small items.

Creating a shadowless product picture is relatively easy to do, if you have a translucent shooting table or area. Position your two-light, three-light or four-light setup, and then put a light on or near the floor, pointing up, directly underneath the item being photographed (**Figures 5.40 through 5.42**).

Figure 5.40 *You don't need to go out and buy professional equipment to create a shadowless setup. For Figure 5.42, we used a glass-top table, a sheet of white paper clamped to our bookcase and three household lamps.*

Figure 5.41 *Shot with a basic two-light setup using household lamps, this photo has a definite shadow, which some people might consider distracting.*

Figure 5.42 *This photo of the same small bronze photographed with a typical shadowless setup is much crisper and cleaner.*

For the bottom light under our shooting table, we use a small light stand that rises to a maximum height of two feet. However, we also have improvised by salvaging a 15-inch pulley gear and bolting a one-foot high, half-inch diameter metal rod through its middle. Then we attach either a regular fluorescent or halogen light to it and shine it straight up under the table. Although the translucency of the shooting table helps diffuse the light, we avoid hotspots by adding a diffuser to the light as well.

If the light is too bright or the shadows don't disappear, it's possible that the bottom light may be too strong or is overpowered by the overhead lights. If this is the case, you can adjust the lighting by doing one or more of the following:

✦ Move your light stands farther away from or closer to the item.

✦ Swap the bottom light for a more powerful (or weaker) light source (such as substituting a halogen lamp for a fluorescent fixture).

✦ Set your camera's exposure compensation (EV) to negative or positive values (although, as we discussed in Chapter 4, we recommend always bracketing EV when shooting for eBay).

Make Your Own Shadowless Platform

You can quickly and easily make your own shadowless platform. Here's how:

1. Buy a sheet of glass or Plexiglas that is two-feet long by two-feet wide and a quarter-inch thick.

2. Carefully suspend it between the edges of two chairs.

3. Tape a sheet of white paper that is 2 x 4 feet to the top of one chair and drape it over the glass.

4. Place a light on the floor and shine it upward.

 Violá! An instant shadowless platform.

Shadowless pictures are even easier to shoot when your background is a solid dark color or black. That's because the dark colors absorb light and shadows like toweling paper soaks up water. You don't need to place a light underneath your shooting table—in fact, you don't need a translucent shooting table. But you do have to adjust the angles and distances of your lights so that no one source of illumination is so powerful that it throws a shadow on the object that can't be neutralized by the other lights or the background.

Improvised Lighting

Because we do photography professionally, we have a fairly extensive assortment of studio lights, stands and other accessories that we've purchased over the years. Some lights we've picked up for a proverbial song, and other systems have cost us mucho bucks. If you plan to seriously pursue eBay auctions, you'll probably find it more efficient and effective in the long run to buy some sort of professional lighting system. (See Chapter 2 for types of lights to consider.) But if you are still testing the waters, you might want to use whatever lights are at hand before you decide to spend money on a lighting system. You can still get great results (**Figures 5.43** and **5.44**).

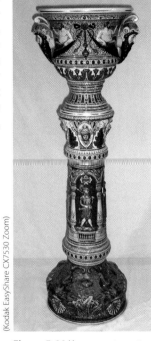

(Kodak EasyShare CX7530 Zoom)

Figure 5.44 *You can get great product photos using household lamps, as long as you pay attention to where the light is falling and what shadows are being created by it.*

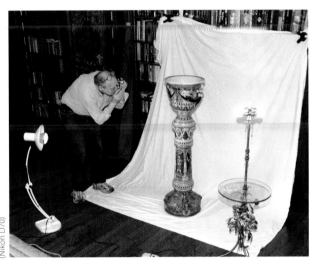

(Nikon D70)

Figure 5.43 *A two-light setup using lamps from Daniel's desk and our living room. If we had wanted to do shadowless photography, we could have put another lamp behind the draped sheet.*

As we have noted throughout the book, we sometimes improvise our lighting setups by employing desk lights, floor lamps, overhead chandeliers, bare bulbs, and other ordinary household lamps and hardware store reflector lamps. While it's a bit harder to position them than lights on a stand, we'll enlist tables, chairs, water pipes, shelves and so on as ad hoc stands. We create our own diffusers by draping white sheets or pillowcases over the lampshades or between the light and the item we're shooting.

As with other forms of lighting, set your camera's meter mode to spot. Because you may be mixing different light sources, such as incandescent light bulbs, tensor lamps, compact fluorescent bulbs and ambient daylight, auto white balance probably isn't going to get the color right. Nor will your camera's presets. If your camera has a manual white balance mode, which is explained earlier in this chapter, you'll get the best results by using this setting. But if the color is still slightly off (mixed lighting is devilishly difficult to get right, even for pros), we show you in Chapter 11 how to tweak it using color correction tools found in photo-editing software.

Photographing Jewelry and other Pocket-Size Products

At any given time, eBay has about 1 million pieces of jewelry and watches for sale. Add to that the fact that jewelry and other similarly small, detailed items are among the most difficult products to photograph, and it's no wonder one of the most frequent questions eBay sellers ask us is "How do you shoot jewelry?"

Some of the worst and the best photographs we've seen on eBay have been in the Jewelry section. Everyone seems to get it right occasionally, capturing clear, attractive, honest photos—sometimes in less than ideal situations (even with old, inadequate cameras and makeshift lights). Unfortunately, they aren't consistently good. And that's a problem. If you have to reshoot, spend too much time using photo-editing software, or post pictures on your auctions that won't attract as many bids as possible, then your efforts have been a waste of time and may cause you to lose income. Getting consistently great jewelry pictures isn't all that difficult if you set up properly, take care while shooting and follow through with the details.

A Matter of Degrees... and Profit

Remember to clean your jewelry, polish your silver and remove fingerprints, tarnish and dust, all of which can detract from the beauty of your items. While a piece might look nice to the naked eye, dirt becomes even more obvious in close-up photographs.

You can approach photographing jewelry (or any product, for that matter) in one of three ways:

✦ Snap away and hope for the best.

✦ Take the time to improvise a good setup and lighting when you need it.

✦ Have a permanent jewelry setup for production-level work.

The slapdash approach of just clicking the shutter button without much attention to composition, exposure, focus and lighting may work from time to time. But as you must realize by now, such an approach isn't a photographic method we recommend when you're serious about making money on eBay. Deciding which of the other two approaches will work for you boils down to such factors as sales volume, percentages and space.

If jewelry is only a small portion of your eBay business and you don't really have the room for a permanent setup, you'll probably end up improvising your shoots when you need them. On the other hand, if jewelry and other small products constitute a significant portion of your eBay profits, you'll want to make the space to create an efficient, effective permanent setup. It really won't take up that much space.

Gear and Settings

Whether jewelry and other small, detailed items are your entire focus or only a portion of your eBay sales, the same guidelines and suggestions will help you get great photographs:

✦ You need a better than average digital camera.

✦ Consistency and efficiency require taking control over your photography rather than letting the camera automatically choose your settings for you.

✦ The right lighting and backgrounds make a major difference.

✦ Thoughtful composition and framing are key to good product shots.

The right digital camera for small stuff

Jewelry and other small, detailed items usually require more sophisticated cameras than other types of eBay photographs, as we explained in Chapter 1, "Choosing Your Digital Camera." To produce consistently good photographs of such small stuff, your camera should have the following attributes:

✦ A tripod socket on the bottom, because the closer you get to an item, the more even the slightest motion can blur the picture (**Figure 6.1**)

✦ A self-timer to further improve the steadiness of your tripod photos

✦ Aperture priority to control depth of field, which helps ensure everything is sharp and in focus (see Chapter 4, "Exposure & Focus")

✦ A focusable macro lens, one that can shoot as close as a couple of inches

Other useful camera features include:

✦ White balance presets to help you capture accurate color; however, manual white balance is preferable (see Chapter 5, "Great Lighting the Easy Way")

✦ A histogram to help ensure your exposure is good (see Chapter 4)

<div style="writing-mode: vertical-lr">(Figures 6.1–6.3 taken with a Panasonic Lumix DMC-FZ3)</div>

Figure 6.1 *Use a tripod! In this photograph, the lens was only a couple of inches from the miniature. Even though Sally has steady hands, just the act of breathing can create this level of motion blur when you're shooting this close.*

Be sure to use spot metering and spot focus rather than matrix metering and focus for jewelry and other small items.

Remember, though, that just because you need a sophisticated camera that lets you take control of your photography, you don't have to spend lots of money on the newest models. A case in point is our Nikon Coolpix 990, which we used to photograph the items in Figures 6.14 and 6.15. It has all the tools and controls we recommend (except a histogram) and does a darn good job on jewelry. Other older cameras from the major manufacturers are similarly effective, as long as they give you the controls you need.

Good depth of field is critical

The closer your lens gets to a subject, the narrower your depth of field will be, as we explained in Chapter 4. Briefly, depth of field is the amount of the item from foreground to background that is in sharp focus. So when you are taking close-up, or macro, photos of small items, you'll want to use a high *f*-stop number (which translates to a small aperture), such as *f*8, *f*11 or *f*16. Keep in mind that many digital cameras' *f*-stops only go as high as *f*8, however.

To make it easier to control your *f*-stops, set your camera to aperture priority mode when photographing jewelry and other small items. However, keep in mind that when using this mode, as your *f*-stop number increases, your shutter speed decreases. This is what keeps your camera's exposure constant. Slower shutter speeds increase the likelihood of motion blur and less than truly sharp photographs (such as in Figure 6.1). That makes it even more imperative to use a tripod when taking macro photographs.

Capturing the sparkle

Good lighting is essential for jewelry and similar items—how else will your photos have the kind of sparkle that will capture a buyer's attention? We've gotten some excellent shots using ordinary household lamps, as explained in Chapter 5. But if you're doing production photography, you'll probably want to standardize on dedicated lights.

What's important is not the type of lights as much as their placement and strength. In addition to determining how well your photo is illuminated, the placement and strength of your lights define what kinds of reflections are created in your jewelry. You want highlights that add a touch of life to gemstones and metal without obscuring the details (**Figures 6.2 and 6.3**).

Figure 6.2 *Be careful that reflections from your lights don't obscure important details.*

Figure 6.3 *By carefully adjusting the angles of our lights, we eliminated the reflection completely. We also used a tripod and initiated the shot by activating the camera's self timer, to avoid motion blur.*

Eliminating unwanted reflections in small items is relatively easy:

+ Pay attention to what shadows and highlights your lights are creating.

+ Quickly check the preview of the photo you just shot in the camera's LCD monitor before moving onto the next one.

+ It usually takes only a slight adjustment of the lights' angles to eliminate unwanted highlights.

+ Use diffusers to soften the light and diffuse the highlights. (See Chapter 2, "Outfitting Your eBay Studio.")

+ Use a softbox to eliminate any glare and create a gentle ambient light that surrounds your item (**Figure 6.4**).

+ Screw a polarizer filter in front of your lens and slowly rotate it until the reflection is minimized or eliminated. Keep in mind that this type of filter will diminish *all* reflections and not just unwanted, obscuring highlights.

+ If you are taking frequent, production-level jewelry photographs, you might consider a dedicated jewelry shooting box (**Figure 6.5**). These are often marketed specifically to eBay sellers. Some include special software for better quality and efficiency. You can expect to pay anywhere from a few hundred to over a thousand dollars for a dedicated jewelry shooting box.

Figure 6.4 *This small softbox folds up flat for storage and can use any kind of lights (including household lamps) to create a soft, diffuse ambient light with no reflections.*

Figure 6.5 *Dedicated jewelry shooting boxes, such as this GemBox from MK Digital Direct (www.mkdigitaldirect.com) enclose your product within consistently soft, even light, which is just what's needed when photographing jewelry.*

Getting up close

For most jewelry setups, you should turn off your camera's built-in flash. Some digital cameras' flashes adjust by greatly reducing power when the camera is set to macro (or close-up) photography. However, most completely blow out, or overexpose, anything that is too close to the lens. Even those built-in flashes that reputedly can be used in close-ups should be used judiciously.

Not all digital cameras' macro capabilities are created equal. Some can focus as close as an inch, while others can get no closer than 10 inches. Check the macro capability of your digital camera (you'll find it in your camera manual) and be sure to shoot only within its specific range. Otherwise, you'll end up with a blurry, out-of-focus picture.

Incidentally, some digital cameras can focus continuously from infinity down to only inches. But most cameras have a macro button, switch, dial mode or menu option that must be activated before it can focus on close objects. If your camera is among the latter group, be sure to turn on the macro before trying to take close-up photos. The macro-mode control or command is usually designated by a flower icon (**Figure 6.6**).

Figure 6.6 *Macro-focusing mode is usually designated by a stylized flower that may or may not look like this Kodak icon.*

Backgrounds: to contrast or not to contrast?

A large percentage of the jewelry photographs on eBay are shot on seamless white or gray backgrounds (**Figure 6.7**). This is true even for professional-quality photos. Part of the reason for using such staid backgrounds has to do with the widespread use of softboxes (Figure 6.4) and dedicated light boxes (Figure 6.5). All of them have a white background, which sometimes turns grayish in certain photographic situations.

As a rule, we strongly recommend using a more traditional contrasting background, because it makes the item stand out rather than meld into the color behind it (**Figure 6.8**). That means using a pale background for dark items and using dark backgrounds for pale items. The human eye sees contrast as sharpness and clarity—contrast makes anything look more dynamic and appealing. This is particularly important with the small and often indistinct gallery pictures that are displayed next to the titles of your eBay auctions in the listing and search result pages. (See Chapter 12, "Posting your Photos on eBay" for more information on gallery photos.)

Figure 6.7 *Silver or pale items on a white or pale background can appear dull, even boring.*

Figure 6.8 *Put the same light-colored item on a dark background, and it appears sharper, more dynamic, and more likely to catch a buyer's eye.*

We have heard some people say that the more subtle, non-contrasting background is better because it's understated. While understated might be a good choice for personal attire in certain situations, when you are competing with hundreds of thousands of other eBay sellers for a buyer's attention, subtle can be counterproductive.

Before, After and How'd They Do That?

Theories about how product shots should be photographed are good and fine, but let's take a look at some typical eBay photographs to see what practical insights we can gain from them.

Figure 6.9 *We've seen lots of photos like this up on eBay. In this picture, the ring is a tiny thing, overwhelmed by the expanse of flesh and the deteriorating manicure.*

(This series—Olympus C-8080WZ)

Shaping your product

We've seen some really sloppy, devil-may-care photographs in the jewelry section. Many are out of focus, poorly composed, off-color and downright ugly. But it doesn't have to be that way. For instance, rings are often displayed on hands (**Figure 6.9**); we imagine the sellers must have thought, "What better way to display a ring than on a finger?" We can think of plenty of better ways.

Even if you rarely sell jewelry and similar small items, you'll still want to get top dollar for each piece. You don't need to spend any more time photographing these pieces than you would have spent taking unappealing photos of them. And you don't need to go out and buy jewelry forms and special lights. But you do need to invest some thought as to how each item will photograph best and be willing to improvise your setup occasionally, depending on the item. It took only about five minutes for us to set up and shoot the same ring in **Figure 6.10**, and it cost us nothing, because all the props are common items we found around our house.

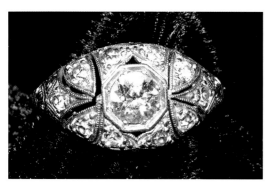

Figure 6.10 *This much more appealing photograph of the same diamond ring would certainly generate more bidding energy than Figure 6.9.*

Figures 6.11 and 6.12 show how we created the setup for Figure 6.10:

1. We found a wooden chopstick in a kitchen drawer, broke it in half and pushed it into an old piece of flower-arranging Styrofoam. Then we put a small computer toolkit under the Styrofoam to raise the entire assembly.

2. To provide a backdrop, we placed a canister of nuts several inches behind the Styrofoam. (Without this rise under the cloth, you would see the wood of our dining table in the background of the picture.)

3. We draped a small piece of black velvet over the entire assembly.

4. We used a flexible-arm desk lamp to direct light onto the ring. (We also had the on-camera flash deployed to add a bit of extra sparkle, because the Olympus C-8080 WZ does a good job of adjusting the strobe's power for close-ups.)

5. We made sure to mount our camera on a tripod, using aperture priority mode and double-checking our focus, macro range and composition.

Figure 6.11

Figure 6.12

Using things like a jar of nuts is a great way to improvise your setup without spending a lot of money. We often employ a host of objects from our kitchen or our office underneath draped cloths, such as the following:

✦ An inverted bowl works nicely as a platform for bracelets and necklaces (**Figure 6.13**). Choose the size of the bowl based on the size of the item so that a bracelet or necklace, for instance, curves naturally around it.

✦ An inverted plate creates a nicely angled platform for pins and flat miniatures. But with some objects, an inverted cup provides a better angle.

✦ Books stacked in a staircase effect create a series of graduated platforms that are useful for sets of things when you want some of the items raised higher than others.

Here's how we got the photo of the rhinestone necklace (Figure 6.13):

1. We made sure that the black backdrop covered not only the inverted cereal bowl but also rose up in the background, to avoid any distracting elements behind it. (If you don't have a shooting table, use something tall under the cloth, as we did for the ring in Figure 6.11. A box would work well, as would clamping the cloth to a shelf behind your table or desk.)

2. The camera was on a steady tripod.

3. Our camera settings were the following (See Chapter 4):

✦ Aperture priority, using an *f*-stop of *f*9.1, so the depth of field would keep the entire necklace is focus.

✦ Spot focus, making sure we were focusing on the stone settings of the drop in the front of the necklace.

✦ The flash was turned off.

✦ Auto-Bracketing mode to quickly shoot several photos at incremental exposure settings, which is an easy way to ensure at least one picture will be perfectly exposed.

(Nikon Coolpix 990)

Figure 6.13 *A small cereal bowl was the perfect size to angle this vintage necklace naturally.*

4. We positioned three lights with diffuser bonnets rather close to the necklace, including one overhead on a boom stand, so that the back of the necklace was well lit. We also placed a white reflector to one side to put some subtle light into the shadows (**Figure 6.14**). (See Chapters 2 and 5 for more on studio equipment and lighting.)

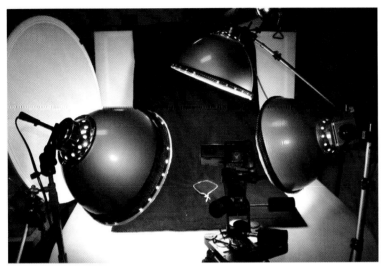

Figure 6.14 *Though we used studio lights and a professional reflector to photograph Figure 6.13, you can easily emulate it using clamp-on lights (with diffuser bonnets) and a white bedsheet or pillowcase.*

5. We also turned the necklace around to take a picture of the clasp and show potential buyers how the stones continue around the back of necklace. If the item you're selling has any maker's markings on the clasp or elsewhere, make sure you get a photograph of that, too. We discuss an easy solution for getting this kind of difficult shot (using a flatbed scanner) later in this chapter.

6. Using Photoshop Elements photo-editing software, we used a very slight touch of Unsharp Mask to give the photo an extra edge of crispness. Then we cropped the photo to make the necklace fill the entire picture. (See Chapter 11, "Photo-Editing Techniques that Make Pictures Zing, for more information.)

Using professional shapes and forms

The jewelry industry supports quite a healthy market in display forms and shapes, some of which you can buy rather inexpensively. These include necklace stands, ring and earring displays and many others. In **Figure 6.15**, we used a stand that came with a watch that we held onto even after the watch disappeared. We've seen all kinds of great displays selling very cheaply at yard sales and flea markets. Of course, they're for sale on eBay, too (search on "Jewelry Display").

(Canon EOS Digital Rebel)

Figure 6.15 *We held onto this watch stand long after the watch was gone. Whenever we photograph products using our displays, we make sure to mention in our eBay auction page that the display piece is not part of the sale.*

Using a scanner for really close details

Three of the more difficult things to photograph are the maker's marks, inscriptions and embossed decorations on metal. But why use a camera, when a flatbed scanner can do a good job much more quickly (**Figures 6.16 and 6.17**)?

We cover how to use a scanner in detail in Chapter 9, "Dealing with Flat or Nearly Flat Items," but here are some hints for using one with jewelry and other small-detailed items:

+ When selecting a flatbed scanner to use for eBay auctions, be sure the hinge on the cover isn't fixed, but is adjustable or even removable. This lets you easily close the lid around small three-dimensional items like watches.

+ If the item is too tall and the cover won't close, drape a dark, light-safe cloth over the scanner (after putting your item onto the glass platen). That keeps out any of the room's ambient light, which could adversely affect scan quality.

+ Make sure the scanner's glass platen is clean. Tiny flecks of dust on the glass can look like large imperfections on your items for sale.

+ In Figure 6.17, we used a piece of black felt over the watch (between the watch and the scanner lid) to give us a black background.

+ If you are trying to capture and show small details, set the scanner interface to scale up (magnify) that small portion to produce a larger image (**Figure 6.18**).

Figure 6.16

Figure 6.17

Getting good, clear, close-up photos of information or decorations embossed or inscribed into metal can be quite difficult. Yet, these pictures took us only two or three minutes to capture using an Epson Perfection 3200 Photo scanner.

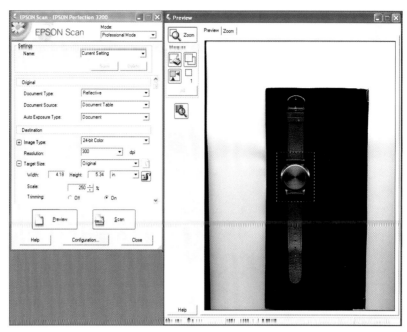

Figure 6.18 *Using the Epson's scanner driver, we cropped closely to the back of the watch and set the scale to 250%, which gave us the results you see in Figure 6.17.*

Scanners can do a great job with a variety of small items, such as pins, charms, flat bracelets, silverware and even silver hallmarks (**Figure 6.19**). However, we have had some difficulty with spoons and other objects that have deep bowls where the scanner's light sometimes can't reach. That's when we go back to using a digital camera to get the picture.

(Nikon Coolpix 990)

Figure 6.19 *Rather than fussing with trying to obtain perfect focus, exposure and macro (close-up) range, as well as putting the camera on a tripod, we used our Epson scanner to quickly and easily create a photo of this small cameo.*

Shooting Items that Fit on a Tabletop

Most of the items that we sell on eBay are of a certain size—those that are easy to pack and ship, as well as lift, move and arrange for photographing on a table. When you think about it, such a category comprises an incredibly wide range of products, from silver teapots to computers, musical instruments to carpentry tools, dolls to showerheads, and thousands of other things. Not surprisingly, small-size to medium-size products constitute the majority of the millions of items up for sale on eBay at any one time.

In this chapter, we'll show you how to photograph all kinds of tabletop products quickly, easily, and in such a way that they attract and encourage vigorous bidding.

Gear and Settings

TIP

Turn on electrical and electronic devices before photographing them to show LED indicators, screen displays and so forth. Not only will it reassure potential buyers that they work, but the picture will capture the excitement of the product in its full glory.

The large diversity of small-size to medium-size items in this category doesn't mean that getting good photographs of them involves applying different photographic techniques. In fact, tabletop-size items have a lot in common. The following guidelines apply to the entire range of products in this general category:

✦ Define and dedicate a specific tabletop area where you will do all your eBay photography.

✦ Choose and arrange your background carefully, being aware of how it affects your picture.

✦ Light your object thoughtfully, taking note of how highlights and shadows affect your photo (see Chapter 5, "Great Lighting the Easy Way").

✦ Use a digital camera that lets you control depth of field and ensure your focus and exposure are correct (see Chapter 4, "Exposure and Focus").

Of course, some items, such as mirrors or objects with tiny details, may require extra photographs or an alteration in your setup. We go into the specifics of photographing particular types of objects later in this chapter.

Do you really need a tabletop setup?

The easiest way to shoot small-size to medium-size products is on a tabletop. That's where they fit, and raising them up to table height makes it very convenient and comfortable for the photographer. Of course, you can shoot some products just as easily by putting them on the ground. For instance, eBay seller Bill O'Malley took photographs of a pair of very collectible chrome Roma art deco sconces on the ground outside his apartment building (**Figures 7.1 and 7.2**). He knew enough to put down some pieces of carpeting to create a more appealing background than the asphalt of the driveway. "It came out a bit scruffy," he explained, "but some thoughtful background is better than no background."

However, Bill realized his photo didn't show off the sconces as well as it could. He decided to connect them to an outside electrical outlet, feeding the wires through holes in the carpet, so they wouldn't be visible. In addition, he contorted into a sort of bending, squatting position to capture a much more appealing angle that actually makes them look as though they are on a wall, where they belong (**Figure 7.3**).

While Bill's final photo isn't the best it could be, it does a good job of capturing the imagination and details of the lamps. And the proof is in the closing bid: Bill's sconces sold to a satisfied collector for several hundred dollars more than Bill had

(Canon EOS Digital Rebel)

Figure 7.1 *Bill O'Malley used the driveway outside his apartment building to photograph a pair of chrome Roma art deco light fixtures.*

Figure 7.2 *Shooting from just above the sconces produced this rather flat, boring photo, and, as Bill noted, the carpet isn't in the greatest condition, but it's far better than asphalt. Notice, also, the lines that look like scratches in the left lamp. They're reflections of overhead trees.*

(Olympus D-360)

Figure 7.3 *This is a much better camera angle than the one used for the photo in Figure 7.2. Notice how the sconces are lit up—a great touch that really captures a sense of romance and makes the picture work.*

been told to expect. So, yes, it is feasible to take photographs of products for eBay without a tabletop setup. However, Bill could have taken the same (or even better) photo more comfortably, with less bending and twisting, and with no concern for weather or traffic, if he had used one of the tables in his apartment with a piece of cloth or paper for a backdrop, which would have been neater and more attractive than the carpet remnants. (By the way, we discuss how to use software tools to remove imperfections, such as stains and loose threads in carpet, using software clone tools in Chapter 11, "Photo-Editing Techniques that Make Pictures Zing.")

TIP

If your table isn't very high, and you have to crouch to get a good camera angle, consider putting forms underneath to raise your product higher. Just be sure the background is higher still.

The right tabletop

You'll want to dedicate a specific place in your home, office or shop for your eBay photography, as we discussed in Chapter 2, "Outfitting Your eBay Studio." Even if it is a space that you dismantle between shoots, having the area designated and well organized will help increase your efficiency and productivity.

We showed you in Chapter 2 how even a washing machine can be used as a tabletop. But even more convenient for many people, is a simple folding table (**Figure 7.4**).

(Hewlett-Packard Photosmart 945)

Figure 7.4 *This card table setup will fit in even the smallest apartment.*

However, like most other serious eBayer sellers, we have found that creating and maintaining a permanent, always-ready shooting table has increased our productivity tremendously (**Figure 7.5**). It's a great convenience and a time-saver, if you have the space for it.

In fact, we have organized our shooting table for maximum efficiency in the following manner:

✦ We keep several background cloths draped on the back edge of the table, out of sight of the camera lens, but readily at hand.

✦ We store several shapes and platforms under the table.

✦ Our lights are already deployed.

✦ We even keep an extra pair of eyeglasses at the table.

All we have to do is select the background, arrange the product on the table (using whatever platforms or shapes are appropriate), angle the lights and take the picture. With a permanent setup, it takes us only about three-to-five minutes between deciding to take a picture and actually shooting it.

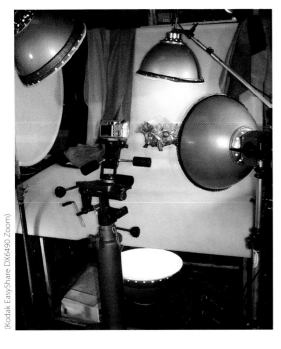

(Kodak EasyShare DX6490 Zoom)

Figure 7.5 *Whenever we want to take a product shot, we don't have to set up anything or go searching for our lights. It's all right there, ready for us.*

Setting the background

As we have mentioned previously, you'll want your background cloth or paper to contrast but not clash with your product. (See Chapter 3, "Creating Great eBay Photos," for a discussion of choosing the right background.) When working with tabletop setups, you'll likely have an even wider variety of cloths around, because, in most cases, you won't need very large piece. We often use solid color scarves or household linens.

You'll want to be careful how you use the background, however. Whether you have a shooting table similar to the one in Figure 7.5 or use some other surface to set up your eBay photos, make certain the background cloth or paper rises up behind your product. Otherwise, you'll have a greater likelihood of producing what we call "creeping background," in which all kinds of distracting elements find their way into your picture (see **Figure 7.6** on the next page). To avoid this, you can clamp the cloth or paper onto a shelf (Figure 7.4) or drape it over something taller than the product (**Figure 7.7**). This simple precaution will quickly and easily eliminate the problem (**Figure 7.8**).

Figure 7.6 *If your background cloth or paper doesn't rise up behind your product, you can end up with distracting and unattractive elements in your background.*

Figure 7.7 *"Creeping backgrounds" can be avoided by putting a box or any tall item behind your product, under your background cloth or paper.*

Figure 7.8 *The best photo for eBay will have nothing in it other than your product on a solid background.*

Camera settings

Because the majority of the items we sell on eBay are ones we can photograph on our tabletop setup, we have been able to develop something of an assembly line method for our photography. This includes always having our digital camera ready for product photography, with the following features turned on:

✦ Aperture priority, with the *f*-stop set at a high number, such as *f*8, to ensure a good depth of field (see Chapter 4)

✦ Spot meter and spot focus to ensure the camera is taking its readings from the object being photographed and not the background (see Chapter 4)

✦ Manual white balance, based on our typical light setup (see Chapter 5)

✦ Exposure compensation (EV) auto bracketing, which automatically takes three shots of each composition at slightly varied exposure settings, to guarantee that at least one photo will have the right exposure.

Many digital cameras have the ability to save two or more custom "user defaults" or "user profiles," so we make sure one of our custom defaults covers our typical tabletop setups. That way, when we are ready to shoot, all we have to do is press a button, glance quickly at the camera's control panel to confirm the correct settings were invoked, and then shoot away.

In addition, we try to increase our efficiency by photographing a series of items that would require the same background and lighting at the same time.

Before, After and How'd They Do That?

Tabletop photography is compact and tends to be easy to manage once you have everything organized. However, we have encountered a number of challenges (and developed various workarounds) with certain kinds of products.

Glass: photographing the near invisible

After jewelry, clear glass items can be among the most difficult types of products to photograph. It's the nature of glass to be nearly invisible and ethereal—a wisp of design that surrounds and displays something else, such as wine, fruit or flowers. So how do you photograph the nearly invisible?

TIP

When we're photographing glass, or anything else that needs to sparkle and is waterproof, we keep a spray bottle of Windex and some clean lint-free cloths on hand. Often, we won't see those annoyingly stubborn dirty spots until we have the lights streaming onto the item.

Figure 7.9 *This glass pitcher practically disappears into the background in this photo.*

A large percentage of photos on eBay are shot with glass on a white or very pale background.

The photo in **Figures 7.9** is indistinct and boring. The only noteworthy aspect about it is that it clearly conveys the pitcher is quite dirty … or are those flecks and rings permanent imperfections in the glass? Potential buyers will doubt the quality and condition of your product if it is dirty.

Photographs of glass are defined by highlights reflecting on surfaces and edges. In other words, white light is the most important aspect of the picture. Since a contrasting background is usually the best choice for an eBay product shot, we chose a black background for our glass pitcher. Black provides the strongest contrast to white, even if the white is as insubstantial as reflected light (**Figures 7.10 and 7.11**).

Figure 7.10

Putting the glass pitcher on black provides a good contrasting background. However, with this three-light setup, the highlight reflections on the pitcher are too large.

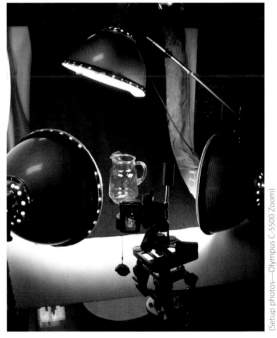

Figure 7.11

While Figure 7.10 shows off the glass pitcher better than Figure 7.9, the reflections of light are large and obscure the details of the pattern in the glass. Changing the angle of the two sidelights produces a photograph in which the highlights provide better definition of the pitcher without overpowering it (**Figures 7.12 and 7.13**).

Professional or simply savvy photographers use softboxes to control reflections and overpowering highlights (**Figures 7.14 and 7.15**), as we've mentioned before. Of course, you can create your own, tenting a white sheet around your product. But softboxes are rather inexpensive, fold up into small flat holders, and are easier to deploy with little hassle.

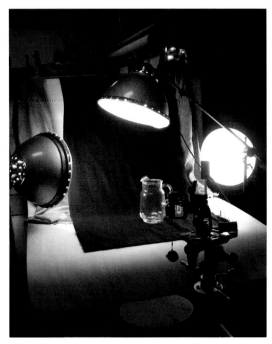

Figure 7.12

We moved the right sidelight so that it backlights the pitcher and the left sidelight so that it shines onto the black background and reflects a subtle highlight onto the pitcher. These adjustments eliminated the large blocky highlights visible in Figure 7.10, while accentuating the edges of the glass.

Figure 7.13

Figure 7.14

Two lights shining through the sides of this softbox produce great soft highlights on the glass. This model of softbox has a slot in the back that makes it very easy to drape a background cloth.

Figure 7.15

Getting the details

When photographing anything for eBay, you'll want to take a series of pictures, so potential buyers can see all sides and aspects. For the glass pitcher (Figures 7.10 through 7.15), two details that buyers will want to see are the top and bottom of the object.

It was simple enough to shoot the top of the pitcher (**Figure 7.16**). However, any time you are taking a similar close-up photo, be sure to remember the following:

✦ Get your lens no closer than the macro (close-up) range of your camera. (Check your camera user manual to find out just how close it can focus.) If that means you have excess background, you can always cut it away, or crop the photo, using photo-editing software. We show you how in Chapter 11.

✦ When you take close-ups, it's important to use a high *f*-stop (small aperture) to assure a good depth of field (deep area of focus), as we explained in Chapter 6, "Photographing Jewelry and Other Pocket-Size Products."

Buyers most likely would also want to see another angle of the pitcher for more information about the shape of the spout. And they would want to see the bottom, which can require some ingenuity in bracing the pitcher (**Figures 7.17 and 7.18**).

Years ago, we purchased a group of Plexiglas platforms of different sizes from a display store. They have proven to be invaluable aids for our product photography. Not only do they raise items up, but when items are positioned upside down like the pitcher in Figure 7.18, they are great for keeping things in place, especially with round items that tend to roll.

Figure 7.16 *This close-up of the top of the glass pitcher was taken with a single overhead light on a boom light stand.*

Figure 7.17 *Buyers always want to see the bottom of glassware, porcelain and other items. This view often provides added information about which manufacturer made it and how it was made.*

Figure 7.18 *Bracing the pitcher so that the bottom is angled toward the camera on its tripod makes it easier, more convenient and more comfortable to shoot a close-up of the bottom.*

Photographing silver, mirrors and other reflective objects

Besides controlling where lights will create highlights on your products, you can and should control other kinds of reflections on anything shiny, such as silver, mirrors or other reflective items (**Figure 7.19**).

You know what you don't want to be reflected—any shape or light that would detract from your product. So the next step is to decide what you do want. We often use reflectors made of large pieces of white cardboard, or cardboard covered with aluminum foil, depending on the item being photographed. Place your reflectors or white boards at the point where the angle from the reflector to your product equals the angle of your camera to the product (see the sidebar).

You don't have to have a protractor to measure angles. It's rather easy to approximate an angle, and then position the reflective surface until you see what you want when you look at the digital camera's LCD screen. However, you don't want the angle of reflection to be too severe, or the photo will distort the product's proportions.

In some setups, we use one of our softboxes to surround the object (**Figures 7.20 and 7.21**).

However, most reflective surfaces aren't flat like our copper tray. And curved items, such as the silver chafing dish in **Figure 7.22**, compound the problem by reflecting everything around them.

(Nikon Coolpix 990)

Figure 7.19 *Be careful when photographing shiny, reflective items. You could be capturing more than you intend, which will make your product less than appealing.*

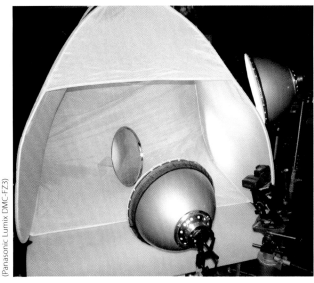

(Panasonic Lumix DMC-FZ3)

Figure 7.20

Figure 7.21

Notice how we have our camera very close to the side of the softbox. When we tilted the copper tray to reflect the side of the softbox, the angle wasn't great, and the photo of the round tray wasn't distorted into a lopsided oval.

We keep on hand pieces of cardboard covered with aluminum foil, specifically for such photographic problems as the unappealing reflections in Figure 7.22. Putting our homemade reflectors at an angle on plate easels very close to each other (leaving only a small space for our camera lens) eliminates the ugly reflections (**Figures 7.23 and 7.24**).

With some silver items, it may be necessary to create something of a tent over the item to avoid having the ceiling lights, fan and whatever else is above from being reflected in the lid. You can often avoid the need for a tent if your photo lights are strong and your ceiling lights are turned off.

Another solution is to use a softbox that has flaps with small holes just large enough for the camera lens to peek inside and take the photo. With such a setup, the only things that could possibly be reflected onto the surface would be the sides of the softbox, any background cloth you put inside, and a small camera lens. For more help in predicting and controlling reflections, see "Predicting Reflections" in the Appendix.

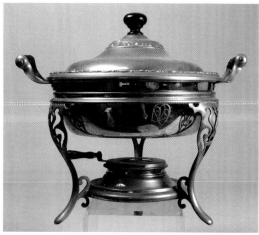

Figure 7.22 *Notice the yellow chair, red cloth, and even our bottle of glass cleaner reflected in this silver chafing dish—all distracting elements that take away from the appeal it might have for potential buyers.*

Figure 7.23

Figure 7.24

If you look closely at the photo of the chafing dish, you can see the tiny image of our camera. However, all the other reflections look like normal silver and light, because the aluminum foil reflectors block out everything else.

(This series—Fujifilm FinePix S5100)

Figure 7.25 *While this is a good product photograph, buyers won't bid up a doll unless they can see more pictures, which provide more detailed information.*

Dolls, figurines and similar products

Phoebe Sharp, an eBay trading assistant (eBay ID: carnabyauctions), says that doll buyers are among the most particular of her customers. "They want lots and lots of pictures, from every angle," Phoebe told us. We've found the same to be true among buyers of figurines, collectible porcelain, handmade pottery and anything else in which slight differences in manufacture or wear can drastically alter the value of the item.

The problem is that getting all the details can require a variety of photographic techniques. The first shot you need is a basic picture, like the one in **Figure 7.25**, which is a relatively standard product shot. All you need do is choose the right background, angle the lights properly and make sure your camera's settings are correct. The inexpensive doll stand (readily available on eBay) does make it easier to get the picture, however.

Various other views (**Figures 7.26 and 7.27**) can be taken under the same conditions, with slight adjustments to the doll.

Buyers want to see details, too, such as the close-up view of our doll's feet, with her shoe soles missing (**Figure 7.28**).

Figure 7.28 *Doll buyers want to see details, like the missing soles of our doll's shoes. The close-up also provides clear visual information about how she was stitched.*

Figure 7.26

Figure 7.27

If you can't get close, fake it

We have discussed how to get good close-up photos using a camera's macro capability and aperture priority to assure a good depth of field (see "Glass: photographing the near invisible," earlier in this chapter, as well as Chapter 6). Problems arise, though, if your camera's macro isn't rated for really close-up shots. Remember, if you try to take pictures by putting your lens closer to the object than your camera's stated macro range, you'll end up with blurry, out-of-focus photos that provide no information to buyers. In fact, such bad pictures can impact negatively on the final auction price.

Don't worry, we've developed two simple workarounds for getting close-up photos when your camera can't:

✦ Cut a detail portion out of a larger photo.

✦ Use a flatbed scanner.

Any digital camera that has the features you need for good eBay photography also will produce picture files that are simply too large for eBay. We show you in Chapter 12 how to resize or shrink your photos for optimum speed and quality on your eBay page. What that means is if you take a typical full-size photo (**Figure 7.29**), you can end up with a large enough, detailed photo that you'll be able to crop, or cut, and shrink for eBay, like **Figure 7.30**. (We also show you how to crop a photo in Chapter 11.)

Figure 7.29 *This photo reflects a good camera angle, but at its native image size, it is too big for posting on eBay.*

Figure 7.30 *Before resizing the picture in your photo-editing software to make it appropriate for putting up on eBay, crop the head profile. That will give you lots more detail of a smaller portion to include on your sale page.*

However, if your digital camera can't get close enough to the tiny paper label on this doll's wrist, cropping into it simply won't give you enough detail. (This is true for any tiny details, including small hallmarks on silver or maker's marks on porcelain.) That's when we're glad we have a flatbed scanner, so we can get clear, in focus, large enough pictures like the ones in **Figures 7.31 and 7.32**.

(Scanned photos—Epson Perfection 3200 Photo scanner)

Figure 7.31 **Figure 7.32**

It was much easier to get these photos of both sides of the doll's label using a flatbed scanner than it would have been using a digital camera.

However, be more careful than we were. We accidentally tore the label when we were arranging the doll on the flatbed's glass platen. By the way, while we had her on the scanner, we did a quick close-up scan of her face. The results were quite remarkable and pleasing (**Figure 7.33**).

Figure 7.33 *This scan of our doll's face provides clear, sharp close-up details that would excite a buyer, providing important information about how she was made and her condition. This is the kind of photo that generates higher and more energetic bids.*

In Chapter 9, "Dealing with Flat or Nearly Flat Items," we'll go into detail about how to use a flatbed scanner for items that aren't truly flat, such as this doll.

Cameras, cell phones, vintage radios, stereo components

The same techniques we've shown you for photographing a doll work well for just about any tabletop shoot, including product shots of cameras, cell phones, vintage radios and other electrical or electronic equipment. However, you usually won't need as many pictures for items that have known brand names and model numbers. Folks shopping for this kind of product pretty much know what they want and what it looks like.

A good series of photographs of most electronic or electrical items for an eBay sale are usually limited to the following:

✦ One overall photograph that captures the essence of the item, preferably turned on if it has a display or lights (**Figure 7.34**)

✦ A close-up photo of any label that has the manufacturer's name, model and serial number (see **Figure 7.35** on the next page)

✦ Close-up photos of any connectors, ports, outlets or controls (**Figure 7.36**)

✦ Detail shots of any noteworthy craftsmanship or anything else that might set it apart

✦ Detail shots of imperfections, such as areas of wear, including brassing (places where the underlying metal shows through a worn finish) and cracks

TIP

Many electronic items, and especially things like stereo equipment, are black, making it difficult to photograph their details. You may need to add more lights to your setup, bring your lights in closer, and/or use a positive exposure compensation (EV) to get a good photo (see Chapters 4 and 5).

TIP

If you need to take a picture through plastic or cellophane, use some of the techniques we wrote about earlier in this chapter for taking photos of glass and other reflective surfaces. Or, try using a flatbed scanner to get the photo. You might also want to experiment with using a polarizing filter on your camera lens—polarizing filters are designed to reduce glare and reflections that a camera captures.

(Olympus C-8080 Zoom)

Figure 7.34 *Leica cameras are so desirable (and the company's models, lenses, accessories and serial numbers are so well known) that a single photo will often say enough to get high bids. However, we would still recommend adding some detail photos to add to the excitement of the auction and get collectors' juices and bidding flowing.*

Dealing with packaged items

TIP

For brand-new products, add a link on your auction page to the page on the manufacturer's Web site that describes and includes photos of the product.

Whether you are photographing a collectible in its original packaging or a brand new item still in the box, taking it out to shoot it may lower its value if you destroy the package. For new items, the solution is pretty straightforward. For instance, if the packaging is informative, as it was for an ice cream maker we sold, then simply take photos of the box (**Figures 7.37 and 7.38**).

The one thing that is considered quite unethical is to post someone else's photos of a product—unless you get the photographer's permission. And, even then, be sure to note on your eBay auction page that the photo isn't of the actual item you're selling and that there may be slight differences between what viewers see in the photo and the item you're selling.

However, if it isn't a brand new item, but a collectible, then the problem becomes much more complicated. Unfortunately, since there are as many different kinds of packages and collectibles as there are collectors, it is difficult for us to give you general guidelines on what to do. We never recommend destroying the packaging when the box, paper, cellophane or other material is part of the intrinsic value of the item. But somehow, you'll need to provide some sort of picture of the item on your auction page.

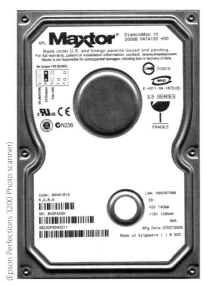

(Epson Perfections 3200 Photo scanner)

Figure 7.35 *Bidders like seeing the actual labels on electronics, such as this one on a Maxtor computer hard drive.*

(Casio Exilim EX-P505)

Figure 7.36 *For some electronic and electrical equipment, having a photograph of the back with all the ports and connectors is more important than a picture of the front.*

Figure 7.37

Figure 7.38

The buyer of this brand new ice cream maker was quite satisfied to learn about it from pictures of the box. But, then, this box was very informative, with good pictures of the item itself.

Shaping soft stuff

We use a variety of household items and professional displays to prop up our products, keep them in place or make sure they maintain their natural shape when we photograph them, as we discussed in Chapter 6. Hats and other head-dresses are an important case in point, in that buyers want to see them as they would look on a head. If you don't have a head shape or a mannequin, try using an inverted bowl (see **Figure 7.39** on the next page).

Figure 7.39 *This Boy Scout Indian headdress would have been nearly impossible to photograph nicely if we hadn't put it on an inverted mixing bowl, which we then placed on a Plexiglas stand. If you look closely, you can see the edge of the bowl peaking out.*

(Olympus C-808 Wide Zoom)

Similarly, we try to display items as they will appear in actual use. For instance, photographing a pillowcase with a pillow inside it captures the feeling of what it would look like on the buyer's bed. However, the flat photograph without the pillow represents what is actually for sale. That's why the buyer would like to see both photographs on the auction page, as well as a view of the back, too (**Figures 7.40 and 7.41**).

When we photograph pillow-cases, we put pillows inside for at least one of the auction photos, but we also show what it looks like without the pillow.

Figure 7.40

Figure 7.41

(Konica Minolta DiMage Z3)

If you have anything in your photos that is not part of the sale, such as a pillow inside a pillowcase or a head shape holding a hat, be sure to note in your auction description exactly what is and isn't part of the sale.

Photographing other items that fit on a tabletop

As we noted in the beginning of this chapter, the kinds of products you can shoot on a tabletop are so varied that it's impossible to cover every single type. But hopefully you get the idea—all the techniques and tips we've shown you can be applied to just about everything, from handbags to power drills.

Getting Great Photos of the Big Stuff

So far, we've expounded at length about the many advantages of using shooting tables, softboxes, ad-hoc setups and other devices and schemes to provide a stable platform for shooting the stuff you're selling on eBay. That's good and fine for small-size to medium-size items that you can easily place on a table. But what about those eminently salable, but devilishly inconvenient items that are too large, bulky or heavy to lift onto a shooting table? You know, things like furniture, clothing, major appliances, office and industrial equipment, cars, trucks and houses. (We've even heard of an entire village that was sold on eBay!)

This chapter will help you determine how to angle, illuminate, isolate and photograph large items. Fortunately, most of the photographic concerns, such as exposure, white balance, framing and focus, are the same, no matter what the size or shape of the item you're shooting. But environmental challenges and lighting issues can be different.

Gear and Settings

The same digital camera you use for your tabletop setups (as well as shooting family outings and parties) will work fine for photographing medium-size and large-size objects. However, we strongly suggest that your camera should be equipped with an optical zoom lens. Why do we recommend one when we've previously discouraged the use of zoom lenses for most eBay photography? Simple. Because you'll be shooting stuff that may not permit you to position them precisely where you want, or to move closer or farther away to frame your photo so that it includes everything you want in it. Using a zoom lens may be the only practical way to capture the item you're selling in a single photograph. We also discuss in this chapter other ways to expand or adjust the coverage of the item you're shooting.

As we have advised in shooting other eBay items, the best settings for your digital camera include:

✦ Aperture priority

✦ Spot focus

✦ Spot metering, or center-weighted metering for really big items and daylight shots

✦ Auto white balance, or manual white balance in mixed lighting situations

✦ Forced flash, or for shooting big or distant items, flash off

Auto white balance is a default setting on most digital cameras. However, you will probably have to go into your camera's menus or press a couple of buttons to select other settings. If you haven't already figured out how, take a few minutes to read your camera's user manual regarding these specific settings (and see Chapters 4 and 5 for more guidance).

The lighting setup you use for shooting smaller items may or may not be suitable for capturing medium-size objects, and almost certainly will be useless for shooting big stuff. So, for medium-size items, be prepared to throw an additional light into the mix, or set a wider beam for the lights you have. Often it's just a matter of repositioning your lights further away from the subject, or bouncing the lights off the walls or the ceiling to get them to cover more area. We discuss in this chapter some lighting solutions for illuminating mid-size items. Since you will probably be shooting most large objects outdoors, the lighting principals we discussed in the "Daylight" section of Chapter 5 apply: Avoid back lighting, don't take pictures in bad weather and shoot your pictures during the best times of the day, which is mid-morning or mid-afternoon.

Creating your indoor shooting area

As we have stated before, the best eBay photos isolate the item being photographed, so that nothing else distracts the buyer's eye. This is relatively easy when your product is small enough to fit on a table. For medium size items that are too big for a shooting table but small enough to move around, we use the backdrop system we mentioned in Chapter 2, "Outfitting Your eBay Studio" (**Figure 8.1**).

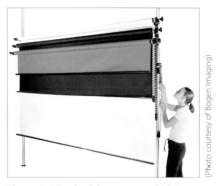

Figure 8.1 *Our backdrop system, which is very similar to this one, fits against a wall of CD shelves in our studio.*

However, if you don't have a backdrop system, you can use cloths and clamps. We often create an instant eBay studio by draping sheets from the bookshelves in our living room, making sure the cloth also covers the floor under the item we're photographing. Larger items and cluttered spaces often require some ingenuity and photographic legerdemain to isolate, however (**Figures 8.2 through 8.5**).

If necessary, use multiple sheets of the same color to cover up everything other than the item you're selling. And try to avoid big creases in the fabric. If you can't, we show you in Chapter 11 how to remove them from your photos using a clone tool that is available in photo-editing software.

Figure 8.2 *In a typical living room, any one piece of furniture is surrounded by other things. The same is true in a warehouse or office. While it may be inconvenient or impossible to move everything aside without wasting lots of time and energy, using a photo like this on eBay is next to useless. The chair is practically camouflaged.*

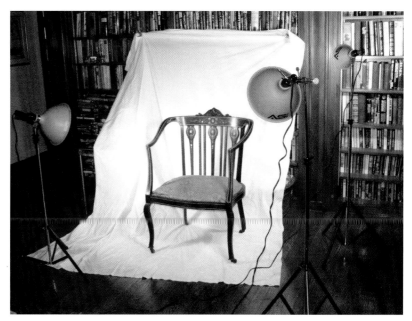

Figure 8.3 *Our collection of solid-color sheets are great, not only for backgrounds that are draped from bookcases, but also for covering up anything near the object being sold. Hidden underneath this sheet are the glass table with its pitcher and bowl, the area rug and the wicker basket of magazines.*

Figure 8.4 *This is a much more appropriate photo for eBay. There's no doubt what's for sale; it's appealing and gives the buyers a clear idea of what the chair looks like.*

Framing and angling

Even using your camera's zoom lens at its widest focal length may not let you capture the entire item in a single picture. That's because what you're shooting is either too big, the space it occupies is too restrictive or both (**Figure 8.6**).

(Sofa photos—Pentax Optio SV)

Figure 8.6 *This large sofa is in a narrow hallway, making it impossible to move far enough away to frame the entire piece while shooting head on.*

If you can't get the photo you need because the item is too large or the space is too small, some options you might wish to explore include:

✦ Shooting the item at an oblique angle, rather than straight on

✦ Using a ladder or stepladder and shooting from a higher angle, but only if the ladder is steady and you're safe

✦ Bending down to shoot from a lower position

✦ Photographing and displaying the item in several separate sections

✦ Buying and attaching an auxiliary wide-angle lens onto your digital camera

Using a combination of these methods and posting a variety of the photos on eBay is actually the best option, because it gives buyers various viewpoints and perspectives on the item.

Angling your picture

Angles are always important in photography. We're accustomed to photographing items for eBay head-on—standing directly in front of the object, pointing and shooting. That works nicely for small objects, especially because it avoids distorted perspectives and provides the most accurate representation of the product.

But when the object is too large to fit into the entire frame, it's time to change the angle. Shooting from either side changes the perspective, so that you can capture the entire item in one shot (**Figure 8.7**).

Figure 8.7 *One method for fitting a large item into a single frame is to shoot from an oblique angle. However, you must be careful not to use severe angles that would make the item look like it was shot on a Hollywood special effects stage. If this were a perfect photo, the dark rectangle on the right side would be covered by a light sheet the same color as the wall. But the rectangle doesn't really interfere with the lines of the sofa.*

You can change the angle of a picture in one of two ways: Move the item or move the camera. The latter is always easier to do, assuming that you have space available for repositioning the camera. With your eyes glued to the LCD screen, flick the zoom lever to its widest setting and walk about, until the item you're shooting fills the entire frame without spilling over. Moving the item may prove somewhat more difficult, because it may be heavy or bulky, or there may not be much space for maneuvering. But if you can, angle it so that you can fit the entire item in the camera's viewfinder.

The one problem with angling is that if you do it too much, the picture will either be distorted or incomplete. So if you use this method, it becomes even more important to include several photos on your eBay page, with each picture showing a different view of the item.

Changing your elevation

Another way to change the angle to get the entire item in the picture is to go high or go low. By going high, we mean using a step stool, stepladder or ladder. The added height changes the perspective, which may let you get the entire item in the picture when shooting at eye level won't (**Figure 8.8**).

TIP

For those tall items that don't fit into the horizontal frame of your LCD screen, simply turn your camera 90 degrees and shoot vertically. In Chapter 10, "Efficiently Handling Your Pictures After the Shoot," we show you how to rotate the photo in software so that it displays correctly.

Figure 8.8 *Sally had to put her ladder tightly against the opposite wall to get this photo. The hallway is so small that we couldn't angle the lights to fill in all the shadows without having the light stands in our picture. Sometimes, getting the shot requires a series of compromises.*

Conversely, shooting low (getting on your hands and knees) can accomplish the same thing. Remember, the picture may look strange—slightly shorter on the top or the bottom, depending on whether you shoot from on high or shoot low.

Shooting portions of your item

Another way of displaying a large item that is too big to show in one shot is to break it up into separate photographs. This you can do by varying the size of the pictures you're taking, by moving closer or farther away or changing your zoom lens from wide angle to normal (and perhaps even to telephoto). When you post the series of photos, potential buyers will be able to see a mosaic view of the item (**Figures 8.9 through 8.12**).

Creating a mosaic-like view is especially useful the larger the item is. For a building or other real estate, it may be the only method possible.

Figure 8.9

Figure 8.11

Figure 8.10

If you can't get one single photo that shows the entire item, take several from different angles and heights to give buyers a composite picture of it.

Figure 8.12

Using an auxiliary lens

One tactic for shooting large items in small spaces is to attach an auxiliary wide-angle lens to your digital camera. Many models either have threads inside the bezel around the lens or accommodate some sort of circular adapter that lets you screw or click on an optional wide-angle lens (**Figure 8.13**).

Auxiliary lenses attach in front of a consumer or prosumer digital camera's fixed lens—as opposed to the interchangeable lenses that replace whatever lens is on more expensive digital single-lens reflex cameras. Instantly, your camera can capture more of what's in front of it. But like so many other things both in photography and life, there's no such thing as a free lunch. Here are the tradeoffs and caveats about shooting with an auxiliary wide-angle lens:

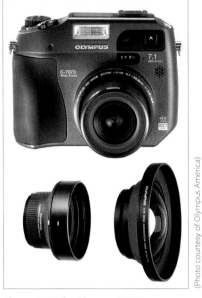

Figure 8.13 *This Olympus C-7070 can accommodate auxiliary lenses, such as the wide-angle lens (lower right), when an adapter (lower left) is first placed over the camera's lens.*

(Photo courtesy of Olympus America)

◆ It will add to the cost of your camera. Depending on the make, model and angle of coverage, an auxiliary wide-angle lens can set you back $35 to $100 or more (unless you buy a used one on eBay).

◆ Optically, it may create quality-robbing distortions like falloff (darker corners), vignetting (cutting off the corners) or barrel distortion (where the picture seems to bulge outward). To minimize distortion, we recommend buying matched auxiliary lenses from the manufacturer of your digital camera, if possible.

◆ You may have to change one or two arcane settings buried deep in your digital camera's menus. It shouldn't be difficult if you follow the user manual. But it does take time, you've got to get it right, and you must remember to change it back when you remove the auxiliary lens.

◆ You may need to direct more light on the item you're shooting. Attaching an auxiliary lens reduces the amount of light entering the camera, which translates into a slower shutter speed, reduced depth of field, or a slightly darker picture. If the item isn't too big to illuminate, adding extra light will compensate for the slight loss of light the lens produces.

Shadows and light

Properly illuminating medium-size objects within a limited shooting space may require imagination and improvisation. You can use a two-light or three-light setup comprising photo lights and stands, or you can employ informal household lighting as we described in Chapter 5. However, the same setup you used for your tabletop might not create large enough cones of illumination, which can translate into uneven lighting and falloff at the edges.

TIP

If you're shooting land, a building or perhaps a car or boat, you may need more magnification than your camera zoom lens provides. That's when you might consider adding an auxiliary telephoto lens to bring the subject close enough to you so that it fills the entire frame. Or you could shoot at your camera's highest resolution and highest quality setting so that you can crop a smaller part of the frame for your eBay auction.

Our best advice is to enlarge the cone of light. You can do this one of three ways:

+ Pull the lights farther away

+ Add more lights

+ Bounce the light

Simply moving the lights farther away from the item enlarges the cone of illumination so that it covers more area. But it also reduces the amount of light that reaches the item.

Deploying additional lights so that the cones of light overlap across the entire item helps produce a better exposed shot, but be careful it doesn't also create hotspots of overexposure at those overlapping points.

Creating indirect light by bouncing lights off the walls or the ceiling usually works well if the walls aren't too far away or the ceiling isn't too tall, and the walls and ceiling are light colored. If they aren't, then use a white bedsheet tied or taped to poles or the wall to reflect the light. You can also move the lights themselves, either closer or farther from the walls and ceilings or the bedsheet. Another way of bouncing light is to use photo umbrellas on your lights, as we showed you in Chapter 2. It may take a little trial and error, but the redirected light should be broad and diffuse enough to illuminate the entire object evenly. You may have to shoot at a slower shutter speed, because the amount of light is reduced every time you bounce it. But that shouldn't be a problem if your camera is mounted on a tripod.

(This series—HP PhotoSmart 945)

Regardless whether you use direct or indirect lights, you should make certain the shadows they create aren't too strong or distracting (**Figure 8.14**).

To minimize harsh shadows, the following techniques can help:

+ Move the item you're photographing several feet away from the wall to soften the shadows.

+ Angle and add lights to illuminate any shadowy areas (**Figures 8.15 through 8.18**).

One other option is to hang, tape or clamp a dark solid color sheet behind the item you're selling. Dark colors absorb camouflage shadows. However, if your product is dark, as the exercise bike in our photos are, then a dark background wouldn't be a good choice.

Figure 8.14 *Harsh shadows are not only unattractive and distracting, but they can also be deceptive. In this photo, it's difficult to see where the shadows stop and the wheel of the bike begins.*

Figure 8.15 *Using a three-light setup, we moved the bike away from the background, directed one light onto the background sheet, bounced a second light on the ceiling and angled a third light toward the bike.*

Figure 8.16 *The photo taken with a three-light setup, has almost no shadows on the background, but the new shadows under the bike are quite unappealing and distracting.*

Figure 8.17 *This five-light setup angles another light from the back to illuminate the background and the areas under the bike. The fifth light shines from a lower point onto the front.*

Figure 8.18 *Using the five-light setup hasn't completely eliminated shadows, but the ones that remain are soft and unobtrusive.*

Getting the critical details

Depending on your theological point of view, God or the devil is in the details. Prospective bidders want to see the entire item that you're selling, but they also want to see any small details that add or detract from the value. For example, you'll want to get up close to show such things as especially fine carvings or craftsmanship; how the item was made or put together; the condition of gold leaf or paint; and any cracks, dings, dents, missing pieces, excessive wear and makers' marks.

We described in the previous chapter how best to photograph tabletop-size items and objects. The principles are the same for photographing small segments of medium-size or large-size objects. While we can't tell you which specific details to photograph (because it varies depending on the item), the general rule of thumb is to shoot and show everything that will entice bidders or give auction winners full information so they won't be surprised or disappointed.

Before, After and How'd They Do That?

Shooting medium-size and big items isn't especially difficult, though some types of products need special attention to show them off at their best. Here is advice on how best to photograph items too large to put on a shooting table. While we focus on specific categories of products, the principles apply to just about everything you can think of that's bigger than a tabletop.

Clothing

At any given time, well over a million and a half pieces of clothing are up for sale on eBay. Alas, the vast majority of photographs provide little visual information on what the dress, shoes, underwear, slacks, belts, coats, hats and other items of apparel really look like, and more importantly, how they would look on the bidder (**Figures 8.19 and 8.20**).

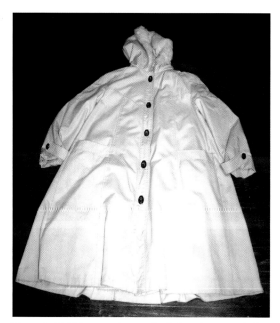

Figure 8.19 *We've seen thousands of eBay photos in which the article of clothing is just thrown on the floor. Unappealing and uninformative, such pictures are not the kind to encourage bidding.*

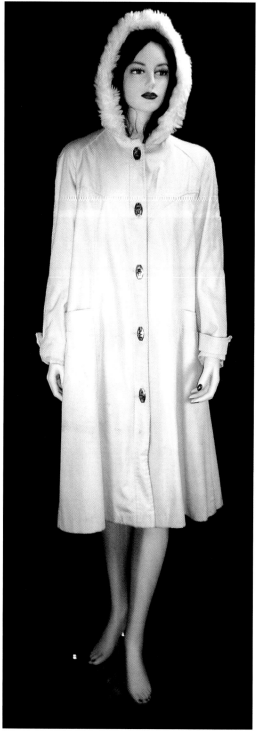

Figure 8.20 *Clothes are meant to be displayed on the human form; it shows them off to their best advantage as well as captures the imagination of buyers.*

Using a mannequin or dress form

Not everyone has a frequently available family member, friend or employee who would be willing to be photographed in clothing that is destined to be sold on eBay. Several years ago, we purchased a mannequin on eBay, which our assistant named Vanessa Quinn (Figure 8.20). She greets visitors to our studio, never complains when we need her to pose for us, comes apart at the waist and shoulders for easy dressing and undressing, and her hair can be removed when it would interfere with a neckline (**Figure 8.21**). Most importantly, she's a great model for clothes we want to sell on eBay.

While full-length Vanessa cost us over $200, we have seen less realistic, but very functional body forms on eBay for under $30 (**Figure 8.22**).

Here are some things to keep in mind when shopping for a mannequin:

◆ If you're doing a search on eBay, type in the word *mannequin*. (You can also try searching using *mannikin*, the less common spelling, but most likely you'll find fewer listings.)

◆ Buy the mannequin that fits the sex and age of the clothes you have for sale—male or female, adult or child.

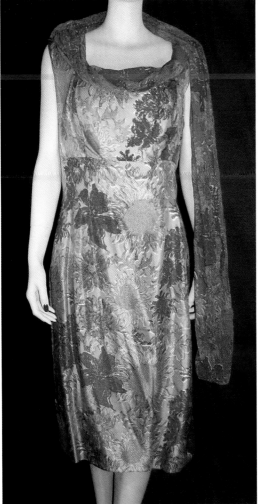

(Konica Minolta DiMage Z3)

Figure 8.21 *We took Vanessa's wig off to avoid having anything distract from the neckline of this dress. As with any other eBay photo, we also cropped everything away that wasn't related to the object for sale—the dress. That's why we always cut out the model's or mannequin's head and legs unless they are needed to display the product, such as the hood of a coat.*

Figure 8.22 *These male and female mannequins sell together in tommyshannon's eBay store and autions for less than $30. They can be stored in a small space because their backs are hollow.*

- If you sell dresses, suits, slacks, jackets—everything except hats and scarves—don't pay extra for a mannequin with a head. Conversely, if your specialty is hats, buy only a dummy head or oval form rather than a full-sized mannequin.

- Mannequins with legs cost extra, but they have one major advantage—you can put them on wheels. An easily movable mannequin is much easier to manipulate and turn, so you can photograph clothing from all angles more quickly (**Figure 8.23**).

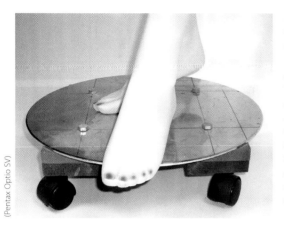

(Pentax Optio SV)

Figure 8.23 *Mounting wheels on Vanessa required drilling four equally and widely spaced holes in her stand (which was included when we bought her), screwing a homemade wood frame under the stand and attaching the wheels to the frame. It was one of the better investments in time and money we've made for the convenience it adds to our eBay photography.*

- Most mannequins are one fixed size only—most often quite small. Plus-size units are available but come up for sale less often. An even better option, if you can find it, would be an expandable "seamstress dummy."

- If your mannequin is a smaller size than the clothing, put soft cloths inside to fill it out rather than let it hang loosely. In Figure 8.21, we stuffed washcloths into the bust line of the dress.

Photographing clothing

Clothing is one of the most personal items a person can buy, and yet, eBayers put down their money without touching it or trying it on. So it's important to give as much visual information as possible, to reassure as well as entice. Therefore, when you photograph clothing, remember that buyers want to be able to imagine what it would look like on them.

To get great photos of clothing, follow these guidelines:

- **Photograph clothing against a solid, contrasting color background.** Try to make the floor part of the background as well, by draping a roll of seamless paper or a sheet across the front of the floor and the wall behind it.

TIP

Ebay trading assistant Phoebe Sharp (eBay ID: carnabyauctions) has found that showing zippers is especially important for selling vintage clothing, because they're metal in the older pieces rather than the plastic zippers we now have.

✦ **Many articles of clothing do not reflect light well.** That's why you want to bracket, or take a series of shots with plus and minus exposure compensation (EV). That way, you're more likely to capture one with just the right amount of brightness and contrast. (See Chapter 4, "Exposure and Focus.")

✦ **Take photographs from the front, sides and back**—capture the way it drapes.

✦ **Details are important selling points.** Be sure to take macro photos that depict the details—buttons, belts, buckles, fringes, rhinestones and so on (see Chapter 6, "Getting Great Photos of Jewelry and Other Pocket-Size Products").

Stained glass

Because, we have looked several years for the right piece of stained glass to install inside a living room door, we've perused many hundreds of photographs of stained glass on eBay. Most of the pictures miss the point and simply don't convey the true beauty of the glass. Nor do they give us a sense of how it would look in our home (**Figure 8.24**).

(This series—Kodak EasyShare DX6490 Zoom)

Figure 8.24 *With all the light in this picture coming from the front, we can't see the full beauty of the stained glass.*

Figure 8.25 *When using artificial lights, be careful to avoid hotspots like the one behind the right lily. Also, stained glass just doesn't look good when it isn't photographed straight. (In Chapter 11, we demonstrate how to straighten crooked photos like this.)*

The highest prices are always for pieces that are photographed beautifully and are usually posted by antiques dealers who specialize in stained glass and other architectural artifacts.

The best way to illuminate stained glass is from behind, with light streaking in. Sunlight is the best kind of light. And the best setup is to prop it up against a window with sunlight streaming in—if the stained glass is light enough and you can safely prop it in place. If you use artificial light and have room behind the glass, pull the lights several feet away from the piece. That enlarges the areas they illuminate on the glass and helps avoid hotspots (**Figure 8.25**).

An old, white bedsheet is one of the more important props for photographing stained glass. If you are using artificial lights behind the glass, hanging the white material between the lights and glass diffuses the light evenly, helping to eliminate hotspots. Also, if the stained glass has any clear glass elements, putting such material behind the glass keeps any background (such as your garden patio furniture) from showing through the glass. The white material may reduce the intensity of the light, which means you may need to add lights behind the glass (**Figure 8.26**).

Figure 8.27 *Close-up photos of beautiful details like this hand-painted lily tend to drive bids up higher.*

Figure 8.26

Many older stained-glass pieces have exquisite painting and etchings. Take close-up shots of such details (see Chapter 6) and post them on your auction page (**Figure 8.27**).

Setting up your camera to photograph stained glass requires a bit more precision than other large items. Here are some of the issues you'll want to address:

+ Stained glass looks best when it's not photographed off-center or at an angle which would introduce a distorted perspective. Putting your camera on a tripod that has a spirit level on its head is the most consistent method for aligning the lens parallel to the center of the stained glass.

+ Set your camera to center-weighted metering and spot focus.

+ Because getting perfect exposure of stained glass is very difficult, bracket your exposure, taking take several shots using various levels of plus and minus exposure compensation (see Chapter 4).

TIP

Photographing embedded stained glass that cannot be easily removed (though you will have to dismantle and pack it once it sells) isn't very different from taking pictures of other stained glass. If it is set into a wall above your head, you may want to get on a ladder or stepladder, to position your camera parallel to the center of the glass. Be sure to shoot when the sun is streaking through it.

✦ Unlike most other eBay products, a smaller depth of field is acceptable, since the glass is flat. In fact, if you're trying to diminish the effect of things you can see through the glass, more limited depth of field is preferable. Using aperture priority, set your aperture to a smaller number f-stop (such as f3.5 or f4.5) than you would typically use for eBay product shots (see Chapter 4).

Rugs and carpets

Make certain the carpet is cleaned and vacuumed. But don't try washing a true Oriental yourself with a rented steam cleaner— you can permanently damage its delicate colors.

At eBay University, Jim "Griff" Griffith frequently shows his audience a photograph from an actual eBay listing of a carpet thrown down on a dirty and cracked concrete driveway. The photo always gets a laugh, but humorous or not, it's a serious cautionary illustration of how not to photograph carpets and rugs for eBay.

The biggest problem with photographing rugs and carpets is that they tend to be large and heavy, which means they need to remain on the floor. And that's where the photographer usually stands—on the floor at the far edge of the rug. The result is a picture that has distorted perspective and doesn't show the rug off well (**Figure 8.28**).

(Konica Minolta DiMage Xi)

Figure 8.28 *The only way to fit this entire carpet into the camera's frame when shooting from floor level is to shoot it standing at its smallest edge. This produces a photo with a distorted perspective. Notice also that the depth of field isn't deep, so the far end isn't as sharply focused and the near areas. (See Chapter 4 for more information on how to increase depth of field.)*

The best way to photograph a rug is to stand as near to the center as possible, which in most cases means climbing a steady ladder and shooting down (**Figures 8.29 and 8.30**).

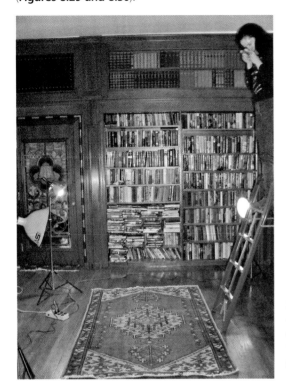

Figure 8.29 *To get a better perspective on the area rug, Sally shot from the top platform of her photo ladder. Notice also the three-light setup.*

Figure 8.30 *Shot from a ladder, this photo has a small amount of perspective distortion, but it provides a much better view of the rug and shows it off well.*

To set up your shoot, follow these guidelines:

✦ As with other eBay photos, pictures of rugs and carpets should be against a simple, unobtrusive background. Spread your rug onto a larger, solid color carpet or a clean wooden floor. Move furniture or anything else distracting out of the frame.

✦ Light the carpet evenly with three or four lights. Don't use your camera's flash unless it's a very small rug, because a flash can create a hotspot surrounded by dark areas.

✦ Use exposure bracketing to get the proper exposure without having to reshoot (see Chapter 4).

✦ Take macro shots of the fringe, damaged areas, spots of excessive wear and any labels.

✦ If it's a true Oriental, take a macro of the back side, showing the weave.

These guidelines apply to all kinds of rugs and carpets, from tiny prayer rugs to huge room-size carpets, and modern weaves to antique Orientals, as well as any other large flat item that you might photograph on the floor, like paintings and tapestries.

Cars, trucks, tractors and other vehicles

eBay Motors is the largest used car lot in the world. At last glance, a total of 31,303 automobiles were listed for sale on eBay. If each one sells for only $1,000 after a seven-day auction (and most bring far more than that), it amounts to billions of dollars each year. Similarly, there were 1,198 minivans, 5,056 SUVs and 4,058 trucks for sale. This doesn't include buses, motorcycles, commercial trucks, tractor-trailers and other types of vehicles.

Selling a vehicle on eBay is not only a big-ticket item, but it's also a big thing to photograph. Big, but not difficult.

As with small and medium-size objects, shooting cars and other vehicles requires the same care and attention, although your settings will be a little different. We suggest using the following:

✦ **Center-weighted metering** so that you don't accidentally lock your exposure setting on a small detail, like bright chrome trim or a dark interior. Exposing for the wrong detail usually produces bad exposure overall. Center-weighted metering averages out everything in the frame, with extra emphasis on what's in the middle of your viewfinder.

✦ **Auto white balance.** Since you'll undoubtedly be shooting outdoors in natural light, don't bother about other presets or using manual white balance. The color should be accurate enough on auto.

- **Your camera's lowest ISO or auto ISO** to ensure the best image quality.

- **Aperture priority.** For that most important, representative shot of the entire car, you may want to set your lens to its largest opening, such as *f*2.8 or *f*3.5, to reduce depth of field and therefore subdue the background. For closer details, stop down your lens to its smallest opening, like *f*8 or *f*11, for maximum depth of field.

As we've mentioned many times throughout this book, when you shoot outdoors, try taking your photos mid-morning or mid-afternoon, have the sun at your back, and make sure the weather is clear or only mildly overcast. For the sharpest shots, use a tripod.

If you shoot in strong sunlight, you probably won't need forced flash for exteriors. In fact, for most of the full body pictures, you'll be too far away to use the flash. However, flash is often the only way to properly illuminate the interiors. Take a few test shots and look at the images on your LCD, checking your histogram, if your camera has one. It tells you if you need flash or not. (See Chapter 4 for more information on histograms.) And except for the odometer and VIN number, most of your shots will be in the regular autofocus rather than macro range.

The right background

You'll want to think carefully about the context or environment of your vehicle photos. This is where the guidelines for cars are different from trucks.

Most commercial trucks, such as panel trucks, tractor-trailers, wreckers, dump trucks and military vehicles, are sold as commodities. Frankly, buyers are much less interested or impressed by the context of the photos than the information the pictures can give them about the condition of the vehicle.

On the other hand, buying any car, motorcycle or other personal vehicle is often an irrational, emotional decision—advertising executives consistently confess they sell fantasies rather than automobiles. That's why, ideally, photographs of personal vehicles should be against a background that best reflects the image you want to project. For instance, a luxury car like a Cadillac or a Jaguar belongs in a background that exudes beauty, comfort and luxury. The best background for a luxury car would probably be a mansion, or a beautiful garden. SUVs should be in the woods or off the road, a minivan might be near a soccer or baseball field, and a family sedan always looks great in a park.

True, it's not always practical to drive to the ideal setting. But it is relatively simple to create some of the ambiance without much hassle. Avoid positioning your car near other vehicles, or where there are distracting elements, like ugly buildings, industrial equipment, and so forth (see **Figure 8.31** on the next page).

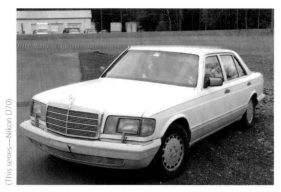

(This series—Nikon D70)

Figure 8.31 *This photo isn't exactly a bad picture, but it conveys the wrong message for a Mercedes Benz. It's set in a work-a-day environment with the asphalt breaking into an uneven stone surface right where the car is parked. In the background are commercial buildings and trucks.*

If you shoot your car in your driveway, make certain that the kids' bikes are moved out of the way and the grass is cut. In other words, you want to shoot your vehicle in a place that it looks its best—without looking out of place (**Figure 8.32**).

If you can't shoot your car against a nice background, the next best thing is to eliminate as much of the background as you can. This can be done three ways:

✦ Get in so close that your vehicle fills up the entire frame, from side to side, but don't cut off any portion of it (**Figure 8.33**).

✦ Shoot from above on a steady step ladder or ladder, so little of the background is visible.

✦ Crop the top, bottom and sides in your photo-editing program (see Chapter 11).

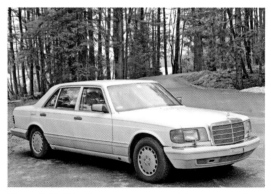

Figure 8.33 *When you're moving in close to the vehicle to fill the frame, be careful to not get too close, unless you are shooting a specific detail. Other unappealing elements of this picture are the dumpster in the background and, worse, the dramatic contrast between the bright highlights and the deep shadow that covers the near side.*

Figure 8.32 *This photo captures more of the romance of having a comfortable Mercedes that might take you to beautiful places and maybe a bit of adventure.*

Planning your shoot

Buyers like to see lots of photos of cars, trucks and other vehicles. The number of pictures you post depends on how you plan to host them. For instance, if you purchase eBay's CarAd, you'll have space for 36 super-size pictures in a very neat automated interface. (We discuss the pros and cons of eBay Picture Services versus other image hosts in Chapter 12, "Posting your Photo on eBay.")

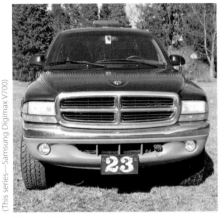

Be sure to shoot all sides of the vehicle, taking various photos of each at different angles (**Figures 8.34 through 8.39**).

When you're selling a personal vehicle, let buyers see it from all angles and perspectives. It's one of the ways to capture their excitement, imagination and bids.

(This series—Samsung Digimax V700)

Figure 8.34

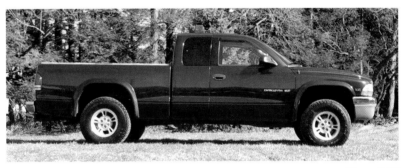

Figure 8.35

Figure 8.36

Figure 8.37

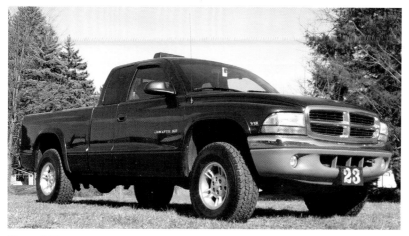

Figure 8.38

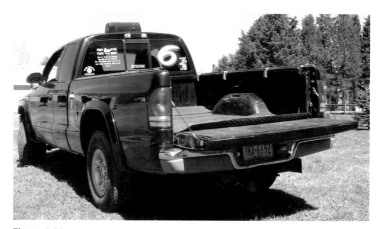

Figure 8.39

To get all those different angles, don't just walk around the vehicle, move closer and away, get low and go high (**Figures 8.40 and 8.41**).

Figure 8.40 *Sally carries her photo ladder everywhere she goes to shoot, because camera angles from above are often needed. But notice the shadow; the sun was in the wrong position. So, we ended up turning the pickup around to get a better picture of the truck bed.*

Of course, buyers want to see more than the body and overall appearance of the vehicle. Here's a checklist of some of the pictures you should take and post:

+ The engine

+ The front seat and instrument panel

+ The rear seat (if necessary, roll the window down and point your camera into the interior)

+ The steering wheel and instrument panel

+ The dashboard

+ The odometer and VIN number

+ If it has one, the console and gear shift between the driver's seat and the passenger seat

Other types of photos can include the upholstery, stereo or CD player, door and window handles or controls, armrests, ducts and vents, carpets, open sunroof, open trunk, tires and rims. In other words, anything that might attract a buyer should be photographed.

Truck buyers want to see a photograph of the truck bed, and if it has them, the cab and mounted toolbox. Conversely, prospective minivan bidders are interested in seeing shots of the sliding door open, what the interior looks like with the seats removed, and if it has a pull-down TV set over the back seat. SUVers look for photos of the 4-wheel lever or control, the locking lugs on the wheels, the

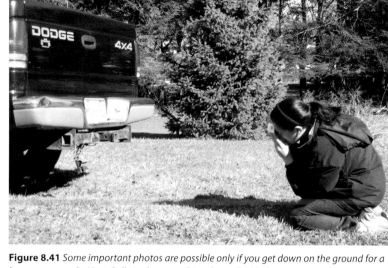

Figure 8.41 *Some important photos are possible only if you get down on the ground for a low camera angle. Here, Sally is photographing the trailer hitch.*

Figure 8.42

Figure 8.43

Showing the full extent of any dings, dents or rust can actually increase sales, as well as keep your feedback rating high.

condition of the tires and any extras, like a winch in front or a mounted tire on the back. Camper and RV buyers want to see appliances, the bathroom, beds, sofas, curtains, and everything else in the interior.

The rule of thumb is that whatever drew you to buy and use your vehicle will appeal to other buyers, within reason.

Similarly, anything that is less than pristine requires a photo. Bidders want to know everything about the vehicle—both good and bad. If you mention a dent and don't show how minor or extensive it is, people will be afraid to bid. On the other hand, if there's a dent and it isn't mentioned and shown, the buyer will be disappointed, angry and likely leave a negative feedback, which will affect your rating on eBay. But if you show even the small dents, buyers will trust that you aren't hiding anything (**Figures 8.42 and 8.43**).

Then there are commercial vehicles. Take photos of the interior of the trailer (if it has one); any machinery, like a towing rig on the back; the engine; the differential; any air hoses or connectors; and anything else that would affect the functionality and productivity of these workhorses.

Boats and Planes

Boats are best photographed in the water; planes are shown best in the air. If you're selling a yacht or a jet for mucho bucks, it pays to hire a chase boat or plane and a professional photographer to shoot your vessel cutting through the waves or your aircraft soaring through the sky. That's not so far fetched. The most expensive item sold on eBay to date was a Gulfstream jet that went for $4.9 million dollars. Of course, most folks selling boats and planes aren't in that league and probably won't want to spend anything extra taking their eBay photos.

If you can't sail your boat out from the pier or slip, take pictures of the keel, stem, stern, wheelhouse, sails, winches, wheel and instrument panel, and every other important part of the boat. If it has a cabin, take flash shots of the interior. If it's on a trailer, make the trailer part of the shot (but tell the bidder whether it's also part of the sale). If it's out of the water, be sure to photograph the propellers and rudder. Take shots from above, if possible, so that you can see the deck and the keel in the same picture. Try to angle the camera so that you don't include any adjacent boats. Use forced flash, if you're shooting from closer than 12 feet. Of course, be sure to show any rust or corrosion, peeling paint or cracked fiberglass, and any other damage or deterioration that the bidder should see.

So how do you get a great shot of a plane when it's sitting on the ground? The first thing is to move it away from hangers and other aircraft, so that it can be photographed by itself. The next trick is to borrow a tall ladder and shoot some of the exterior from above, or at least at eye level with the plane. That way, you use the tarmac itself as a neutral background. Also, get low on the ground and shoot upward, getting more of the sky in the background. Like cars, boats and other means of transportation, you will want to take exterior photographs—nose, engine(s) fuselage, wings, struts, wheels, doors and tail. Make sure that you include the registration number in at least one of the fuselage or wing shots. When photographing the inside, turn on the forced flash and be sure to get details of the left and right-hand seats in front, at least two different views of the instrument panel and yoke or wheel, and any seats in the rear. Good angles are through an open door, from the outside looking in. It also may be useful to include a person in one of the exterior shots, to give bidders an idea of the aircraft's size. Two things to try and minimize are glare from the glass in the instrument panel and deep shadows cast by the wings and fuselage. It may take some trial and error to get it right.

Real estate

Every year, thousands of homes, condos, farmhouses, hunting lodges, apartment buildings, commercial structures and parcels of land are bought and sold on eBay. The reason for eBay's popularity for selling real estate isn't hard to understand: Millions can view your listing, you don't have to shell out a hefty 6 percent to 8 percent commission to a realtor, your property can sell within days and, best of all, you get paid faster and possibly more than you would if you went through the traditional sales route. Of course, realtors aren't sleeping at the wheel: they represent a large percentage of the folks selling real estate on eBay.

Photographing buildings for eBay is a very simple and straightforward exercise, since the exterior usually involves standing far enough away to capture everything in a single frame, pointing the camera, and pressing the shutter. Because it's daylight and the building will be farther than 10 feet to 15 feet away from your camera, you don't have to be concerned about lighting, white balance, forced flash or focus. The outside shots should be taken in mid-morning or mid-afternoon daylight, when the weather is good, and ideally, the sun should be behind you. Because of the foliage, spring and autumn are especially good times of year in the northern part of the country.

Shooting the exterior of a building

When you take pictures of the exterior of a house or building, have at least one of your photos include whatever surrounds the property, such as the lawn, garden, yard or sidewalk. Before you shoot, spend some time and energy cleaning up the surrounding area—mowing the lawn, pruning the shrubbery, picking up bikes and other things lying around and clearing the porch of any boxes or debris (**Figure 8.44**).

A few other guidelines for getting good exterior shots include:

✦ For an urban property with a street in front, wait until no car is parked in front of the property before you photograph it, even if you must wait a few hours to do it.

✦ If your house has a driveway and attached garage, take one shot with the door(s) closed and one with the door(s) opened, so bidders can get a sense of how large and how deep the garage is.

✦ Take one or two pictures of the side or back of your house, but only if it has a patio, swimming pool, lawn, garden, play area or landscaping that looks great and adds to the value and appeal of the property.

TIP

Be sure to use a tripod to take any interior shots. In such low-light situations, the shutter speed tends to be slower (to let in more light) and that means a greater likelihood of camera shake, which produces blurry pictures. Also, rather than pressing the shutter button (which can jar the camera), activate the self-timer instead.

Figure 8.44 *The front entrance of a home is a key, definitive shot for capturing a buyer's attention. Be sure it's pristine with no litter or debris, the lawn is mowed and the shrubs are trimmed.*

Going inside

Taking interior shots of a house or any structure is a little trickier, because you're probably not going to want to spend the time and effort to meticulously light every room, hall, stairway or entrance. But lighting remains a key issue, because most interior shots are dark. Here are some suggestions for getting good pictures in low-light situations:

✦ Turn on all the lights in a room and open all the curtains to let in daylight.

✦ Try to schedule your shoot for a time when daylight is streaming into the more important rooms in the house, such as the kitchen.

✦ Boost your camera's ISO equivalency to its highest or next-to-highest setting. You'll get some noise in your pictures, but that's better than serious underexposure.

✦ Use exposure bracketing to ensure that you get the photos you need (see Chapter 4).

✦ Activate the forced flash and augment it with slave units to fill dark corners with light (see Chapter 5).

Pictures taken from the
corner of rooms tend to
have more interesting lines
than those shot with your
back against wall. Plus, it
has the added advantage
of providing a wider
perspective of the room,
capturing more of it.

If you follow these guidelines, you should have enough light to produce proper exposure. If your pictures are still dark, you can lighten them further in a photo-editing program like Photoshop Elements (See Chapter 11).

Another problem with taking interior shots is that most digital cameras don't have very far-ranging wide-angle lenses. So you may not be able to capture, for example, an entire living room in one picture. You can extend the angle of coverage by shooting through a doorway, or even though an open window. And as we already mentioned, attaching an auxiliary lens helps widen your vista. In addition, shoot from opposite corners to create a mosaic-like collection of pictures that captures the various elements of the room.

Take pictures of all the rooms in the house, but pay special attention to the kitchen, bathrooms, living room, family room, finished basement (don't bother if it's unfinished) and master bedroom (**Figures 8.45 through 8.47**). Of course, shoot any special or noteworthy features, such as stained glass windows, a library, conservatory, home office, cedar closet or sauna.

Figure 8.45

Figure 8.46

When sunlight is streaming in through a window or door but significant portions of the room are dark, take your exposure reading in the dark area. You do this by pointing your lens at a shadowy section, and holding down the shutter button halfway to lock in the exposure reading. While keeping the button pressed halfway, frame your picture so you have the composition you want. Then, press the shutter button all the way down to take the picture.

Figure 8.47

A good kitchen sells a house. Take pictures from every angle if the room is attractive.

Land

TIP

For truly large properties that will bring in lots of dollars, hire a small plane and pilot for a half an hour and shoot it from the air. Set the camera to its fastest shutter speed (the *f*-stop is relatively unimportant), or if you can't adjust the shutter, select sports mode.

Unless you are selling a vast tract, taking photographs of land that you want to sell isn't much different that shooting snapshots during a leisurely afternoon stroll. You will want to shoot the landscape and anything important or interesting that's on it—structures, trees, shrubs, water, hills and valleys. The best place to begin photographing land is wherever its boundaries are, whether it's a road, fence, stream or any other natural or manmade demarcation. Again, it's always best to shoot with the sun to your back, though you might want to go for the dramatic by taking photos at dawn or dusk (with a tripod, of course). Where the light and shadows fall matters less with flat land than it does with clearly defined three-dimensional things. If the land is larger than you can include in a single shot, you might want to shoot it in sections. Remember to take it from different viewpoints, such as both ends of a meadow (**Figures 8.48 and 8.49**).

(Both photos—Samsung Digimax V700)

Figure 8.48

Take pictures from both ends of a meadow, to show buyers the different viewpoints.

Figure 8.49

You are under no obligation to shoot every inch of the property you are sell-ing—only what is most important and representative of the land itself. But don't forget the great views and the nooks and crannies that capture the imagination (**Figure 8.50**).

You may want to include a map, marking the area that you photographed, to help the bidder get oriented. And like photographing an aircraft, it's always help-ful to include something of a known size—a person, dog, chair or whatever—that shows the bidder a sense of scale.

(Nikon D70)

Figure 8.50 *Show the small, charming spots on a property, such as a streamside overlook. But be sure to mention whether things like chairs or other items in the shot are part of the sale.*

Dealing with Flat
or Nearly Flat Items

So far, we've covered how to use your digital or film camera to shoot a wide array of items and objects that you see on eBay. But we haven't addressed a large category of products that have height and length, but little or no width.

In other words, flat objects.

This includes such things as souvenir programs, autographs, books, baseball cards, tickets, stamps, coins, military medals and anything else that is two-dimensional. Depending on the size of the item, the best device for getting a great picture is to use either a scanner or a copy stand. On the other hand, if it's really big, you can use your digital camera and a ladder to shoot things on the floor.

This chapter is designed to help you understand, set up and use a flatbed scanner or copy stand to photograph any flat items you want to sell on eBay. We cover how to choose between a digital camera or a scanner, prepare items for scanning or copying, select the best settings to use for eBay auctions and operate a copy stand for shooting oversized items.

Using a Flatbed Scanner

If you're shopping for a scanner, make certain that the device uses a USB 2.0 interface and not the older USB 1.1 interface. USB 2.0 is 12 to 40 times faster than USB 1.1. Of course, your computer's USB port must also be 2.0-compatible (most systems less than three years old are). If it's not, you can buy a plug-in USB 2.0 board, if your computer can be expanded.

Let's talk about scanners first. You can use almost any color flatbed scanner, regardless of its age or the type of software interface it provides. It can be an old SCSI-based scanner, a slightly more modern parallel scanner or a USB-compatible scanner. The only things the scanner *must* have are the following:

+ At least 24-bit color

+ An optical (not interpolated!) resolution of at least 300 x 300 ppi (pixels per inch, which can also be referred to as *dpi*, or dots per inch) to ensure your scans capture enough data

+ A working driver (software) to interface, control and activate the scanner

+ The appropriate hardware interface so that you can connect the scanner to your computer

If you haven't yet purchased a scanner, here's what you should look for:

+ 24-bit color or greater (most current units are 48-bit devices) for photo-quality scans

+ An optical resolution of 600 x 1200 ppi or higher for capturing greater details

+ A scanning area of at least 8.5 inches x 11 inches to accommodate letter-sized originals

+ A movable or removable lid, for scanning thick objects like books

+ USB connectivity so that the scanner easily and automatically connects to your computer.

One-button scanners save time and effort

Many modern scanners have one or more buttons on the front that help automate the scanning process. All other things being equal (such as price, size and speed), buy the scanner that comes with programmable buttons. These buttons let you set up your scanner so that when you hit a button, it automatically begins scanning at the proper resolution, opens up your photo-editing program and can even name and save the scan to a pre-arranged file folder.

One-button scanning can save you lots of time and hassle. And as we have said before, the faster you can get your photos, the sooner they'll be up on eBay, helping you sell your products.

Do you need a transparency adapter?

Unless you sell transparent items like old X-rays, negatives or transparencies, magic lantern glass slides, acetates or animation cells, you won't need a scanner with a transparency adapter. But if you do handle transparent items, a scanner with this feature may be just the tool you need for getting great pictures.

A transparency adapter allows light to pass through the item, rather than reflect light off it, as happens with regular scans. The resulting picture reproduces the same effect you would get if you were holding the object up to a window, which is what buyers really want to see when bidding on transparent items.

Make certain that the illumination area of the transparency adapter is large enough to cover the items you'll be scanning without cutting or clipping the edges. Though the scanner may work with reflective documents that are 8.5 inches x 11 inches or larger, the area for scanning transparencies is usually much smaller, since most are designed to work with 35mm film strips and 2-inch x 2-inch slides (**Figure 9.1**).

Don't bother scanning or photographing covers of contemporary commercial books, CDs or DVDs, because eBay already has them on file. All you have to do is insert the name or IPC code of the item into the auction form, and eBay will insert the photo into the auction for you.

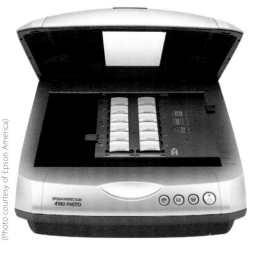

(Photo courtesy of Epson America)

Figure 9.1 *The lighted area in the lid of this Epson Perfection 4180 Photo scanner is the size of the transparency adapter. Notice how much smaller it is than the overall scanner bed. It works well for scanning transparent items no larger than 4.5 inches x 10.75 inches.*

Don't pay for an ADF

You also should avoid paying extra for a scanner that has a built-in or add-on automatic document feeder (ADF). An ADF may sound like a useful time-saver—it lets you automatically scan a stack of similarly sized papers. But it works by gripping each sheet of paper and pulling it through a 180-degree curve, sometimes folding or creasing the very pieces of paper you're trying to sell on eBay. That can reduce their overall value.

Setting up your scanner

TIP

The best place to put your scanner is right next to your computer keyboard and monitor. This allows you to open and close the lid, clean the glass and press the scan button without moving from your seat. Another time saver is to have two nearby bins for your originals, moving each item from one bin to the other as you complete the scan.

Setting up your new scanner should be a piece of cake. It probably won't take more than about 20 minutes to unpack the scanner, set it up and do your first scan.

Before you turn on your new scanner for the first time, make sure you read the setup sheet that came with it to determine whether it has a hardware lock. If it does, it must be unlocked before you turn the scanner on, or *you can permanently damage the scanner arm.*

If you're using Windows XP or Mac OS X, installing the device driver and the software is pretty straightforward. Just make sure you follow the manufacturer's instructions on the setup sheet. Some scanners require that you first power them up and plug the USB cable into your computer, and then install the software. Other scanners install the other way around—software first, and then the hardware.

Choosing your software options

Using a scanner involves relying on some sort of software interface to guide you through and execute your scans. Generally speaking, most scanners provide the following software choices:

✦ Press the scanner's button to do automatic scanning

✦ Scan from within your photo-editing program

✦ Use the scanner's stand-alone program

As we mentioned earlier in this chapter, one-button scanning is the most efficient method. So, if your scanner has it, we recommend you take the time to read the user's manual and set up this feature according to the way you like to work. For example, we like to have our automated eBay scans saved to a specific eBay folder that we've created on our hard drive and then brought directly into Photoshop Elements, where we can view them and perform whatever edits are necessary.

Another method is to access the scanner from within your photo-editing program. Usually, when you install your scanner software, links to it are automatically placed by your computer's operating system so that your photo-editing program sees it. Depending on the specific program, you can usually can find it by choosing File > Get Photos or File > Import from the main menu (**Figures 9.2 and 9.3**).

Our least favorite method for scanning objects is using the scanner's stand-alone program. That's because it adds extra steps to the process, requiring us to open the scanner's software, do the scan, save the file and then open our photo-editing program and locate the file on the hard drive so that it can be edited.

Getting your scan

Explaining how to scan probably takes more time and effort than actual scanning. Once your scanner is set up properly, it takes less than a minute to lay down the item you want to scan, press a button or click your mouse, and watch as your just-scanned image pops up on your computer monitor.

Here are the basic steps:

1. Turn on your scanner.

2. Place your item on the platen and close the lid.

3. Initiate your scan by pressing the scanner's button or going through the steps that your photo-editing program presents.

Figure 9.2

Figure 9.3 *If you want to scan from within your photo-editing program, look for your scanner driver (software interface) by choosing File from the main menu, and then choosing something like "Get Photos" or "Import."*

Straight Scanning

Make sure you place your item onto the platen (the glass surface of the scanner) so that it is straight. Otherwise, you'll waste time trying to fix it in your photo-editing program. Of course, some people do post crooked photos onto eBay, but we don't recommend it, not only because it doesn't look good, but because it's counterproductive. To understand why, look at **Figures 9.4 and 9.5.**

Figure 9.4

Figure 9.5

Both scans are the same size, but all the details in the skewed version are much smaller than the details in the straight one.

Both photos are approximately the same file size, but Figure 9.5 provides more information while Figure 9.4 wastes a portion of its "real estate" on blank areas. Because the size of the photos that can be posted on eBay is limited by practical considerations, it would be a waste to have any image data posted that doesn't provide visual information to buyers (see "The right scanner settings for eBay" later in this chapter for more information about file sizes). Now look at Figure 9.4 closely; the individual postmarks and words are smaller than those in 9.5, so the buyer won't be able to see the details as clearly in the crooked photo. For picky buyers (who are the folks most likely to bid the highest), not being able to see the details can make or break the deal.

If your document is paper and is curling, put a piece of cardboard that is about the same size behind it so that you can better control the placement of the document on the glass. Avoid creating any permanent folds or creases when you close the scanner's lid.

If the scan isn't automated, then you'll need to do the following once the scanner's software is open:

1. Click on Prescan or Preview to view an image of your item.

2. Some scanner software automatically recognizes an item's size and position and puts a dotted line (marquee) around its image. If your scanner software doesn't do this, use the selection tool to draw it (**Figures 9.6 and 9.7**). Keep in mind that you may want to include a small border of background around the edges of your product to ensure potential buyers can see the condition of the sides and corners (**Figure 9.8**).

Figure 9.6 *Everything inside the dotted lines of the selection marquee will be scanned. Here, that includes too much background.*

Figure 9.7 *We clicked and dragged each of the marquee edges closer to the ticket. (This is done by holding down the mouse button while you move the mouse, which in turn moves the marquee on your screen.)*

Figure 9.8 *The scanned image of the Snow White commemorative ticket is just the right size, because of the adjustment we made to the selection marquee before we scanned it. If we had scanned the selection in Figure 9.6, we would have ended up with lots of excess background.*

3. Double-check your settings for height, width, scale and resolution, which are usually located to the left of the image preview in the scanner software. (See "The right scanner settings for eBay," later in this chapter for specifics.)

4. Press the Scan or OK button.

Scanning more than one photo at a time

Some scanners let you select several areas independently and then create separate files for each of the areas you selected. This capability can be useful in a couple different ways.

If you have a few small items that need scanning, you can put as many as will fit onto the scanner and get a separate photo for each one. You do this by selecting the image of each object with a separate marquee (**Figure 9.9**), setting the file size and/or dimensions for the individual frames and hitting the Scan or OK button.

Figure 9.9 *Using SilverFast software, which came with our Epson scanner, we can scan several different items at once, so each becomes a separate image file.*

In addition, you can create several photos from a single item, such as a picture of the entire object, plus several zoomed-in detail scans from small areas of the product. Because you can set the scanning size for each item, the results can be quite useful (**Figures 9.10 through 9.14**).

Not all scanners can capture more than one photo at a time. All other things being equal, we highly recommend getting one that provides this time and energy-saving feature.

Figure 9.11

Figure 9.10 *You can select several different portions of the same item to be scanned as separate files, each at different sizes.*

Figure 9.12

Figure 9.13

Figure 9.14

Figure 9.15

The result is that the scanned pictures of details (such as these stamps) can be as large as the overall photo, providing valuable visual information that will encourage bidding.

The right scanner settings for eBay

Have you ever tried to view an eBay auction (or any Web page, for that matter) that took an inordinately long time to open? Usually, the reason is that the photos on it are too large, and sending such enormous files over the Internet to your computer takes extra time. What do you think happens if a buyer clicks on your auction page to open it and instead has to wait and wait to see it? Well, when it's us, we simply click to another auction listing. And we're the rule rather than the exception. Folks just don't have the patience to wait for large pictures to open.

On the other hand, if a photo is too small, it won't provide enough visual information to encourage bids.

We typically recommend setting your scanning size so that it fits into a file that is no more than 800 x 600 pixels, or about 1.4MB (megabytes). If you plan to use the standard eBay Picture Services (as opposed to the premium SuperSize or other photo hosting services), 500 x 375 pixels works well, or about 500KB (kilobytes). We go into more detail explaining the pros and cons of the different photo services and their size requirements in Chapter 12, "Posting your Photo on eBay."

After you have drawn your marquee around the area you want scanned (see "Getting your scan," earlier in this chapter), then you should check your scanning settings and make sure that the largest dimension (width or height) is no more than 800 pixels (or 500 pixels for eBay Picture Services).

Other scanner-setting options you'll want to have include:

◆ RGB color, or 24-bit color, which is the universal setting for full, high-quality, continuous tone photographs. Anything less, and the colors somehow look wrong, more like a poster than a photograph.

◆ A reflective original setting, which scans solid, non-transparent items, or a transparency setting, if you are using the transparency adapter, to scan transparent objects.

Don't let dust devalue your product

A scanner's worst enemy is dust. Because a scanner is an electrically charged device, it generates static electricity and attracts dust like foxes to a henhouse. Every piece of hair or speck of dust on the platen is recorded and prominently displayed on the scanned image. This can make your product look dirty or even damaged. So either eliminate the dust and hair before you scan, or spend valuable time editing in your photo-editing program. (See Chapter 11, "Photo-Editing Techniques that Make Pictures Zing," to learn how to remove unwanted blemishes from your picture using a clone tool.)

We keep the following items near our scanner to help us eliminate dust, dirt and hair:

+ Canned air

+ Anti-static cloth

+ Camel's hair brush

+ Windex or similar cleaning solvent

(HP PhotoSmart 945)

Figure 9.16 *We keep canned air (with an attached anti-static gun) and our StaticMaster camel's hair brush near our scanner, as well as glass cleaner and a soft lint-free anti-static cloth.*

The best way to blow dust and debris away is to use canned, pressurized air. Not just any air, but anti-static air, so that it doesn't attract more dust than it blows away. You can buy cans of anti-static air at Staples, Office Max, Circuit City or any good photo or electronics store. Or you can get regular canned air and add an anti-static gun like the one we have from Kinetronics (**Figure 9.16**).

In addition to air, we recommend having a clean anti-static cloth. Some commercial cleaning cloths are saturated with a cleaning agent that doesn't leave streaks, but pushes dust away (without building up a negative static charge which would attract even more dust).

We frequently sweep the glass—as well as the originals to be scanned—with a $30 StaticMaster 3-inch camel's hair brush. Its replaceable Polonium-210 strip releases a charged stream of ion particles that prevents static buildup. Actually, any camel's hair brush will do, but unless it is specifically anti-static, you'll have to use it in conjunction with the anti-static canned air.

If you are scanning a newspaper or magazine, you might notice a background pattern that isn't visible to the naked eye. This pattern is related to how the page was originally printed. Try using a "descreen" option, available on most scanner software, to remove it. Descreening works by melding the dots together so the scan looks more like a photo than a series of tiny printing dots.

We sometimes clean the platen with plain old glass cleaner. However, ammonia-based cleaners in general often leave annoying white streaks that are devilishly difficult to eliminate. So instead of wiping and drying with a cloth, we use crumpled up newspaper. Believe it or not, that's the best way to avoid streaking.

Using contrasting backdrops

Most scanner lids have a white underside, so the area not covered by the item you're scanning will appear white in the picture. This works well much of the time. But as we discussed in Chapter 3, "Getting Great eBay Photos," a contrasting background is usually better for showing your item to its best advantage. If what you are scanning is white or light-colored, it's particularly important to set it off with a darker, complementary background.

We keep a small black cloth next to our scanner. In addition, we periodically use solid colored scarves or other small pieces of material, if the product would look better with color instead of black in the background.

Simply place your item onto the glass platen (straight, of course) and then cover it with the cloth. Close the scanner lid and scan as you usually do.

By the way, a few scanners have reversible backs, which can be easily switched from white to black, and vice versa.

Unconventional scanning for high-quality photos in less time

Many scanners have articulated lid hinges, which lets you put thick items onto the platen and still close the lid on top of them. Manufacturers pictured these hinges coming in handy for scanning thick items such as books, but we take advantage of them to scan items that are typically photographed rather than scanned, such as small dolls, watches, pins and flat plates. Small details, such as makers' marks and the painting of doll's eyes are much easier to scan than to take close-up photos of them (**Figures 9.17 through 9.19**).

When scanning in items that have some curve to them (like our Rockwell plate), we have sometimes experienced internal reflections within the scan, such as the discoloration at the bottom of the word "authenticated" in Figure 9.18. When it is distracting or unappealing, there's usually no recourse other than to take the item out of the scanner and photograph it either with a copy stand, or on one of our tabletop setups.

Figure 9.17 *If you're careful with your lighting and camera settings and use a tripod, you could probably get a good, clear photo of the information on the back of our Normal Rockwell plate. But it would take more effort and time than scanning it, which gave us this excellent picture with no planning and in very little time.*

Figure 9.18

Figure 9.19

Zooming in on the images of the plate's rather small seals with a camera would be quite difficult. But we got them at the same time as the scan in Figure 9.17, using our scanner's multiple-image selection feature.

Scanner, Copystand or Tabletop Setup?

We have found no foolproof rules for deciding which to use for our eBay photographs: scanner, copy stand or tabletop setup. However, here are some guidelines:

✦ If it is flat and fits on a scanner, definitely scan it.

✦ If it is nearly flat and fits on a scanner, try scanning, which is always easier and faster than photographing it. If for some reason that doesn't work, then try a copy stand or table-top setup.

✦ If it is flat, too large for your scanner, but fits on a copy stand, use the copy stand.

✦ If it is flat and won't fit on a scanner, copy stand or tabletop setup (or would be awkward to photograph on a tabletop), put it on a wall or the floor and photograph it there.

We often combine the various techniques to get different pictures of the same item. For instance, we took photographs of the front of the Normal Rockwell plate (which you can see in Chapter 5, "Great Lighting the Easy Way"), used the copy stand to get pictures of the original box, and scanned in the back of the plate (Figures 9.17, 9.18 and 9.19), as well as the printed certificate of authenticity and details of the box.

Another problem, which is much easier to remedy, is that when the lid is raised a bit or all the way to accommodate items that have some depth to them, light can get inside the scanner, affecting the device's excellent automatic exposure. The solution is easy: Just cover the entire scanner with a black light-blocking cloth (**Figure 9.20**).

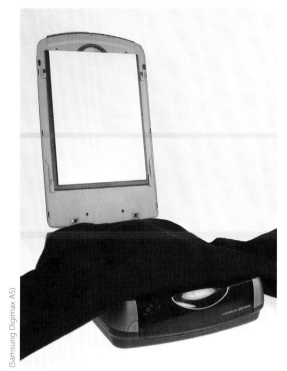

Figure 9.20 *When we scan thick items, we always put a light-resistant black cloth over the scanner to keep light from altering the scanner's exposure reading. Sometimes we put the lid down first (such as over books), but we often leave the lid up to avoid putting pressure on valuable items and possibly causing damage (such as a broken book spine).*

(Samsung Digimax A5)

Copy Stands

We sometimes humorously refer to a copy stand as a "camera on a stick," because, when you come right down to it, that's exactly what a copy stand is (**Figure 9.21**). Copy stands are useful for photographing items too large to fit on a scanner (such as posters or oil paintings), relatively flat objects having some depth or detail (like ornate scroll work on antique picture frames), or three-dimensional articles that can't be easily stood up when shooting (such as porcelain platters or hand-crocheted linens). No wonder used copy stands sell like hot cakes on eBay.

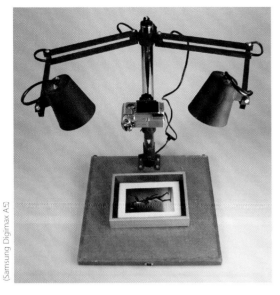

Figure 9.21 *We purchased this copy stand about 15 years ago (for $40) through a Shutterbug Magazine ad.*

(Samsung Digimax A5)

Copy stands come in all sizes and configurations. Alas, if you don't have a fairly good idea of what you want and need beforehand, you may get stuck with a gizmo that you'll hate to use, or worse yet, won't allow you to take great product shots.

Here's what you should look for when selecting and buying a copy stand:

✦ Get one designed for a 35mm camera. Heavy-duty copy stands made for medium-size and large-size cameras are big, heavy, hard to work with and usually cost a lot more than those designed for smaller cameras.

✦ Make sure that it comes with matched lights. Properly illuminating items shot on a copy stand can be very difficult to do properly if you have to use improvised lighting or lights not originally designed to work with your particular copy stand.

✦ The column and the baseboard must be big enough to accommodate the items you'll be photographing. If you're shooting something larger than the copy stand's baseboard, chances are the column won't be tall enough for your camera to capture it all in a single shot. In addition, the lights wouldn't be large enough to properly illuminate the item without some vignetting or falloff on the edges.

✦ Buy a copy stand that features a crank, counter-balance or friction movement. Cheap stands that you must manually push up or down are clumsy and somewhat inconvenient to use.

- Create a space on your desk or floor to place the copy stand so that when you mount your digital camera vertically on the column, you can easily view its LCD screen. Otherwise, you may need a step stool or stepladder to peer down onto the LCD screen to see exactly what your camera is capturing.

Bogen, Beseler, Kaiser, Testrite and Bencher are the best-known copy stand brands, but there are many other no-name and generic versions. Of course, you can buy one new, but there's no reason not to look for a much less expensive used one. Going prices on eBay for copy stands with attached lights run the gamut in price, from about $25 to many hundreds of dollars.

We created our own copy stand platform by stacking two flat-file six-drawer cabinets (the type used for storing blueprints) on top of each other. (We bought the filing cabinets at going-out-of-business sale for a local office-furniture store.) The large file drawers are great for holding original prints, drawings and posters, with specific drawers dedicated to items still to be photographed, items to be packaged and shipped and even one for spare light bulbs and other accessories (**Figure 9.22**).

Figure 9.22 *Our larger copy stand sits on a set of lateral file cabinets that are great for keeping our flat items organized, but it means we need to use a step stool to see the camera's controls and LCD viewfinder.*

(Pentax Optio SV)

Notice in Figure 9.22 that the copy stand's baseboard has a grid of lines etched into it. That makes it easier to square up your item so that you don't end up with a skewed picture. If your copy stand doesn't have lines like that, we recommend creating some. Or, at the very least, take the time to arrange your object so its edges are parallel to the edges of the baseboard.

Like scanners, there are certain accessories that you'll want to keep near your copy stand: canned air, an anti-static cleaning cloth and maybe some glass cleaner. The glass cleaner is handy if you decide you want to keep a piece of quarter-inch plate glass on hand to cover your paper items and keep them flat while you're shooting. If you do, make sure that when you have the glass cut at your local glass and mirror store it is at least an inch larger on all sides than your largest originals. Also ask them if they can round the corners and sand the edges so that you don't cut yourself when you handle it. Another accessory we keep on our copy stand is a level (available in any hardware store), to make certain that the camera is absolutely parallel to the item being copied. Otherwise, both the focus and the perspective may be off.

Lay It on the Floor or Tape It to the Wall

Why buy a copy stand or a scanner when you have a perfectly good, readily accessible surface for shooting flat items? We often put prints, posters and other artwork right on the floor, bend over it, and take a quick shot using the camera's flash as our primary light source. It usually works well. For a sharper, steadier shot, we'll put the camera on a tripod and adjust its legs so the camera lens hovers above the middle of the item we're shooting.

For a neutral background, we make certain the object is positioned on bare hardwood or on a piece of plain carpeting (*not* on one of our Orientals!). We also set our zoom lens approximately midway between wide angle and telephoto to help eliminate any possible distortion. Although depth of field is not critical with flat items, we do stop the lens down a bit (to about *f*5.6) to compensate for not shooting precisely parallel to the floor. However, we have to be very careful not to have our feet or the tripod legs in the photo.

When the item is too large to fit into the viewfinder, we haul out our stepladder, climb up, lean over and shoot. The camera's flash usually illuminates with no problem, but if it's too weak, or creates glare or a hotspot, we'll move a pair of studio lights over and point them at the item. A couple of shots quickly tells us whether or not the illumination is strong and even enough, or if we need to reposition the lights. By the way, there are tripod heads and movable arms that clamp onto ladders, designed specifically for shooting from an overhead position. They'll give you more stability and of course, sharper pictures.

But please, be careful if you do decide to climb a ladder. Our photo ladder is specially designed as a steady platform.

Similarly, we often put large linens and similar items flat against a wall, using clamps, clothes line and straight pins (to attach to the clothes line). It's often the only way to show off the entire quilt, sheet, lace panels and so on.

Build Your Own Vacuum Frame

Glass is a good, inexpensive way of keeping your items flat, but it does come with one big problem: reflection. Usually, you can minimize or eliminate most reflections using a trial-and-error method of angling your lights. But the best way to keep your papers and sheets flat while shooting is to use a vacuum frame. Graphic arts vacuum frames can cost hundreds or even thousands of dollars—or you can make your own for about $75 (**Figure 9.23**). Here's how:

1. Buy or build a simple wooden window casement about 3-inches thick, with the width and length the same size as the vacuum frame you want (ours is 24 inches x 36 inches).
2. Have a piece of plywood cut to the size of the casement, and nail or screw it to the bottom, so that you end up with an open box.
3. Seal all the inside seams using wood putty, glue or bathtub caulking.
4. Have a piece of pegboard cut to the size of the casement, and nail or screw it to the top of the casement.
5. Drill a 1.5-inch circular hole in the side of the frame. Then slip a 12-inch long piece of 1.5-inch circular PVC pipe into the hole so that half of the pipe is inside the frame and half is sticking out.
6. Seal all the outside seams with wood putty, glue or bathtub caulking.
7. After the seal has dried, paint the entire frame a matte black.

Your vacuum frame is now ready. All you have to do is attach a vacuum cleaner hose to the pipe (we use a $35 shop vacuum), which nicely substitutes for an expensive vacuum pump. Lay the original over the pegboard holes, cover up any open peg-holes with black construction paper and turn the vacuum cleaner on. It's noisy, but it keeps any paper items as flat as proverbial pancakes.

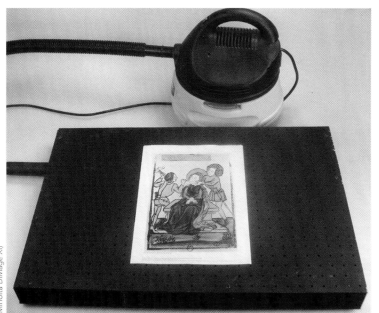

(Minolta DiMage XI)

Figure 9.23 *Our homemade vacuum frame connected to its shop vacuum. Normally, the uncovered peg holes would be covered with black construction paper to maximize the vacuum's suction, but we kept them uncovered for this picture so that you can see how the frame was made.*

Efficiently Handling Your Pictures After the Shoot

Organizing and managing the large number of image files that a typical eBay seller generates can seem like a daunting task. But once you develop a system for downloading your photos from your camera and scanner, and then name and save them so that they are easy to find and retrieve, it will become a nearly automated process.

In this chapter, we'll walk you through the painless processes of moving pictures from your digital camera onto your computer, organizing your eBay shots so that you'll always be able to access them quickly and easily, and using batch processing to save time.

Getting Your Pictures into the Computer

Transferring photos from a digital camera to a computer is one of the greatest concerns—and frustrations—of new digital photographers. But those who have been doing it for some time will tell you it's one of the easiest aspects of digital photography.

The transfer process involves two elements:

✦ The hardware that enables the connection between the camera and the computer so that the digital images can be physically moved

✦ The software programs that do the actual transferring

Hardware

Before you can initiate any transfers, you need to establish some sort of connection between your camera and your computer so that they can communicate with each other. Generally speaking, you can use any of four possible hardware connections to get your digital photos into your computer:

✦ A cable connecting the camera and the computer

✦ A memory card reader

✦ A camera dock or cradle

✦ A wireless transmission

A direct connection

For many years, the only way to get your digital camera to communicate with a computer was to plug in a cable that would physically connect the two of them. A direct connection doesn't cost you anything extra, because the software and cable you need almost always come in the box your camera shipped in.

Most new digital cameras use USB or FireWire (IEEE 1394) connectors (**Figures 10.1 and 10.2**). The latest, most advanced models use USB 2.0 rather than the older USB 1.1 interface. (USB 2.0 is between 12 and 40 times faster than 1.1.) FireWire has an even faster throughput (sustained speed) than USB 2.0, but it is usually found only in higher-end and professional cameras.

If you are going to use a direct connection to connect your camera to the computer, we recommend keeping the USB cord that came with your camera permanently plugged in to the back of your computer, with the unused end dangling at the front. That way, you can reach it quickly and easily when you want to plug in your camera. (Yes, we know most computers now have USB ports in front, too, but leave those open for those things you must insert and remove on a regular basis, such as key drives.)

When your camera is connected via USB to a modern desktop computer, the computer automatically recognizes it, as though it were a hard drive inside the computer. That's when the computer system's software takes over. All you need to do is open Windows Explorer or Apple iPhoto, and you can immediately view the photos on the connected camera.

TIP

Any computer that runs Windows XP or Mac OS X automatically recognizes an attached camera or memory card. See "Treating the Digital Camera or Memory Card as a Hard Drive" in the Appendix for more information.

(Olympus E-1)

FireWire port

IEEE 1394

USB port

VIDEO OUT

DC-IN

Figure 10.1 *The ports (or holes) for plugging in a USB cord (as well as FireWire, if your camera has it) are typically found under a flap on your camera.*

Figure 10.2 *This universal symbol for USB is usually etched or printed next to the port on your camera and the corresponding port on your computer.*

A memory card reader

We have memory card readers plugged into a USB port at every computer in our studio (**Figure 10.3**). Card readers are much more convenient than a direct connection: After we're finished shooting, we don't have to take our camera off its tripod to transfer our photos to the computer. We just remove the memory card from the camera and insert it into the reader.

Our readers are compatible with just about every kind of memory card on the market (**Figure 10.4**). But if your digital camera is the only device you have that uses memory cards, you can save money by getting a reader that is dedicated to only that one type of card. (PDAs, MP3s, digital tape recorders, camera phones and even many digital camcorders also use memory cards.)

In the same way that newer-model computers immediately recognize digital cameras connected to the computer via a direct connection, they also recognize memory cards after you insert a memory card into a connected reader (see the sidebar, "Treating the Digital Camera or Memory Card as a Hard Drive").

Figure 10.3 *Every computer in our studio has a memory card reader permanently attached to a USB port.*

(Konica Minolta DiMage A2)

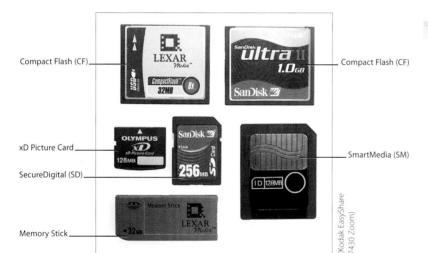

Compact Flash (CF)

xD Picture Card

SecureDigital (SD)

Memory Stick

Compact Flash (CF)

SmartMedia (SM)

(Kodak EasyShare 7430 Zoom)

Figure 10.4 *Some memory card readers are compatible with many different types of memory cards, such as Compact Flash, xD Picture Card, SD (or SecureDigital), SmartMedia and Memory Stick. However, your camera likely uses only one type, or at the most a couple of different kinds, so you should choose your reader based on the type of memory card(s) you'll be using.*

If you plan to use a memory card reader, you'll prefer working with a digital camera whose memory card slot isn't on the bottom. That way, when the camera is on a tripod, you'll still be able to remove and replace your memory card without taking the camera off the tripod.

A camera dock

A number of digital cameras are designed to work with cradles, or docks (**Figures 10.5 and 10.6**). Like memory card readers, the cradle remains plugged into your computer's USB port. When you want to download your pictures from the camera to the computer, you simply insert the camera into its dock and, with most models, press a button, which initiates an automated download, as well as other processes (depending on the brand and how you set up the cradle).

Figure 10.5

Figure 10.6

Each manufacturer has its own type of cradle, and they are not interchangeable. Notice how different Kodak's and Fujifilm's cradles are.

Camera docks have two other important advantages:

+ They recharge the camera's batteries.

+ Because you'll naturally get in the habit of leaving your camera in the cradle after transferring your images to the computer, you'll always know where your camera is when you're not shooting. (For those of us who can't remember where our keys are five minutes after putting them down, this is important.)

Some manufacturers include the cradle in the price of the camera, while others charge extra. They are great conveniences, but only if you take the time to read the user's manual and program yours to automate the downloading in the manner that best fits your needs.

A wireless transmission

Only a handful of current-model cameras are capable of transmitting pictures wirelessly to your computer, but we anticipate more next-generation digital cameras will come equipped with this capability. If you don't want to wait (or you're

not willing to splurge for one of the current models that has a wireless interface), you can buy add-on devices, such as special memory cards, that also have wireless interfaces and antennas built in. Of course, you need a wireless network for these devices to work.

If you are fortunate enough to have a state-of-the-art wireless digital camera, or have an add-on wireless device like SanDisk's wireless memory cards, transferring your images to your computer is as easily as pressing a button or activating a menu command on your camera. Once activated, the wireless interface automatically detects and communicates with any wireless network hub or router within range. Assuming that the software is set up properly, it will begin transmitting the images directly into the designated computer folder.

When the next generation of digital cameras does arrive, most of these cameras will be able to transmit images directly to photo printers and computers. We wouldn't be surprised if cameras someday come equipped with some sort of eBay direct connect that automatically sends your photo to the item listing on eBay. Alas, that's still at least a few years away from reality...but not too many years, we suspect.

Software

Most of today's photo-related programs, such as ACDSee and other image-database programs, include a utility that automates the downloading of your photos from a connected camera or memory card. In fact, even many current photo printers, such as those from Hewlett-Packard and Lexmark, come with such utilities. And of course, many photo-editing programs, such as Photoshop Elements, have the same capability. When any of these are installed onto your system, they bypass the Windows or iPhoto download interface and use their own. In other words, when you insert your memory card or attach your camera, the installed program pops up a window on your computer that does one of two things:

✦ It displays your pictures and asks you what you want to do with them.

✦ It automatically copies and saves your photos to a folder you previously designated on your computer's hard drive.

Both options are often (but not always) available in the same utility. For the automatic download, you will probably need to configure the program initially. This may require reading the documentation or checking out the Help menu. But after you've configured it, everything should work with no further intervention on your part.

Let's look at how Photoshop Elements handles these processes to provide you with some insights as to your options and how this type of program enables automated downloads.

Not Using a Photo-Editing Program?

If you don't have Photoshop Elements or any of the other programs that provide download utilities, and if your computer uses Mac OS X or Windows XP, your operating system takes over the process.

On a Windows XP system, the first time you connect a camera or insert a memory card, a dialog box pops up, asking what you want the computer to do with the photos on that card or camera (**Figure 10.7**).

Figure 10.7 *Initially, Windows XP displays this dialog box whenever you connect your camera or insert a memory card or any other removable drive.*

The Windows XP dialog box presents a number of options, including automatically transferring the photos to a specific folder, copying the pictures to the hard drive and opening the images in photo-related programs you have installed on your computer. What happens next depends on what software you have installed on your computer and which option you choose. If you choose to "Copy pictures to a folder on my computer using Microsoft Scanner and Camera Wizard," the wizard launches automatically and guides you step by step through the process of transferring your photos to a specific folder on your computer. This wizard has many of the same options you'll find in other programs, including Apple's iPhoto:

+ Viewing all the photos on the memory card
+ Rotating specific pictures
+ Renaming selected pictures at once
+ Saving photos to a specific folder on your computer

Once you have chosen how you want Windows to react to an attached camera or inserted memory card, if you select the Always Do the Selected Action option, your computer will bypass this dialog box whenever it detects a camera or inserted card and automatically execute your chosen option.

If you use Mac OS X, as soon as you connect your camera or insert your memory card into a reader, iPhoto copies your pictures to your computer when you choose the Import command. iPhoto also provides tools for organizing your photos and some basic photo editing tools. In many respects, all the other operations we discuss in this chapter are accomplished with iPhoto using very similar commands to those used in Photoshop Elements.

Downloading photos using Photoshop Elements

If you have Adobe Photoshop Elements installed on your computer, whenever you attach a digital camera or insert a memory card, the Downloader utility in Photoshop Elements opens and displays all the photos on the camera or card (**Figure 10.8**). It happens automatically; you don't even have to have the program open or active.

Figure 10.8 *When Adobe Photoshop Elements Downloader pops up on your computer screen, it automatically displays all the photos on your attached camera or inserted memory card.*

You can leave all the fields in the Downloader at their defaults and simply click on the Get Photos button to transfer the photos to your computer. Just be sure to pay attention to where it saves the pictures so that you can find them again. By default, the Downloader creates a new subfolder on your computer in the Adobe/ Digital Camera Photos folder. The name of the subfolder is based on the date and time of transfer. For example, in the Save Files field in Figure 10.8, the subfolder name is 2005-04-25-2226-01. Software engineers obviously seem to think it's apparent to everyone that those numbers refer to April 25, 2005, at 10:26:01 p.m.

We prefer to take control over the download ourselves so that we can use names of folders and files that make sense to us.

Here's how we use the Downloader utility:

1. In the Save Files section of the Downloader dialog box, first determine exactly where the pictures will be saved on your computer. We always save our eBay product shots in a folder we have created specifically for that purpose and which we have named, quite logically, "eBay Photos" (**Figure 10.9**).

2. Designate a separate subfolder for each product by selecting the Create Subfolder Using option and assigning a sensible name. In Figure 10.9, we assigned the name "Italy doll" to the subfolder. That way, when we're looking for our pictures of the Italian doll that we want to post on eBay, we will always be able to find them.

Figure 10.9 *Whenever we use Elements' Downloader or any similar utility, we replace the default names and folders with names and locations that make sense to us so that we can easily find them again. Notice the blue outline around some of the thumbnails, which indicates that we have selected them in preparation for rotating them.*

3. Rename the files by selecting the Rename Files To option and entering a descriptive root name, to which the Downloader will automatically add consecutive numbers.

 Like the cryptic date/time folder name, all digital cameras assign anonymous file names to photos that are impossible to recognize and are, therefore, quite useless. When you see names like dc987.jpg or dsc0214.jpg, how can you possibly know whether it's a picture of your summer vacation or of the porcelain figurine you have for sale? It's better to rename them using filenames you'll easily recognize.

4. Notice how several of the photos in Figure 10.9 are on their sides. Whenever we take photos of products that are taller than they are wide, we turn our cameras 90 degrees, to capture a vertical rather than horizontal picture. Some cameras automatically turn the picture, so it is upright when you look at it. But most cameras don't. So, if you don't rotate them sometime before posting them onto eBay, buyers will have to crane their necks sideways to try to see what's for sale.

 To rotate several pictures at once, you first have to select them, telling the program which ones should be affected by the command:

 ✦ To select contiguous photos (ones that are next to each other), click on the first thumbnail picture, hold down the Shift key, and click on the last thumbnail.

 ✦ To select several photos that aren't next to each other, click on the first, then hold down the Command key (on Macs) or the Ctrl key (on PCs) while clicking on all the other pictures you want.

 Once all the photos you want to rotate are selected, click on one of the icons in the lower left corner of the Downloader to rotate the selected pictures either counterclockwise (the left icon) or clockwise (the right icon).

5. Click the Get Photos button, and the pictures are saved where you want them, using the names you've chosen, with each one rotated correctly.

The ability to apply a command or groups of commands to several photos at once is called *batch processing*. It's an invaluable time-saver.

Managing Your Photo Files

Anyone who has been using a digital camera for more than a few months can attest to the vast volume of digital photos you can accumulate on your computer. Photo management programs and utilities, such as iPhoto or the Organizer utility in Photoshop Elements, display a collection of thumbnail views of your photos so that you can organize and edit them one at a time or as a batch (**Figure 10.10**).

Like the download utilities we discussed in the previous section, organizers can save you time because they provide various batch-processing capabilities, including rotating or renaming whole groups of photos. Other tools help you copy and archive your files efficiently.

Let's look at how the Organizer utility in Photoshop Elements works. It follows the same standard practices used by iPhoto and other similar programs.

1. Notice the handful of vertical photos in Figure 10.10 that have blue outlines. The outlines indicate that we've clicked on those photos to select them (see the previous section on the Downloader utility for instructions on how to select photos).

2. Open the Edit menu by choosing Edit from the main menu.

3. Choose Rotate Selected Photos 90° Right (**Figure 10.11**). All the selected photos are turned clockwise by 90 degrees (**Figure 10.12**).

Figure 10.10 *Management programs and utilities like Organizer in Photoshop Elements are useful for helping gain some control over the vast number of digital photos that your computer can hold.*

Figure 10.11 *The Edit menu has numerous commands we could apply to the selected group of photos. Here we have chosen Rotate Selected Photos 90° Right.*

Figure 10.12 *All the photos we had selected are now upright.*

Protecting your original photo files

We discuss in Chapter 11, "Photo-Editing Techniques that Make Pictures Zing," various editing techniques that will make your photos more effective sales tools for eBay. But before you do any photo editing, you should save your original pictures to separate files and work only on copies. That way, if you have any difficulties or make any mistakes, you won't have to reshoot the product.

Copying your originals is another batch process you can do with your organizing program, and the procedure is nearly identical to the batch rotating we described in the previous section. It can be done using the Organizer utility in Photoshop Elements Organizer, iPhoto, Windows Explorer and other programs.

Let's look at how it's done using Windows Explorer:

1. Select all the original photos (**Figure 10.13**).

Figure 10.13 *The blue outlines around all the product shots of our quilted pillowcase indicate that we've selected them.*

2. Choose Edit > Copy from the main menu (**Figure 10.14**).

Figure 10.14 *The Copy command is found within the Edit menu on the main menu of any program.*

3. Choose Edit > Paste from the main menu to create copies of all the selected photos in the same folder (**Figures 10.15 and 10.16**). If you navigate to a different folder before using the Paste command, the copies will be saved in the new folder.

Figure 10.15 *The Paste command is always in the same menu as the Copy command.*

Figure 10.16 *The duplicate photo files are displayed in the quilted pillowcase folder.*

Once you have duplicates, you can edit the files to your heart's content and still be assured that the originals will remain intact, in case you ever need to go back to square one in your editing.

Archiving Your Photos

We tend to sell one-of-a-kind items on eBay. So, we keep our photos on our hard drive for only about a month after the buyer has received the product and left feedback. That extra time is added insurance in case the buyer has any problems or complaints. The photos are part of our proof that we described the item accurately.

However, if you plan to sell the same item again, it makes sense to hold on to your photos, storing them both on your hard drive and on a backup system of some sort. The easiest way to back them up is by storing them on CDs. Most computers running Windows XP or Mac OS X have the capability to "burn," or copy files, to CD. Here's how we do it:

1. Open iPhoto or Windows Explorer.

2. Put a blank CD into your computer's CD drive.

3. Select the photos on your memory card or in your camera that you want to archive by doing one of the following:

 ✦ To select a group of contiguous files, click on the first photo file, and then press and hold the Shift key while clicking on the last photo file in the series.

 ✦ To select several photos that aren't contiguous, click on the first one, and then press and hold the Ctrl key (on a PC) or the Command key (on a Mac) while clicking on each additional photo.

 ✦ If you want to archive an entire folder full of photos, just click on the name of the folder to select it.

4. Once all the photos you want to archive are selected, click and drag the photos onto the name of the CD drive.

5. Repeat Steps 3 and 4 with each folder that contains photos you want to archive.

6. Follow the prompts of the dialog box (or wizard) for burning those files to a CD.

Photo-Editing Techniques That Make Pictures Zing

Photo-editing programs are great for giving your product shots the final touch that makes them better, more appropriate and more effective for generating bids and sales for your eBay auctions. While we don't recommend spending too much time trying to fix poor-quality pictures—it's almost always faster and easier to reshoot bad photos than to try to edit them—we have found that a few minutes' work in a program such as Photoshop Elements can do wonders for improving color and exposure, cropping to better focus attention on your product, and resizing photos for optimum speed and quality on the auction page.

Quick Fixes

Be sure to save a copy of your original photo file separate from the version you edit. That way, if you make a mistake, you won't have to reshoot (see the section "Protecting your original files" in Chapter 10). In addition, we recommend saving versions of your photo as you edit it, so that you can return to intermediate points in your editing rather than having to go all the way back to the beginning, should it be necessary.

Most photo-editing programs have auto corrections and quick fixes that work well for typical eBay photographs.

Such quick fixes usually include the following commands (**Figure 11.1**):

◆ Auto fix, which analyzes the entire photo and tries to guess what it needs

◆ Auto exposure (sometimes called *auto levels*)

◆ Auto color

◆ Auto sharpen

Figure 11.1 *The Quick Fix interface in Photoshop Elements includes a Before and After view, so that you can see the effects of your edits. Using the Auto Smart Fix button worked well for this picture, or we could have used the other individual auto commands on the right side of the screen, one at a time. Notice the Reset button beside the After photo, which deletes all the applied edits.*

Many photo-editing programs also have one-click rotate command, which is useful for those photos that you shoot vertically, so that the picture is tall rather than wide. However, if your software has a batch rotation command that applies the same edit to a series of photos all at once, we recommend using it instead of rotating one picture at a time. (See Chapter 10 "Efficiently Handling Your pictures After the Shoot.")

Usually we edit our photos in this order:

1. We try using Smart Fix to see what it does for our picture, which often is all the photo needs (**Figures 11.2 and 11.3**).

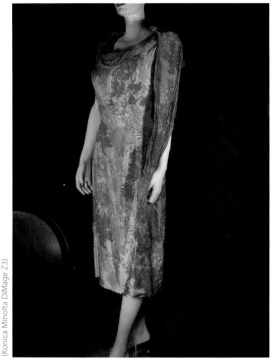

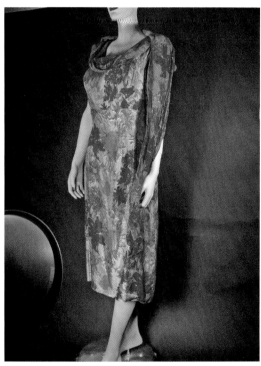

Figure 11.2 *This photo is too dark and the colors are muddy, mostly because it was shot at the wrong exposure, and we didn't use manual white balance.*

Figure 11.3 *Clicking once on Photoshop Elements' auto Smart Fix cleaned up the picture very nicely, but it's still a bit dull and doesn't show off the vibrant colors of the silk dress.*

(Konica Minolta DiMage Z3)

2. If Smart Fix works, we leave well enough alone. If it doesn't, we try one of the other Auto commands, such as auto levels to fine-tune the edits (**Figure 11.4**).

3. If these auto commands don't work (and if we decide to not do a reshoot), we do manual edits. (We describe these in the next section.)

Auto corrections work well most of the time and are very easy to use, requiring no more than a quick press of a mouse button. While quite powerful, they also can be destructive if you use them without paying attention to their effect on the color and exposure of your picture. In particular, over-sharpening can make a picture look grainy and unappealing. Even worse, over-sharpening can create an inaccurate photo of your product (**Figure 11.5**).

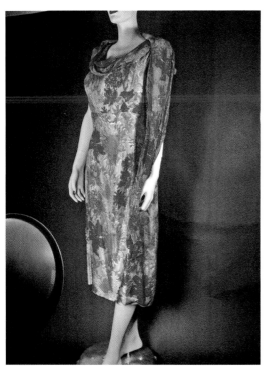

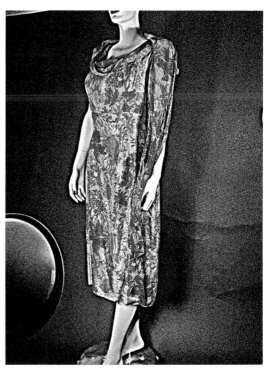

Figure 11.4 *After using the smart fix, we clicked on the auto levels button, which automatically corrected the exposure, making the colors and dynamic range of this photo much more lively and accurate. However, the photo has too much excess background in it for a good eBay product shot. We discuss how to crop the photo later in this chapter.*

Figure 11.5 *Dark outlines around the edges and a multitude of minuscule dots in this picture—called noise—are caused by too much sharpening.*

Similarities Among Photo-Editing Programs

All of the images in this chapter were edited using Photoshop Elements 3.0, an excellent, easy to use and powerful program. However, all the tools and commands we cover in this chapter are also available in most other photo-editing software, such as Corel PhotoPaint, Microsoft Digital Image Pro and Roxio PhotoSuite. In fact, if you are just starting out, you may want to try one of the free photo editors available such as IrfanView (www.irfanview.com). Regardless what photo-editing software you use, the Photoshop Elements interface that is captured in many of the screenshots in this chapter provides useful guidance (**Figure 11.6**).

Most photo-editing programs have interfaces similar to Figure 11.6 and follow typical software conventions, such as:

✦ Tools represented by icons, often grouped together in a "toolbox."

✦ Options controlling the icon's tools, usually accessed in either a status bar or a dialog box.

✦ A laundry list of specific controls or tools can be accessed by clicking on the words

displayed across the main menu at the top of the window and viewing their pull-down menus and options (**Figure 11.7**).

The best way to get comfortable with these programs is to use them fearlessly, experimenting with the various commands, icons and controls. You can almost always reverse any edit using the Undo command if you don't like it or make a mistake. And as long as you have saved a copy of your untouched original file, you don't really have to worry about ruining your picture.

Figure 11.7 *We chose Enhance from the main menu of the Photoshop Elements screen, which opens a pull-down menu that provides access to the tools used to adjust lighting.*

Figure 11.6 *The Photoshop Elements interface has several points of reference that are similar to most other photo-editing programs.*

When using any editing tools that change the nature of your photo, such as brightness, contrast, color or clone, be aware of how the changes affect the definitive details of your product, such as the gemstones in a necklace, the subtle gradations of color or the etched lines in a stained glass window. Reduce the amount of the edit if any such details are lost.

Correcting Exposure and Color

Quick fix tools are based on suppositions the software makes about your photo, which may or may not be correct. For instance, for certain tools, it may assume that the lightest point in the picture is meant to be white, but that isn't always true. Such erroneous assumptions can lead to auto corrections that make the picture look worse, or at least not any better than it was.

Sometimes, the only way to edit a picture well is to forego auto corrections and take over by manually editing the photo.

If your photos need slight adjustments to correct exposure or color, most photo-editing programs have at least the following easy to use tools:

✦ Contrast and brightness sliders

✦ Color-correction eyedropper

Your software may also have various tools for independently adjusting highlights, midtones and shadows.

Contrast and brightness sliders

Most digital photographs can benefit from a slight boost in contrast and brightness (**Figures 11.8 through 11.10**).

When you use the brightness and contrast sliders, keep the following in mind:

✦ A change in one control (brightness or contrast) usually requires a similar, though not always equal, change in the other.

✦ Be careful to not overdo it. Increasing contrast too much destroys details in the shadows and highlights, while reducing the midtones (**Figure 11.11**). And too much brightness makes a photo look dull, boring and underexposed (**Figure 11.12**).

✦ Make sure the Preview option is checked, to help you gauge the effect of your edits on the photo.

Figure 11.8 *The photo is nicely exposed with good color, but it could be improved.*

Figure 11.9 *The increase to 10 in both brightness and contrast made this version of the doll's photo a bit more lively and exciting, without altering the accuracy of the picture.*

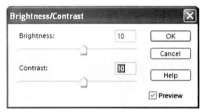

Figure 11.10 *When you use the brightness and contrast sliders, be sure to have the preview option checked so that you can be sure not to overdo with this powerful control.*

Figure 11.11 *Increasing contrast too much creates an unappealing photo, in which the details in the shadows and highlights are lost.*

Figure 11.12 *A photo that has been brightened too much becomes dull and overexposed.*

Adjusting shadows, midtones, highlights

The contrast and brightness sliders are great, but they apply their edits across the board to everything in your photo. What if your picture's highlights and shadows are just right, but the midtones are too dark? Perhaps, it's the highlights or shadows that need adjusting, but everything else is fine.

Some programs provide the following tools for independently editing shadows, midtones and highlights:

✦ Sliders for shadows, midtones and highlights

✦ Levels, or histograms

Using individual slider controls

Very few programs have individual sliders for shadows, midtones and highlights, which is unfortunate, because they can be remarkably useful for handling photos taken in difficult to shoot situations (**Figures 11.13 through 11.16**).

(Kodak EasyShare DX6490 Zoom)

Figure 11.13 *Photographing the interior of a house on a sunny day can be quite difficult, especially if you also want to show the outside through the windows. The challenge is finding the right exposure setting that captures both the details in the bright sunlight as well as in the comparatively shadowy room.*

Figure 11.14 *When we used brightness and contrast sliders on this photo to brighten the inside, we lost details of the outside deck, hot tub and backyard trees in overexposure.*

Figure 11.15 *The Shadow/ Highlights tool in Photoshop Elements's let us adjust the shadows, highlights and midtone contrast independently.*

Figure 11.16 *Notice how the interior of the room is now well exposed, but unlike Figure 11.14, the exposure of the scene through the patio doors has maintained visual integrity.*

Using a software histogram

In Chapter 4, "Exposure and Focus," we showed you how to use the histogram available in many digital cameras to zero in on the right exposure for each photo. Histograms have their roots in photo-editing programs, where they are often called *levels*. The difference between the software and hardware versions lies in how you use them. In cameras, they are simply graphs providing a statistical analysis of what percentage of the image are shadows, midtones or highlights. But in software, we can use them to manipulate specific areas of exposure (**Figures 11.17 through 11.19**).

Highlight pointer / Dark pointer / Midtone pointer

Figure 11.17 *The histogram of this underexposed image has no data in the highlights area (to the right), but lots in both the midtones and shadows.*

Figure 11.18 *Moving the Highlight pointer to the left until it aligns under the right side of the graph's data remaps or changes the brightest point in the photo to white, as well as lightens all the data down to the midtones. However, the midtones are now too light.*

Figure 11.19 *Moving the Midtone pointer slightly to the right darkens the midtones without affecting the highlights or shadows. Notice that at no time did we change the shadows using the Dark pointer.*

Software histograms are one of those tools that are easier to use than to explain. We recommend experimenting with them, moving the pointers to see what effect they have on your picture (with the preview option is checked). That's how we learned to use them.

The color-correction eyedropper

Sometimes, regardless how careful you are with white balance and lighting, a photograph's color may be off, introducing a color cast, or shift, that makes the entire picture inaccurate and unattractive (**Figures 11.20 through 11.22**).

Some programs have three color-correction eyedroppers, called *black point*, *white point*, and *gray point* (**Figure 11.23**).

To use the Black Point tool, click on a spot in your photo that should be truly black. Similarly, the White Point tool should be clicked on a spot in your photo that is meant to be pure white. These tools help adjust exposure as well as color. However, be very careful using them. If you click on a point in your photo that is not meant to be black or white, quite a bit of color and exposure information can be destroyed. That's whe the Undo command, which reverses your last edit, can be invaluable.

(Panasonic Lumix DMC-FZ3)

Figure 11.20 *This photograph was taken under fluorescent light, using the wrong white balance setting (for daylight instead of fluorescents), which caused a greenish color shift.*

Figure 11.21 *Photoshop Elements' color-cast control is a gray-point eyedropper. Using the eyedropper, we clicked in the background of the photo, which we knew should be a neutral gray because our shooting table (the background) has no inherent color.*

Figure 11.22 *With the area that should be gray set to a truly neutral gray, the color shift has been removed, giving us an accurate reproduction of the miniature's true color.*

Black Point
Gray Point
White Point

Figure 11.23 *Black Point, Gray Point and White Point eyedropper tools are distinguished from each other by the color inside the eyedropper tube in the icon.*

Creating and Using Macros for Greater Efficiency

Once you get your eBay photography organized into an assembly-line-type of production, you will likely find that you are applying the same edits to groups of pictures. This is especially true for series of photos that you shoot under the same lighting conditions with the same background. For example, you might find yourself opening each photo; selecting the tool needed, such as brightness and contrast or levels; adjusting the sliders; and applying the adjustment. Then if you need to correct, say, the color, you also apply an auto color to the photo. Once you've edited and saved these changes on one photo, you might find yourself repeating these exact steps for every photo in the series.

A much more efficient method is to create a *macro*, which is also called an *action*, to streamline your edits.

Macros are a type of batch processing that records a specific series of steps, as you do them to one photo. (For information on other kinds of batch processing, see Chapter 10.) When you invoke the macro on another photo, the software automatically applies all the same steps with a single mouse click. Some programs even apply macros to entire groups of photos.

Any time you find yourself doing the same edits to more than a couple of pictures, pause a moment to click on the record macro button before starting work on the next picture. When you're done, save the macro using a name that describes exactly what kind of edits it covers.

It takes no time at all to record macros, because you do it while you're editing. And it can save you hours of repetitive editing.

Correcting Photo Composition

Sometimes we can't control exactly how we compose our photographs because of the size, location or environment of the item, which can result in product shots that are crooked, include extraneous elements or have too much background. These types of photo-composition problems can be easily corrected using photo-editing software.

Cropping to focus attention on your product

A good product photograph focuses entirely on the item you want to sell, while not wasting any image real estate on excess background. However, you can't always move close enough to an object to make it fill your frame. Sometimes, it's because the lens won't focus that close; other times, it's because you are physically constrained by the environment or setup. What's more, camera viewfinders are inaccurate, which means that what you see through the lens when you're taking the photo can be as much as 20 precent less than what the photo actually captures. The result is a photo that needs to be cropped (**Figure 11.24**).

The Crop tool (**Figure 11.25**) is a special type of selection tool that you use to draw a rectangle around the area you want to keep in a photo.

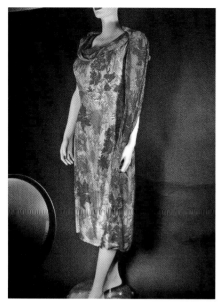

Figure 11.24 *Here's the photo of the silk dress we worked on at the beginning of this chapter, which has too much area given over to the background.*

Figure 11.26 *Notice the dotted line of the crop-selection marquee, which indicates the part of this photo we want to retain. The rest will be discarded. To fine-tune the selection, click and drag on the small boxes on the sides or in the corners of the rectangle.*

Figure 11.25 *This Crop Tool icon is universally used by just about all photo-editing programs.*

Here's how you use a Crop tool:

1. Click the Crop Tool icon to activate it.

2. Click the point in your photo that you want to become a corner of your smaller, cropped picture. Don't release the mouse button.

3. While still holding the mouse button down, drag your cursor diagonally, releasing the mouse button at the point that you want to be the opposite corner in your smaller photo.

4. You can adjust the selection by clicking and dragging on the tiny boxes at the corners and in the middle of the sides of the rectangle (**Figure 11.26**).

5. When you are satisfied with the selection, click either inside the rectangle or the Okay or Apply button.

6. The result is a smaller, more focused product shot (**Figure 11.27**).

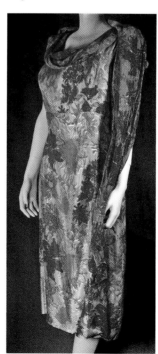

Figure 11.27 *This cropped photo has nothing in it to distract the buyer's eye, focusing all attention on the dress. See the "Removing distracting elements" section later in this chapter to find out how we used the Clone tool to remove the rim of our light that remained in the lower left corner of the picture in Figure 11.26.*

Straightening crooked pictures

We showed you how to rotate photos by 90 degrees in Chapter 10. However, sometimes a photo is skewed by an odd number of degrees, often because you didn't hold the camera straight, or you weren't able to frame the picture easily because you were stuck in a cramped space.

Given that there are practical limits to the size of the photos we can post on eBay, a skewed or crooked photo is a waste of eBay real estate (see the section on Size Matters later in this chapter). Too much background isn't only distracting, but also means that the image of your product is smaller (**Figures 11.28 and 11.29**).

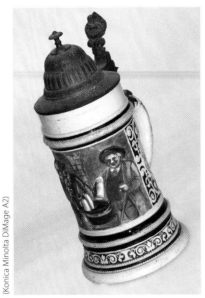

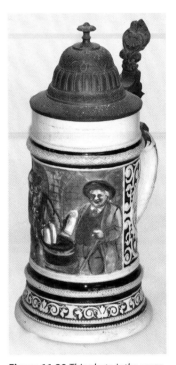

(Konica Minolta DiMage A2)

Figure 11.28 *This crooked photo has excess background, which means the picture gives less real estate to providing detailed visual information about the item to buyers.*

Figure 11.29 *This photo is the same size as Figure 11.28, as measured in total megabytes. Compare the face and other small details in this straight photo to those in the skewed picture. These are larger than the same areas in the skewed picture.*

If possible, we recommend reshooting a skewed photo, because it's a more efficient use of your time. The other option is to use software transform tools. Here's how:

1. Before doing any cropping, select the entire picture. The Select All command is usually found in a Select menu at the top of your screen. That places a dotted line, called a *selection marquee*, around the edge of your photo (**Figure 11.30**).

Figure 11.30 *The dotted line around our skewed photo is the selection marquee. In Photoshop Elements, the Transform command is found in the Image pull-down menu, located at the top of the Photoshop Elements interface.*

2. Look for the Transform command, which is often on the main menu within the Image or Edit pull-down menu at the top of the photo software screen.

3. Place your cursor near a corner of the photo until it changes to a curved double-headed arrow icon (**Figure 11.31**).

Figure 11.31 *Notice the curved double-headed arrow in the upper right corner. That's the transform rotate cursor.*

TIP

Selection Tools, such as the
clone tool, Magic Wand
and Magnetic Lasso, can
help you gain more control
in less time while editing
your eBay photos. See
"Using Selection Tools to
Help Control Your Edits"
in the Appendix for more
information.

4. Making sure the cursor remains the shape of a curved double-headed arrow, click near the corner of the photo and drag either clockwise or counter-clockwise, until the object in your picture is straight (**Figure 11.32**).

Figure 11.32 *Click and drag clockwise or counter-clockwise with the Free Transform Rotate tool until your object is upright.*

5. You can adjust the angle of rotation by repeating Steps 3 and 4.

6. When you're satisfied with the result, click inside the picture to set the rotation (**Figure 11.33**).

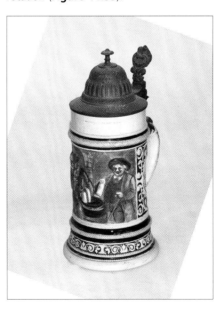

Figure 11.33 *This photo is now straight, but we're not finished with it just yet, because it has all that excess background, as well as those ugly white corners.*

7. Use the Crop tool to get rid of the excess background (Figure 11.29).

Additional transform tools work in a similar manner to correct perspective and other distortions. While they are useful and fun for general photo-editing, we don't use them for our eBay pictures. We're more concerned with getting good photos that sell our products and do it quickly. So we try to avoid using too many tools that aren't, or shouldn't be, necessary for eBay. Remember, if your photo needs lots of editing, it's time to consider a reshoot, which is usually faster and more efficient than spending extra time at your computer.

Removing distracting elements

While it's important that eBay product shots be clean, with no distracting or misleading elements, we can't always control how we set up our photos. This often happens when shooting large items or in cramped, cluttered environments (**Figure 11.34**).

Figure 11.34 *This sofa is in a very narrow, cluttered hallway, which presented a number of challenges that we discussed in Chapter 8. But with all our focus on dealing with those larger problems, we failed to remove the picture on the wall just above the left side of the sofa.*

The picture on the wall in Figure 11.34 would be easy to remove before a reshoot. But you'll encounter times when the distracting item isn't so easy to remove or a reshoot isn't practical. Experienced digital artists use the Clone tool to remove such unwanted distractions or photographic mistakes (**Figure 11.35**).

The Clone tool is a brush that paints an area of your photo using another area as its "paint." To use it, you must first define the source area you will use to paint over the imperfection. Here's how it works:

1. Click on the Clone icon in the toolbox to activate it.

2. Set the size of the Clone brush to something that is large enough to achieve the task without being so large that it is difficult to control.

If your software provides the option to change how paint brushes display, choose Preferences and set the brushes to display their size and precise position. That way, whenever you have a brush selected, your cursor displays as a circle indicating the exact size of the brush in relation to your photo.

Figure 11.35 *Called by various names, depending on the software you're using, the Clone, Rubberstamp or Stamp tool is useful for removing imperfections or distractions from your photos.*

Remember, the brush size relates not only to how much "paint" the brush lays down, but also the size of the area being used as the clone source.

3. To select the area you want to use as your clone source, press and hold the Alt (on a PC) or Option (on a Mac) key while clicking in that area (**Figure 11.36**).

Figure 11.36 *The circle to the right of the photo on the wall is our initial source area for our Clone brush to use as its paint. Notice the status bar at the top of the Photoshop Elements screen, where we set the size of our brush and checked the aligned option. Sometimes, we adjust the opacity to help blend the edges of the newly painted area into the background.*

4. Click and drag over the area you want removed (**Figure 11.37**).

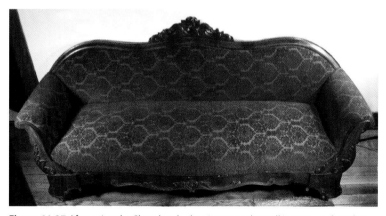

Figure 11.37 *After using the Clone brush, the picture on the wall is gone, as though it never had been there at all.*

5. Repeat Steps 3 and 4 as you paint. You may need to redefine your source area as you change your paint area to pick up other colors and textures.

Practice using the Clone tool. Once you become proficient using it, it will become another one of those easy, powerful tools that you almost take for granted as part of your photo-editing arsenal.

Blur Distracting Reflections

If you were unable to avoid large, distracting reflections when photographing items such as big mirrors, try this technique, which we have found usually works well.

1. Select the area that contains the reflection using one of the selection tools (**Figure 11.38**).

2. Use a Blur filter or some other special effect filter, depending on what the reflection is and how it reacts to the filter (**Figures 11.39 and 11.40**).

Of course, all this editing may take more time than a reshoot, but when all else fails, you have options for getting rid of ugly reflections.

Figure 11.38 *Not only is the reflection distracting in this photo, but the mirror is very dirty. We selected the glass containing the reflection using a Magnetic Lasso selection tool.*

Figure 11.39 *A Blur filter often works nicely on reflections, though it depends on how strong the colors of the reflection are.*

Figure 11.40 *We also like the effect of the Cloud filter in Photoshop Elements, which creates a very soft look.*

Size Matters

TIP

Before resizing any photo and after you have done any other edits, be sure to create a backup copy. That way, you can always have a good, larger version of the edited photo if you need it—or if you make a mistake resizing.

Photos are the biggest culprits in slowing down the Web and email. If an attached picture is too large, email can take much longer to download to your computer. Even worse, when a photo is too large, the page takes too long to open on a buyer's computer. Few people have the patience to wait; instead they usually click to someone else's auction, before even seeing how great your product is. Therefore, a photo that is too large can lose you bids and cut into your profits.

On the other hand, a photo that is too small won't provide the visual information and details about your product that buyers need to see to be enticed to bid.

Determining the right size

The best size photo for eBay can vary, depending on what method you use to put them up onto your auction site.

✦ If you plan to use eBay's standard Picture Services, your photos shouldn't be larger than 500 x 375 pixels, or about 500 kilobytes.

✦ For those photos that you have decided to pay eBay to super-size, your picture shouldn't be larger than 800 x 600 pixels, or about 1.4 megabytes.

✦ If you are using a third-party Web site to host your photos, we recommend you remain rather close to 800 x 600 pixels, but you can go a little bit higher—up to as much as 900 x 700 pixels, or about 1.8 megabytes.

If you are selling lots of stuff on eBay, it's likely you'll be using both eBay's standard Picture Services (for the one free photo you get) and a third-party image host to reduce your costs. But if you sell on eBay only occasionally, you probably will stick with eBay's services, just for the sake of convenience. (In Chapter 12, "Posting your Photo on eBay," we explain the pros and cons of using eBay Picture Services versus other image hosting options.)

After you have cropped your photos, few of them will fit into a rectangle that is exactly 500 x 375 pixels, 800 x 600 pixels or 900 x 700 pixels. Therefore, when resizing your photos for eBay Picture Services, make sure the longest edge of your photo isn't bigger than the largest dimension (500, 800 or 900). If you plan to use another image host, pay attention to the total file size when you resize your photos, making sure they aren't larger than 1.8 megabytes, or smaller if necessary, to conform to the host's limits.

Resizing your photos

Resizing is remarkably easy. The first thing you have to do, however, is figure out what your program calls it— resizing, sizing, sampling or resampling (**Figure 11.41**). The rest involves simply filling out the dialog and making sure the correct options are checked (**Figures 11.42 and 11.43**).

The two most important options in resizing are:

✦ Constraining proportions

✦ Resampling the image

They may be called something else in other programs, but the concepts behind the various names is the same.

Figure 11.41 *In Photoshop Elements, you resize a picture by choosing Image > Resize > Image Size from the main menu.*

Figure 11.42 *When the Image Size dialog box appears, it displays the current dimensions of your photo. The top section measures the size in pixels, which is what you want to focus on for eBay. Also, keep an eye on the total size of the photo—10.8M (megabytes) in this example. The Document Size section relates more to sizing it for print, where the resolution, expressed in pixels per inch, becomes an issue.*

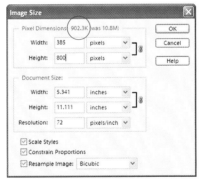

Figure 11.43 *When we set the biggest dimension of our photo to 800 pixels, the software automatically set the other dimension to 385 pixels. This means the photo retained its original proportions. You can see that the new total size is now 902.3K (kilobytes).*

Resizing is another command that many photo-editing programs can turn into a macro. We have six resize macros, named according to the size photo each created, as well as the orientation of the composition—500 x 375, 800 x 600 and so on. That way, resizing involves only a single mouse click on the appropriate macro.

If the Constrain Proportions option isn't enabled, you would be able to resize each dimension independently. The result could be fun-house-like distortions—a squat, fat picture or a tall, thin picture—neither of which would be an accurate representation of your product.

Checking the Resample Image option tells the software that it's okay to throw away pixels and make the picture file smaller.

Incidentally, be aware that when your photos are uploaded to eBay, they are automatically resized by whatever service you use. (We discuss uploading and image hosting services in Chapter 12.) So, why should you waste your time doing it? Because the tools used by the Web sites that are handling your photos are generally more coarse than those in photo-editing programs. In addition, when you do the resizing, you have a chance to double-check the quality of your picture before it is uploaded. If, for some reason, you are unsatisfied, you can always undo the resize and try it again with slightly different numbers.

Posting Your Photo on eBay

Now we come to the main purpose of this book—getting your product photos up onto an eBay listing. Posting your photos can be quite straightforward if you are willing to pay eBay some small fees to handle it all for you. But those small fees can add up for eBayers who are selling lots of items every week.

In this chapter, we show you the easiest way to post your pictures onto eBay and discuss the pros and cons of other various options you have. Then we provide easy to follow instructions for posting the way the experts and power sellers do it.

Posting Photos the Easy Way

Before you create your listing, do a search on eBay for similar items, both in current and completed auctions, to see what the going prices are. That will help you set your own prices. Also, note in what categories similar items are listed; you'll need that information for your listing, also.

eBay started back in 1995, under the name of AuctionWeb. Over the years, the company has grown dramatically and fine-tuned its various services. It now has an easy-to-navigate interface and a rather streamlined, almost effortless system for posting pictures, called *eBay Picture Services*. Of course, eBay has a vested interest in making it simple for you to illustrate your listing with product shots. After the first photo, which is free, they charge a very small fee (15 cents at the time of this writing) for each additional picture. Multiply those few cents by the millions of listings that get posted on eBay each and every week, and we're talking about major bucks—all riding on making it convenient and smooth for sellers to post their pictures. No wonder so many people choose to do things the easy way by using eBay Picture Services.

Getting started selling on eBay

Before you can post your photos, you have to create a listing where the photos belong. To get started, go to www.ebay.com, and click on the Sell button at the top of the screen (**Figure 12.1**).

Figure 12.1 *Start by clicking on the Sell button, which is one of the navigation buttons at the top of the screen at www.ebay.com.*

You need to sign in to eBay using your eBay ID name and password, if you haven't already. If this is the first time you are selling on eBay, you'll probably have to click through at least one page of advertising. But eventually, you'll get to the page that asks what kind of listing you want (**Figure 12.2**).

Figure 12.2 *The first decision you need to make is what format your eBay listing will be. The vast majority of folks choose Online Auction, which is what we always use.*

The choices are:

✦ Online Auction

✦ Fixed Price Listing

✦ Real Estate Advertisement

The Online Auction format is what eBay is most famous for, and the way most people sell on eBay. You put the item up for sale, folks bid on it for a set length of time, and the person with the highest bid when the auction ends is the buyer.

One option in the Online Auction format is Buy It Now, for which you can set the price you want and a bidder can choose to buy it at that price rather than wait through the bidding. According to eBay, Buy It Now has been so popular that eBay now has a separate type of listing in which there is no bidding, just the fixed price. Use the Fixed Price listing if you have multiple units of the same product and want to offer it at a set price.

The Real Estate Advertisement is just what it sounds like. It's an ad for a piece of real estate, similar to what you might see anywhere real estate is offered. There's no bidding, just information, pictures and the asking price. The purpose of this option isn't to sell property, at least not immediately, but to generate leads of people who might be interested in buying.

For the sake of this discussion, let's assume that your listing is an online auction, as most are. Choose that option and click on the Start a New Listing button.

In the next screen, you need to decide in which category you want to list your item (**Figure 12.3**).

Figure 12.3 *The first step in creating an eBay online auction is to decide in which category it should be listed.*

If you're not sure of the best category for your item, you can type in some descriptive words (including a maker's name, if any) in the field in the upper right corner of Figure 12.3, under "Enter keywords here to find a category." That's where we've typed *pottery pitcher*. Click the Search button to the right of this field. A window opens, displaying a selection of categories that might be appropriate.

You can also use the Browse categories section of this window, choosing a general category from the left column. This opens a second list in the next column of subcategories under the general category you chose. More columns of subcategories continue to unveil as you make your choices in each column, until no more subcategories are available (**Figures 12.4 and 12.5**).

Figure 12.4 *When we selected Pottery & Glass in the first column of categories, two options displayed in the second column: Glass or Pottery & China.*

Figure 12.5 *We chose Pottery & China, which opens another column from which we selected Art Pottery. The final column was a list of manufacturers' names, but our pitcher has no maker's mark or label, so we selected Other.*

For our example, we're posting a piece of art pottery and we don't know who made it, so we selected Pottery & Glass > Pottery & China > Art Pottery > Other. You can add a second category for an extra fee if buyers might look in one of two categories for your item (because it fits in both categories). Listing your auction in a second category might be worthwhile if you expect that item to go for a good price.

After you've defined the category for your listing, click the Continue button to move on to the next step. This brings you to the page where you describe the item for sale (**Figure 12.6**).

Figure 12.6 *The description page is where you complement your great product shots with an informative, intriguing verbal description.*

Your verbal description of your item should complement your photographs, catching buyers' interest and imagination. It should also provide them with the facts they need to make an informed decision about whether or not to bid. As with your pictures, be sure your description is accurate and doesn't mislead buyers. Here are some of the components you'll want to try to include:

✦ A physical description of exactly what it is that you're selling, including material, colors and anything noteworthy or unusual.

✦ Any information about where it came from (an old estate, grandma's attic or the divorce settlement, for example) and any history you might have about who has owned it and where it has been. Make it a good story, if possible.

✦ Whatever you know about where it was made, when and by whom, including the maker's name, model name or serial number.

✦ The physical dimensions.

✦ The condition, including any chips, dents, rust or other imperfections.

✦ Your opinions and thoughts about the item, such as how it might be used and what excites you about it.

Notice the Enter Your Own HTML tab in the Item Description section of Figure 12.6. We'll return to this tab later in the chapter, when we cover more advanced posting methods.

Using eBay Picture Services

After you've created your description and have clicked the Continue button at the bottom of the description page, the Enter Pictures & Item Details page displays. About halfway down that page is the Add Pictures section (**Figure 12.7**). It contains 12 boxes for pictures, though only one is free.

Figure 12.7 *The Add Pictures section has space for 12 photos, one of which is free with your auction listing. To see the additional six boxes, use the scroll bar to the right of the Add Pictures boxes.*

Here's how we upload our pictures:

1. Click the Add Pictures button in the free box, which is Box 1. A standard Open dialog box pops up (**Figure 12.8**).

Figure 12.8 *When you click the Add Pictures button, a standard Open dialog box opens. Use it to navigate to where you have saved your photos. Notice the clearly descriptive names of our files and folder. You can also see the original photo files, which we saved separately from our edited versions. (See Chapter 10 for more information on renaming and copying photos.)*

2. Navigate through the Open dialog box to find the photo you want to insert into the eBay listing. As you do this, it becomes obvious why we insisted in Chapter 10 that folders and files have descriptive names rather than the obscure alphanumeric names that cameras and photo-editing software assign.

In our case, the clearly descriptive names make it easy for us to recognize and find the folder we created for eBay, as well as the subfolder containing the dragon pitcher. Each photo's name says quite clearly what view of the pitcher it represents.

3. Highlight the name of the picture that you want to be the first thing buyers see when they look at your listing. Then click Open. The photo is placed into Box 1, with a preview in the larger box to the right (**Figure 12.9**).

Figure 12.9 *The photo we highlighted and opened from the Open dialog box is now in Box 1.*

eBay Picture Services lets you put up to 11 more pictures onto your auction page. Rather than go through the process 11 more times, here's how you can add several pictures at once:

1. Click the Add Pictures button in Box 2.

2. From Open dialog box that appears, select all the pictures you want to add to your listing (**Figure 12.10**).

Figure 12.10 *You can add several photos at once, by selecting multiple files and clicking the Open button.*

Selecting multiple pictures is the same regardless which program you use to work on photos in your computer. Just use the following combination of keys:

◆ To select a group of contiguous files (ones that are next to each other) on both a Mac or PC, click on the first photo file, then press and hold the Shift key while clicking on the last photo file in the series.

◆ To select several photos that aren't contiguous, click on the first one, then press and hold the Ctrl key (on a PC) or the Command key (on a Mac) while clicking on each additional photo.

When you select several files and click the Open button, the software automatically populates additional remaining picture boxes with your photos (**Figure 12.11**).

Figure 12.11 *We now have six photos uploaded to the eBay listing.*

We recommend always inserting the first photo on its own, and then doing a multiple file insert for the remaining photos. That's because the photo that goes into Box 1 is the picture that's put at the top of your listing. You'll probably want to make sure the right one is used in that premier position. In addition, the first photo is shown as your Gallery picture, should you add that feature. (We cover Gallery listings later in this chapter.)

To see a larger preview of the picture, click on any of the six boxes. By the way, at this point, we have added a grand total of 75 cents to the cost of our listing (15 cents for each of the 5 additional photos).

One last edit

You have one last chance to fine-tune your photos, even after you have uploaded them to eBay. Notice the photo-editing tools at the top of the large preview window in **Figure 12.12**.

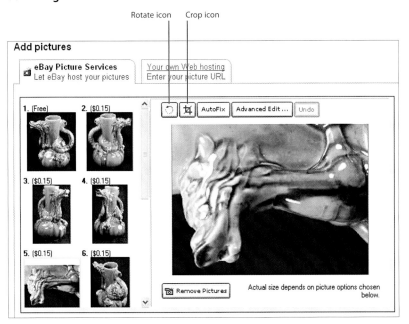

Figure 12.12 *The close-up of the dragon's head spout is on its side and should have been rotated before being posted. No worries—you can fix it here.*

While these tools are very minimal, you can do the following with them:

✦ **Rotate the picture.** Click on the Rotate icon to turn the previewed photo counterclockwise. Each click will rotate it 90 degrees, so you'll need to keep clicking until the picture is upright (**Figure 12.13**).

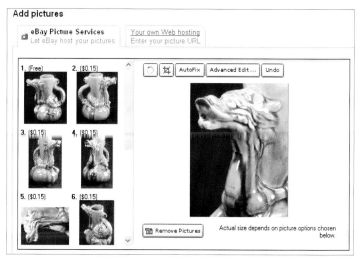

Figure 12.13 *Click on the Rotate icon until the previewed photo is no longer on its side or upside down.*

✦ **Use the Crop tool to cut away any excess background.** It works exactly like the crop tool in photo-editing programs, which we demonstrated in Chapter 11, "Photo-Editing Techniques that Make Pictures Zing." However, we don't recommend cropping after you upload to eBay. The photo file that is uploaded to eBay has been resized for optimum online viewing (see Chapter 11 regarding the right file size for eBay). That means it is much smaller than your original picture. Cropping it now would make it even smaller. Always try to crop before resizing, which means before uploading.

✦ **Autofix color and exposure.** This is a very coarse tool that probably won't do justice to your photos. Again, we recommend not using it.

✦ **Use Advanced Editing tools to adjust contrast and brightness.** Clicking the Advanced Edit button opens another window that contains one-button tools for adjusting brightness and contrast (**Figure 12.14**). While these exposure tools aren't as precise or as good as those found in most photo-editing programs, if you need to use them, they can sometimes work well enough. Watch the preview carefully as you use them, to be sure not to overdo it.

What it looks like

After we have finished creating the listing, putting in all the pricing, shipping and other terms, the resulting auction page displays all our photos of the dragon pitcher (**Figure 12.15**).

The first photo we uploaded is at the top of the auction page. Below the description and above the information about shipping and other terms of sales, we see all our photos displayed. To see larger versions of the thumbnails to the right, a buyer simply clicks on the thumbnail and the selected photo replaces the one on the left.

Increase Contrast
Decrease Contrast
Decrease Brightness
Increase Brightness

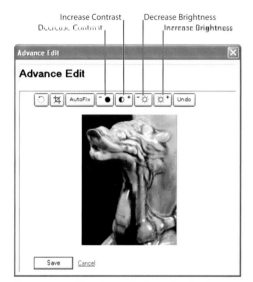

Figure 12.14 *The Advanced Edit window has buttons for increasing or decreasing the brightness or contrast of your photos.*

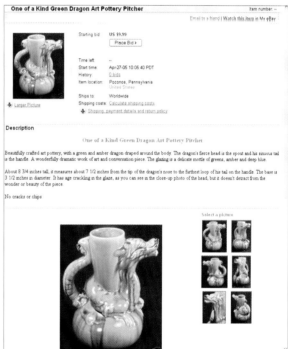

Figure 12.15 *The auction page for our dragon pitcher shows the six photos we had uploaded. (The auction has no bids, because this is the preview that is shown at the time of designing the page and not the actual auction.)*

The value of a Gallery picture

Before you list an item for auction, check the prices for various options, including the cost of each photograph beyond the first shot, bolded text and Gallery pictures. While the prices we list are what is charged at the time of this writing, eBay can and does change fee schedules whenever it likes.

eBay Picture Services has several premium options, for which you pay extra. The most important of these is the Gallery picture, which presently costs 35 cents. When you buy the Gallery option, eBay places a small photo in the listing of your auction that comes up when folks browse through categories or in the search result pages (**Figure 12.16**).

Figure 12.16 *Gallery pictures are the small thumbnails that appear on search result pages or when you browse category listings. This is the list view; the Gallery view shows slightly larger thumbnails. When a seller doesn't pay for a Gallery picture, the space where the thumbnails are normally located remains empty or contains a camera icon, indicating the page has pictures.*

eBay Motors CarAd

If you are selling a vehicle, you should seriously consider using eBay's CarAd premium option for creating really dramatic listings that catch buyers' eyes and dollars. We're talking from experience, as folks who have bought cars on eBay. The CarAd for our last Mercedes was downright beautiful.

With CarAd, you can have up to 35 photos, in an attention-getting interactive and animated interface that lets buyers zoom in on details of the Supersized pictures. Other features include selling guidance, checklists and links to vehicle-related services, such as CarFax, which for a fee let buyers check the history of that specific vehicle.

CarAd costs only $9.95 per listing, or $299.95 unlimited for 30 days. Relisting of unsold vehicles is free.

Whenever we browse on eBay, we always gravitate to those auctions that show a Gallery picture, because it gives us an idea of what we'll see when we click on the listing to open up the auction page. We tend to ignore those listings that have no Gallery picture. It's human nature. Clicking on a listing and waiting for the auction page to open takes time, even at the fastest Internet connection. If the auction isn't anything related to what we're looking for, it's a waste of time. The Gallery picture gives us a sense of what we'll see when we click. What's more, a picture conveys much more information than a short auction title ever could.

Look at the last item in Figure 12.16. The title "Hattie Carnegie Egyptian Revival Scarab Necklace" might catch the interest of someone who has been looking for that specific item or collects Hattie Carnegie jewelry. But the photo is a great way to attract the interest of anyone else who might be browsing through vintage jewelry. The opening bid was $27 02. Fourteen bids later and three days still to go in the auction, it is up to $265. (Two bids were placed in the time it took us to write this paragraph.)

When you browse or search through eBay, you may also see listings that have a tiny camera icon where others have Gallery pictures. That indicates that the auction does have photos in it, but the seller didn't purchase the Gallery option. Later in this chapter, we show you how to get that icon onto your listing, even if you're using some other service than eBay Picture Services to host your photos. However, we do recommend using the Gallery picture option for most items you sell regardless of what hosting service you use, and we'll show you how later.

Making Your Listing Stand Out

The browse and search results listings (Figure 12.16) can contain thousands of items. For those items that you want to stand out from the crowd, you can have the text bolded (for $1), add a border around the listing ($3) or have a bright highlight color as the background instead of the gray or white that normal listings have ($5). You can even do all three.

Further options you might consider for high-ticket items include Gallery Featured, Featured Plus, or Home Page Featured.

Gallery Featured ($19.95) puts your listing at the top of a Gallery view page. Featured Plus ($19.95) gives your listing prominence at the top of category browse and search result pages.

The Home Page Featured option ($39.95 for 1 item, $99.95 for vehicles, and $24.95 for vehicle parts and accessories) gives you a chance, but no guarantee, of having your listing displayed on the eBay home page and eBay's Buy Hub page. It also includes Gallery Featured.

As we mentioned earlier, the first photo that you upload to eBay—the one that goes into Box 1 in the Add Pictures section of the Enter Pictures & Item Details page—is the one that eBay will use for your Gallery picture. You'll want to take care in selecting the right photo. Notice on Figure 12.16 how small the thumbnails are. A Gallery picture needs to convey just what's for sale, in that small amount of space. As a general rule, which applies to most items for sale on eBay, it should be an overall picture of the entire item, shot on a contrasting background so it stands out. But sometimes, a specific detail is more important than the overall picture, especially if the item is distinctive because of that detail (**Figures 12.17 and 12.18**). If you use a close-up photo for a Gallery picture, you will, of course, want to include at least one overall photo on the auction page.

Figure 12.17 *Even thumbnail size, this photo is clearly a tall bar glass.*

Figure 12.18 *This thumbnail shows the important detail about this glass that will sell it—that it is from Jimmy Buffet's Margaritaville in Orlando.*

(Photos taken with a Casio Exilim EX-P505)

Given how small the Gallery pictures are, you won't want to waste any of that tiny space on unnecessary background, so be sure to crop the photo closely in your photo-editing program (see Chapter 11).

Gallery pictures don't guarantee energetic bidding on your product, but it gets folks in the door, looking at what you have to sell.

Premiums Cost: Is Your Product Worth It?

Every time you add a premium service, you increase your cost of selling the item. So be sure it's worth the added expense. One rule of thumb you might want to apply is that the profit you can expect from the sale of your product should be at least ten times the cost of selling it. That's the profit, not the total income from the sale. When calculating your profit, remember to subtract what you paid for your product, as well as the cost of the auction, premium services, shipping materials and other such expenses, from the projected final auction price. Be realistic; base your projections on your experience with selling similar items or your research of how much others have gotten for them on eBay.

Of course, selling on eBay is always a gamble. What might pull in enthusiastic, energetic bidding one week might not even sell the next. It all depends on who is shopping and if they happen to be looking for what you have. Remember, it takes at least two bidders to get the price moving upward, so be selective when adding premium services on individual auctions.

Other eBay premium Picture Services

eBay's other premium Picture Services include:

+ Supersize pictures

+ Picture Show

+ Listing Designer

Supersize pictures

While the standard eBay Picture Service displays your photos in a 400 x 400 pixel window, the Supersize option (75 cents per picture) boosts the picture to 800 x 800 pixels. For those items that have lots of detail, supersizing makes sense, because buyers will be able to see the fine points more clearly.

Consignment seller Chris Miller (eBay ID: paquin6) told us, "I supersize things like comic books. If it has details that people want to look at before they bid or that I want people to notice, then I supersize."

Personally, we have never supersized our auction pictures. 75 cents per photo seems to be a rather hefty fee. Instead, we prefer to provide extra photos with zoomed in views of the specific details we want them to see.

Picture Show

Picture Show (25 cents per item) creates a slide show of all the photos you uploaded to the auction page via eBay Picture Services. It's placed at the top of your auction where the first photo you upload would normally be. But instead of a single picture, it has controls below it that let users flip through all your photos without having to scroll down the page where they are also displayed (**Figure 12.19**).

Figure 12.19 *The Picture Show option creates a slide show of all the photos you have uploaded onto the auction page via eBay Picture Services. Buyers use the controls under the picture in the same way they would use a DVD player's controls, by clicking on the right arrow to flip through your photos.*

Figure 12.20

Figure 12.21

Figure 12.22

Figure 12.23

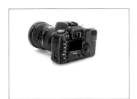

Figure 12.24

Figure 12.25

(This series—Nikon Coolpix 990)

Picture Show works well, especially if you use it to create a little animation. To do that, you need to plan your photos carefully, as though they are consecutive cells in a cartoon (**Figures 12.20 through 12.25**).

Picture Show is certainly an interesting item that buyers enjoy playing with, but we're not really sure it appreciably adds to the value of the listing for the seller. The one effect is that buyers may spend more time looking at the auction page, watching the picture show. But we haven't had any concrete experience or anecdotal information that it will increase the level of bidding. However, if you have an item that is automated, like a wind-up toy, this is the perfect way to display how it works.

Listing Designer

Listing Designer (10 cents per listing) places a colorful border and background on your auction page (**Figure 12.26**).

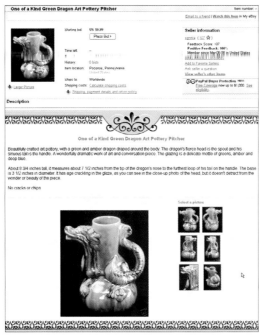

Figure 12.26 *Using one of the couple dozen templates eBay offers brightens up our listing*

If these photos are displayed in a Picture Show, when buyers look at the slide show, it will appear to be a small movie of the camera revolving, with the memory card door and flash opening and closing in turn. Notice that we didn't crop these photos, because all the pictures need to have a common center point, so the camera doesn't appear to jump around as the animation plays.

Applying a template is an attractive way to display your wares. If you decide to use an eBay Listing Designer template, we recommend choosing one that fits your personality and the type of items you sell and sticking with it for all your auctions. That way, it can create something of a visual brand recognition for you among buyers.

However, our greatest objection to using eBay's templates is that many thousands of others may be using the exact same design. That means the one important value of using a template—to create a personality and presence that buyers will recognize—is diluted by the many other sellers whose auctions will look identical to yours. We prefer some exclusivity in our templates. We discuss more exclusive templates, including custom design ones, later in this chapter.

eBay Stores

If you sell a lot, and your inventory tends to be the same series of products, you might want to consider opening an eBay store. A store creates an ongoing professional presence on eBay with links to your current auctions. It's also a virtual home office where buyers can check out and buy from your entire inventory, without your having to relist every week.

Starting at $14.95 a month and going up to $499.99 a month for really high-volume sellers, store owners qualify for auction-listing discounts and promotion opportunities, including special treatment when buyers search for items you might have for sale.

Using Other Image-Hosting Services

What is important to understand is that your pictures don't actually "live" on the auction or store pages. Instead, they are saved elsewhere on the Internet and a code is embedded into the auction page that creates a link to them. When buyers open the page, they automatically see the photos, because the link is live and automatic. This is true whether you use eBay Picture Services, eBay Picture Manager (see sidebar) or another service to "host" your pictures.

Either eBay Picture Services or eBay Picture Manager is probably the most convenient way to get your photos onto eBay. That's because the code containing the link to your photos is transparent from your vantage point. All you need to do is upload your pictures, and eBay does the rest. But eBay's extra charges can add up. What's more, they limit you in the number of photos you can post. That's why many eBayers use third-party image hosts, even though it adds two extra steps to the posting process. First, you have to upload your pictures to whatever site you choose as your image host. Then you have to add HTML code in your auction listing to create the link to your pictures. (We cover how to do that later in this chapter.)

eBay Picture Manager

eBay Picture Manager is eBay's own image-hosting program, which the company initiated in response to the many third-party services that continue to siphon income from eBay. Unlike eBay Picture Services, which keeps your pictures up on the eBay network only as long as the auction is live, Picture Manager functions like other image hosts. So you can store photos that you plan to use over again, including any you might keep up all the time in your eBay store. The prices are on a sliding scale, based on how many megabytes of storage you need. The prices start at $9.99 a month and range up to $39.99, with special discounts for some eBay store owners.

Users of Picture Manager don't pay the extra 15 cents a photo that eBay Picture Services charges for putting multiple photos onto an auction page. And because Picture Manager is part of the eBay environment, it is fully integrated with the Sell Your Item form and easily accessible from your eBay store. You don't need to know or use any HTML to get your photos to and from Picture Manager.

Many sellers swear by Picture Manager for its speed and convenience. But others feel that it's still more expensive than other hosts. Diane Clark (eBay ID: kcanddi) feels strongly that "there are so many ways to host your own photos, so why pay eBay for something you can do for free? And the quality is so much better than eBay's compression."

Choosing your image host

A slew of different companies offer image-hosting services for eBay sellers. Some are free, while others charge a fee. The three most important differences between the two are:

✦ **The maximum size.** Limits how large each photo you upload can be.

✦ **The amount of storage space.** How many megabytes of photos you can upload and leave there.

✦ **The bandwidth.** How much traffic, or, how many people can view your pictures at one time.

One other criteria that is absolutely imperative for any image host—free or fee-based—is that they must allow outside links to access the photos. Otherwise, you won't be able to get the pictures up on eBay.

For many sellers, the free services are quite adequate. If you have dozens of auctions going at any one time, or if you keep a very active inventory in your eBay store, you might need more storage or bandwidth. In that case, consider upgrading to a host that charges a fee.

For instance, we are currently using a free account at www.photobucket.com. The free account gives us a maximum image size of 250 kilobytes, 25 megabytes of storage space and 1,500 megabytes of monthly bandwidth. For only $25 a year, we could upgrade to a service in which the storage space and bandwidth are unmetered, and the maximum image size is 1 megabyte.

Many different companies offer a wide variety of image-hosting services, but those services can change frequently. That means any hosts we might recommend today as we write this book may or may not be ones that we would recommend by the time you read this book.

However, this is where the great eBay community can help. We have found over the years that folks who are most active on eBay, especially on the discussion boards, tend to be very generous with their time and knowledge. Two individuals, who have proven time and again to be great resources, are Bob Bull and Lesley Fenney. They both maintain personal Web sites (www.bulls2.com/bobstips2.htm and www.zoicks.com/ebaylinks.htm) that are chock-full of advice, including suggestions as to what services the various image-hosting companies are offering. So the first place to look for suggestions for an image host are their pages.

Bernie Andreoli (eBay ID: bern2) suggests that you contact your ISP (Internet Service Provider) to find out if you have free image hosting through them. Your ISP is the company through which you access the Internet and which probably hosts your email. He uses Verizon, and as part of the service, it gives him 20MB of image storage space. "They don't advertise it, but it's all part of the package," Bernie explained, "so you have to ask for it."

By the way, the ultimate image host is a personal or professional Web page. If you have your own domain, it is, by its very nature, an image host for you. When you upload your eBay photos to your own Web site, there's no reason why they should be visible to viewers of the Web site unless you want them to be. The eBay photos can simply be parked there invisibly and be viewed only on your eBay pages.

Getting your hosted photos onto an eBay listing

Once you have your photos up on an image host or parked at your ISP or Web site, you then need to link them to your eBay page. It's really a lot easier than it may first appear.

To get your photos onto your eBay page, they need to be added to the item description. Let's go back to the Sell Your Item form that we used earlier in this chapter, when we were posting those photos of our green dragon art pottery pitcher via eBay Picture Services (**Figure 12.27**).

Figure 12.27 *You saw this form earlier in this chapter, when we created the auction page for our dragon pitcher. This page is where we typed the description.*

Notice the tabs at the top of the box where we wrote our description for our dragon pitcher. The currently active tab is for the Standard view, in which everything is *WYSIWYG*, or What You See Is What You Get. In other words, we typed our description into this box and it immediately appeared exactly the way it will look in the auction page. We used the various tools for font color, size, attributes and positioning that are at the top of the box, just as if we were using similar tools in a word processing program (such as Microsoft Word or Corel WordPerfect). When we wanted to change from centered, bolded text for the title to normal text that was aligned to the left margin, all we had to do was click on the appropriate icons at the top of the box. Similarly, we chose the color, size and typeface of our text from the drop down menus.

But creating a page for the Internet is not exactly the same as typing in a word processing program. Underneath it all is HTML, the coding language that provides instructions for any computer linked to the Internet so that it can display Web pages in the manner the designer meant them to be displayed.

Click on the other tab in the description box—the one that says "Enter your own HTML"—to see what the description we wrote for the dragon pitcher looks like under the skin (**Figure 12.28**).

Figure 12.28 *This is the HTML code representing the description of our dragon pitcher that we wrote.*

At first glance, HTML code may look intimidating, but don't worry, you don't really need to learn how to read it, unless you want to (see the sidebar). Remember, we generated all that code just by typing in the Standard window, using commands similar to those we use every day with our word processing program. The only reason you even need to know this HTML view exists is so that you can paste links to your photos into it.

Reading and Writing HTML Code

If you want to understand how HTML code works, it's best to look at some that has already been written. The following is the HTML code for the title of our description of the dragon pitcher:

```
<P align=center><FONT color=green size=4><STRONG>One of a Kind
Green Dragon Art Pottery Pitcher</STRONG></FONT></P>
```

`<P align center>` indicates that it is the start of a new paragraph and the line should be centered.

`` defines the color for the line, which is green and a size of 4, which in Internet terms means a bit larger than the typical text. (You may remember we set the type for the title to 14 points instead of the 12 points that we used for the body of the description.)

`` is the code for bolding the title.

Then those three tags have to be turned off before beginning the next area of text, which is the first paragraph of the body of the description. So `` turns off the bold, `` ends the font color and size attributes that had been established at the beginning of the line, and `</P>` turns off the paragraph.

If you want to try your hand at writing HTML, several eBayers maintain helpful sites, such as Diane Clark's at www.kdwebpagedesign.com/tutorials/auction_html.asp. When you're ready to practice, we highly recommend Lesley Finney's HTML practice board at www.zoicks.com/practice.htm. Another eBayer's site, www.isdntek.com, has a free program, called *TagBot*, that is popular for helping sellers create HTML listings for eBay.

In the tradition of "a little knowledge is a dangerous thing," it's important to understand that creating the HTML code for an eBay listing is not the same thing as coding a Web page. That's because the eBay listing is going inside a Web page that is already defined. And certain HTML codes pertaining to the structure of the page need to be unique and not overruled by what you add to it. Otherwise the eBay page won't work. What that means in practical terms is that you don't want to use Front Page or some other Web page authoring software to create your eBay listing.

Pasting your photo links onto your eBay page

The only HTML code you really need to know or recognize is the link that pulls your photos from your image host and displays them automatically in your eBay page. Here's the format:

``

Let's look at some of our dragon pitcher photos that we have uploaded to our album on www.photobucket.com (**Figure 12.29**).

Figure 12.29 *Four of our dragon pitcher photos as they are displayed on the Photobucket image-hosting Web site. Notice the* `` *tag line under each of them.*

Under each photo are three fields, but the only one we care about is the tag field that has the `` link that we need for eBay. Double-clicking in that field selects the entire tag. We chose Edit > Copy from the main menu. Then we windowed back to the HTML view of our description in the Sell Your Item form on eBay, and chose Edit > Paste from the main menu (**Figure 12.30**).

Figure 12.30 *Notice the two tags we pasted at the bottom of the HTML code for our item description.*

We repeated the process for five photos. Why five when we have six photos of our green dragon pitcher? Because we always take advantage of the one free photo upload that eBay provides with every auction listing (**Figure 12.31**).

Figure 12.31 *Even if you use a third-party image host, we recommend using the one free photo upload that eBay offers with every auction listing.*

Uploading the one free photo to eBay has three advantages:

+ It is the only way to have a photo on our auction page at the very top, so buyers can see a picture as soon as the page opens up.

+ It allows us to buy a Gallery picture option, which we do for almost all our auctions. (See "The value of a Gallery picture," earlier in this chapter.)

+ If there are ever any problems with our image host link, we always still have that one photo. And, yes, sometimes even the best hosts (including eBay) experience downtime when photos don't display.

The resulting page has the small opening photo at the top of the page. The five large photos that are actually links to Photobucket.com are below the description, and a larger version of the opening photo is below them (**Figure 12.32**).

Remember, at no time did we have to type any HTML code to do this.

eBayers are among the most helpful and friendly people we have met on the Internet. If you have a question about getting your photos onto your eBay page or HTML code, go to the Photos and HTML discussion board on eBay and post your question. You'll get lots of useful answers, usually within minutes.

Figure 12.32 *When you view an auction page that was created using HTML code to link to photos on an image host, you don't see any code. All you see is the text and photos that belong there.*

No Gallery Picture?

If you aren't going to have a Gallery picture for your listing and for some reason you decide not to take advantage of the one free photo upload from eBay, you will want buyers to know that you do indeed have photos on your auction page as they browse categories or search results. Click on the Your Own Web Hosting tab in the Add pictures form (Figure 12.31), and a different photo form opens (**Figure 12.33**).

Click on the checkbox next to "The description already includes a picture URL for my item" and whenever buyers browse categories or search results pages where other sellers' listings have a Gallery picture, yours will show a camera icon (**Figure 12.34**).

The camera icon tells buyers you do indeed have photos on your auction. However, we strongly doubt that the Hattie Carnegie necklace would have generated quite as much spirited bidding if the listing hadn't had the Gallery picture. Incidentally, you'll notice another field for a photo URL in Figure 12.33. That's where you can upload a free photo from your

image host to the primary position, if you don't want eBay to host your photos. The format should be the following:

`www.imagehose.com/yourfolder/yourphotoname.jpg`

We don't bother with this extra step of typing in or copying and pasting a photo URL, when it's so much easier to just let eBay handle this one free service.

Figure 12.33 *If you aren't going to take advantage of the free photo upload that eBay offers, click the checkbox next to "The description already includes a picture URL for my item."*

Camera icon

Figure 12.34 *Here's the same search results page as Figure 12.16, except the listing for the Hattie Carnegie auction doesn't have a Gallery picture. Instead, it has a camera icon indicating that the auction does have photos.*

Making your eBay page look even better

The auction page we created with the `` links to our dragon pictures is not the neatest, because the photos just sit there in a pile (Figure 12.32). If you want to make your auction page look a bit neater, you could use HTML code to add borders, specify where in the description the photos should be positioned or add other formatting controls. It's not something we like doing, because we're in eBay to make money, not to spend time writing code.

Two other options include:

◆ Purchasing a template

◆ Getting a custom designed template

eBay's Listing Designer premium option (discussed earlier in this chapter) creates nice templates if you are using eBay Picture Services or Picture Manager to post and host your photos. However, they don't handle photos brought in from other image hosts particularly well. Several eBayers sell off-the-shelf templates that will place your photos neatly within an attractive design, giving your listings a polished look (**Figure 12.35**).

(Template copyright by Diane Clark)

Figure 12.35 *This off-the-shelf template gives a polished look to the auction. The linked photos from our Photobucket account are tamed neatly, with thumbnails that the buyer clicks to see the larger versions.*

Various eBayers sell templates, with prices ranging from $5.99 to $12.99. We like those offered by Diane Clark (eBay ID: kcanddi).

While these off-the-shelf templates are very nice and certainly aren't used by as many sellers as eBay's Listing Designer service, we have decided to ask Diane to design a custom template for us (for about $40). This means that all our auctions will be uniquely ours, which will help build brand awareness among our buyers. Another template designer who is highly recommended by lots of eBayers is Lesley Fenney (eBay ID: Lesley_Fenney).

If you have an eBay store, a custom template can employ the same design for both your auctions and your store. Just as you know at a glance if a delivery truck is from UPS or FedEX, serious eBay sellers want buyers to recognize and look for their pages

Appendix

Thank you for reading our book on how to take great photographs for your eBay auctions. We hope that we've helped you to shoot smarter, better and faster, so that you can make more money while saving yourself unnecessary hassle and frustration.

Many years ago, one of Daniel's instructors in art college disparagingly described the improvisational kind of shooting we've outlined in this book as *meatball photography*. Of course, he was a well-known traditionalist photographer with decades of studio experience, using hideously expensive equipment and having eager assistants at his beck and call. Personally, we kind of like to use *meatball photography* as a way of describing how we illustrate our eBay auctions, because it's fast, easy, inexpensive, and uses whatever materials and resources are at hand. You simply don't need to study photography or use complicated, expensive equipment to shoot like a pro.

However, in trying to keep everything in this book as simple and direct as possible, we've concentrated solely on taking product shots, and not on photography in general. If you wish to learn more about how your digital camera works, as well as how to take great photographs that aren't destined for eBay auctions, we humbly suggest buying one of our other books, the *PC Magazine Guide to Digital Photography* (it's available at your local bookstore or Amazon, etc.).

By the way, if you feel that our advice has been helpful to you as a citizen of eBay nation and you wish to learn more from us, you may want to attend one of our *PC Magazine* seminars, eBay University photo workshops or other programs in a city near you. For a schedule of when and where we'll be teaching, check Daniel's web site, www.DigitalBenchmarks.com, or Sally's web site, www.TheWellConnectedWoman.com.

Thank you and happy shooting!
Daniel and Sally

Predicting Reflections

While reflections may seem random, you can predict and, therefore, easily control them. The rule of photography (and physics) that governs reflections is called, not surprisingly, the *angle of reflection*.

The angle of reflection, or what will be reflected in your product, is defined by the angle of your camera to the object. If a reflective surface is parallel to the front of your camera lens (which is a 0 degree angle), then the angle of reflection will be 0 degrees (**Figure A.1**).

In other words, if your camera looks directly at a reflective surface, the reflection in the surface will be of the camera and everything behind and around the camera.

If the angle from the reflective surface to the camera is, say, 30 degrees, then what will be reflected in the surface when you take the picture is whatever is 30 degrees from the surface in the opposite direction (**Figure A.2**).

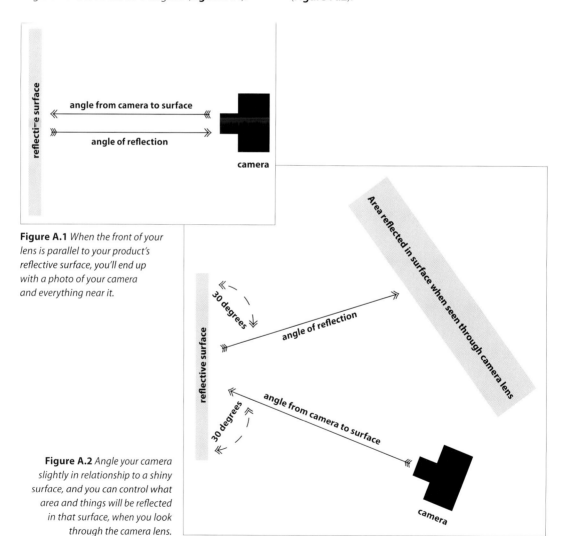

Figure A.1 *When the front of your lens is parallel to your product's reflective surface, you'll end up with a photo of your camera and everything near it.*

Figure A.2 *Angle your camera slightly in relationship to a shiny surface, and you can control what area and things will be reflected in that surface, when you look through the camera lens.*

Selection Tools Can Help Control Your Edits

We tend to move rather quickly through the photo-editing portion of our eBay photography, trying to cut down on the number of minutes per product we spend in preparing the photos for posting. For that reason, we often use selection tools to give us more precise control in less time as well as limit the areas that our edit changes. This is especially useful with the Clone tool, when we want to paint over unwanted elements but ensure that no changes are made to the central item in the photo. We also use selection tools when we want to apply an exposure or color edit to a portion of our photo without affecting the rest.

You saw above how we selected an entire picture to rotate it. Other selection tools that can be used to delineate specific areas of the picture include:

✦ The Magic Wand, which selects areas based on color and lightness. Click on one spot in the picture, and all the contiguous pixels that match it are selected. You can set the tolerance level so that pixels similar to the original pixel can also be selected.

✦ Selection tools come in various shapes, too, such as rectangle or ellipse.

✦ The Magnetic Lasso tries to select areas based on what the software sees as an edge. That makes it easier to select a specific item (**Figures A.3 and A.4**).

Your software certainly has other selection tools. Check your user manual or help menu to find out how they work in your particular program. It's worth taking the time to learn them, because of the greater efficiency you'll have in editing your eBay photos.

(Nikon D70)

Figure A.3 *The dotted selection marquee outlines the area that is currently selected. We used the Magic Wand tool, clicking in various areas of the background to select it. Then we used the Magnetic Lasso tool to fine-tune the selection. Notice that the gaps in the figurine, between his arm and body, are also selected.*

Figure A.4 *With the background area selected, we were able to fill the background with black with a single click of a mouse button, leaving the figure unchanged. If we had wanted to edit the figurine's exposure, color or any other attribute, we could have inverted the background selection to include everything but the background.*

Treating the Digital Camera or Memory Card as a Hard Drive

If your computer runs Windows XP or Mac OS X, it automatically recognizes an attached camera or a memory card inserted into a reader as a storage device. In other words, all the files (your photos) appear to the computer's operating system as though they are stored on a hard drive that is part of your computer. You simply open Windows Explorer or Apple iPhoto to view the photos on the card or camera (**Figure A.5**).

Once you can view the thumbnail photos, you can work manually within Windows Explorer or iPhoto, dragging and dropping them into the folder on your computer where you want to save them. But we'll show you a more efficient way to organize your photos later in this chapter.

Figure A.5 *When we came inside from photographing this pickup truck, we inserted our memory card into one of our readers and were able to view its contents in Windows Explorer right away. On the left side of the window, you can see that the card is recognized by our computer as Nikon D70 (drive) I. On the right side, all the photos on the card are displayed as small thumbnail pictures.*

If It Sounds Too Good to Be True...

You know the old saying—if it sounds too good to be true, it probably isn't true. Be very wary of unusually low-priced cameras from unknown merchants: You may end up a very disappointed buyer. When a new camera is advertised far below what the competition is asking—in fact, below its wholesale price (which is usually 25 to 35 percent off its suggested retail price)—you might suspect it's one of the following:

✦ **A grey market camera.** Grey market products are imported into the country through unofficial, quasi-legal channels, thus circumventing the authorized distributor. They may be cheaper, but they're not warranted, so you'll get no local service or support. Furthermore, because it wasn't intended that the device be sold in this country, the menus and documentation may not be in English, the charge unit may be the wrong voltage, and so on.

✦ **Incomplete.** Inside the box, you may discover that the batteries, charger, memory card, documentation or software are missing. If you want them, you'll have to pay extra (which brings the price up to what you would have paid from a reputable reseller).

✦ **A refurbished or used unit.** There's nothing wrong with buying either (we do), but not if they're represented as brand-spanking-new units.

✦ **A crooked vendor.** You may be buying stolen goods, the product could be non-existent, the dealer might disappear after getting your money, the shipping and handling charges may be usuriously expensive, or the dealer might severely pressure you to buy unnecessary, highly overpriced accessories before closing the deal.

Bargains are great. Too cheap to believe is best left in fantasyland.

Buy Brand-Name Digital Cameras

Dozens of different digital camera brands are on the market, including a number of generic and Brand X types. We have nothing personal against buying an unknown or unfamiliar brand of most products, especially if the price is right. But for eBay, you'll be far better off with a major-brand digital camera. This way, you'll know exactly what you're getting, and you will have some recourse if your camera needs warranty repair or replacement, you must speak with someone from technical support, or you want to download the latest driver from the company's Web site.

Digital camera manufacturers that make models you should consider buying include (in alphabetical order): Canon, Casio, Epson, Fujifilm, Hewlett-Packard, Kodak, Konica Minolta (or simply Minolta from before the merger), Kyocera, Leica, Nikon, Olympus, Panasonic, Pentax, Samsung and Sony. You may notice that we've left a few major brands off this list. That's because their products are, for one reason or another, too simple, too expensive, too complicated, or otherwise not appropriate for eBay use.

Shadow and Light Exercise

We're firm believers that trying something out for yourself is much better than having it explained to you. So we recommend trying the following exercise to gain an intuitive understanding of shadows in photography:

1. Put an object on a white cloth or paper near a bright light or sunny window, or outdoors on a sunny morning or afternoon.

2. Walk around it, taking a series of photographs from various angles, including the front, back and sides, as well as from high and low positions.

3. Review the photos in your computer, and study the affects of the light and the shadows.

Index